The paint
effects
bible

The paint effects bible

100 recipes for faux finishes

Kerry Skinner

FIREFLY BOOKS

A FIREFLY BOOK

Published by Firefly Books Ltd. 2003

Copyright © 2003 Quarto Publishing Inc.

All rights reserved. No part of this publication may be
reproduced, stored in a retrieval system, or transmitted in
any form or by any means, electronic, mechanical,
photocopying, recording or otherwise, without the prior
written permission of the Publisher.

First printing

National Library of Canada Cataloguing in Publication Data

Skinner, Kerry
The paint effects Bible: 100 recipes for faux finishes /
Kerry Skinner.

Includes index.
ISBN 1-55297-718-8

1. Paint. 2. Interior decoration-Amateurs' manuals.
3. House painting-Amateurs' manuals. I. Title.

TT323.S53 2003 747'.3 C2002-905402-8

Publisher Cataloguing-in-Publication Data (U.S.)
(Library of Congress Standards)

Skinner, Kerry
The paint effects bible: 100 recipes for faux finishes /
Kerry Skinner.-1st ed.
[256] p. : col. photos. ; cm.
Includes index.
Summary: Directory of 100 faux finish paint formulas and
how to apply them.
ISBN 1-55297-718-8 (pbk.)
1. Painting-Technique. 2. Texture painting. 3. Paint. I. Title.
698/.142 21 TT323.S55 2003

Published in Canada in 2003 by
Firefly Books Ltd.
3680 Victoria Park Avenue
Toronto, Ontario, M2H 3K1

Published in the United States in 2003 by
Firefly Books (U.S.) Inc.
P.O. Box 1338, Ellicott Station
Buffalo, New York 14205

Conceived, designed and produced by
Quarto Publishing plc
The Old Brewery
6 Blundell Street
London N7 9BH

Art Editor and Designer Michelle Stamp
Project Editor Vicky Weber
Assistant Art Director Penny Cobb
Text Editors Claire Waite-Brown, Sarah Hoggett, Alice Tyler
Photographer Tim France
Index and glossary Diana Le Core

Art Director Moira Clinch
Publisher Piers Spence

The author, publisher and copyright holder have made every
reasonable effort to ensure that the recipes and formulas in
this book are safe when used as instructed, but assume no
responsibility for any injury or damage caused or sustained
while using them.

Manufactured in Singapore by Universal Graphic Pte Ltd
Printed in China by Midas Printing International Ltd

9 8 7 6 5 4 3 2 1

Contents

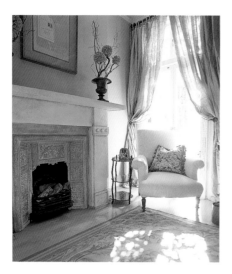

Clockwise from top left: lilac-colorwashed walls and stone-effect fire surround with metallic-copper-effect fireplace; kitchen cupboard with lining, collage, and decoupage; handpainted, stencilled sisal rug and decoupage screen; crackleglaze and decoupage cupboard with gilded-cornice.

Introduction

The purpose of this book is to demonstrate some of the vast array of paint effects you can use to decorate surfaces. A paint-effects directory covers 100 faux finishes, all of which are clearly illustrated with step-by-step instructions, and cover a wide range of traditional and contemporary finishes with varying degrees of difficulty.

You will come to see that the most important ingredient needed for any project is enthusiasm and patience. A good general rule is to spend a lot of time visualizing your goal—preparing, researching, and experimenting with colors and materials.

At this planning stage, samples and idea boards are invaluable. Often the simplest techniques and color combinations can convey the most complex ideas. The biggest hurdle for most of us is learning to work confidently—gaining an understanding of your own intuitive response to color is a great way to become more self-assured.

It is also very important to consider environmental issues—you need to find biodegradable materials, and a low-waste technique that will make as little impact on the environment as possible. Most of the projects show the use of freely available multi-purpose tools and equipment. Manufacturers are usually happy to hear your concerns and have begun to offer more choice for the discerning decorator who wishes, for example, to try out water-based products for a project when all traditional examples demonstrate the necessity of oil-based materials. Again, confidence and a willingness to experiment can lead to exciting results.

It is also important to realize that everyone has their own unique style and there is no definitive, prescribed way to achieve the perfect paint effect. The projects are offered as a starting point for each finish—to offer you help in accomplishing the particular painting you envisage. The techniques shown are open to endless variation and personal interpretation—and indeed your own decorative effects can add more individuality, glamor, and surprise as well as being extremely challenging and fun to achieve. Let your imagination run riot and marvel at the results!

Color theory

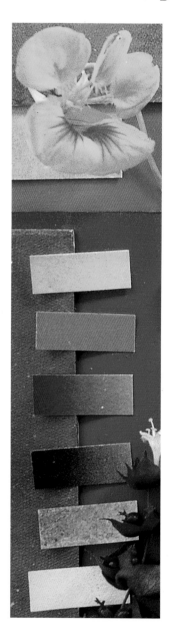

Color is amazingly expansive as a subject. Indeed, it is possible to become involved with color and combinations of color endlessly before even beginning to deal with the structural, textural, or figurative elements of a project. This makes it necessary to have a focus and to ignore the dictates of fashion and fad that can distract you from your personal vision. If you have a complete understanding of the logic of color theory you can choose colors to work with that could stimulate, soothe, or enhance your enjoyment of home, work, and life in general. Learning the simple rules means that you can then adapt, interpret, and break them to suit your own aims.

The use of color is a skill that needs to be learned like any other: an understanding of the color wheel and its potential and values is essential, as is an appreciation of the relationship between colors and their combinations. As an element of form, color is a major influence. It can arouse appreciation and stimulate more thoughts and feelings than any other aspect of interior design.

The color wheel

The color wheel as a basic reference is an invaluable tool when learning about color. The bands of color—red, orange, yellow, green, blue, and violet—are arranged in a segmented circle to show their relationships more effectively. Red, yellow, and blue are known as the primary colors. Mix together two of the primary colors and you will create one of the secondary colors—red and yellow make orange, yellow and blue make green, and red and blue make violet.

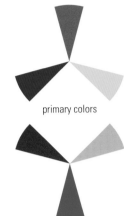

primary colors

secondary colors

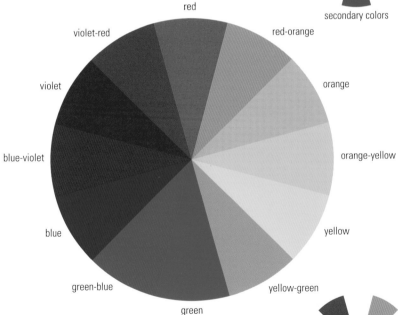

Mixing equal parts of primary and adjacent secondary colors will produce tertiary colors. For example, red and violet make crimson, blue and green produce turquoise, and yellow and green create lime.

tertiary colors

all the colors on the color wheel are hues

tints are created by adding white to a color

shades are created by adding black to a color

yellow has the brightest tone and violet the darkest

Hue, value, and intensity

A particular color can be defined by referring to its three qualities: hue, value, and intensity. Hue is the specific spectral name of a color, such as red, blue, or yellow. The color "pink," for instance, is a "red" hue.

Value refers to the darkness or lightness of the color and includes tints, shades, and tones. Tints are created by adding white and shades by adding black—although for a more subtle shading when mixing your own paint colors it is often better to use burnt umber rather than black. A sense of tone can easily be viewed on the color wheel, where yellow has the brightest tone and violet the darkest. Red and green, however, appear similar: they have a similar tonal value, which is why they can be mistaken as the same by someone with red/green color blindness.

Intensity refers to the saturation of color—its purity, brightness, or dullness. A color with high intensity is bright, strong, and clean, as opposed to one that is muted, dirty, or dull.

Color scheme considerations

Once color is used in a practical way, one needs to take into account not just the individual qualities of each color but also the relationship of combined colors. The mood you create will depend on these combinations.

Calm and restful schemes will be produced if analogous/adjacent hues on the color wheel are used. This is because these colors are harmonious and close in character, as opposed to complementary colors, which sit opposite each other on the color wheel. Combined complementary colors can be very busy and distracting. However, using a small amount of a contrasting color within a single-color scheme is a simple means of achieving an interesting balance.

Combining neutral tones, such as black and white, black and yellow, or blue and white, or clashing

primaries against white will create a dramatic impact.

The positioning and amount used of each color can suggest a color is advancing or receding; bright, warm colors tend to advance while dull, cold colors recede.

Warm or cool colors can illicit an emotional response. Red is associated with passion, action, and danger; orange with vibrancy and health; yellow with happiness, warmth, and sunshine. By contrast, blues suggest space, coolness, tranquillity, and melancholy. Our emotional response to different colors is also closely linked to their environmental associations. For example, green suggests growth and is refreshing and cooling. Brown suggests earthiness and harmony. Purple is the finite color combining warmth and coldness, distance and closeness, and is often viewed as inspirational, religious, and soothing.

analogous hues on the color wheel appear harmonious

External considerations

The balance of light, colors, tones, and textures must be considered carefully in the planning of any project. For example, the textural finish of an applied color will affect how it is viewed. A matte or rough surface will seem darker than a shiny, glossy one, due to the difference in reflected light. It is therefore important to have these practical considerations in mind when choosing the application of color, in addition to the aesthetic, subjective reasons. Smooth finishes are more appropriate for utilitarian kitchens, whereas texture is probably better in an area where you want to suggest softness, and comfort, such as in a reception room.

Consideration must also be given to the source and the quality of light available. Daylight and artificial light affect colors very differently, so view paint samples in various conditions to see how the color changes. Halogen bulbs issue a whiter light than ordinary household bulbs, while natural light varies with the seasons and all light is affected by the choice of curtains and lampshades. Metal, glass, and mirrors can all be used to reflect and diffuse colors and light.

complementary colors are opposite each other

combining complementary colors can be too intense

warm colors advance while cool colors recede

Understanding paint

Primary color boards

These mood boards demonstrate the different qualities of the primary colors, illustrating the huge range of intensities, hues, and values within each one. They also clearly show how varied colors appear when applied to different surfaces and when combined with one another.

The application of paint is the quickest and easiest way to add color to any environment. Paint contains two main ingredients: color in the form of pigment and/or dye; and the medium that carries the color, whether water, oil, and/or a blend of synthetic resins and plastics. Manufactured binders make paints tough and easy to use, but their manufacture encourages the use of non-renewable resources. As the processes of decorative painting become demystified, the traditional techniques such as limewashing, distemper,

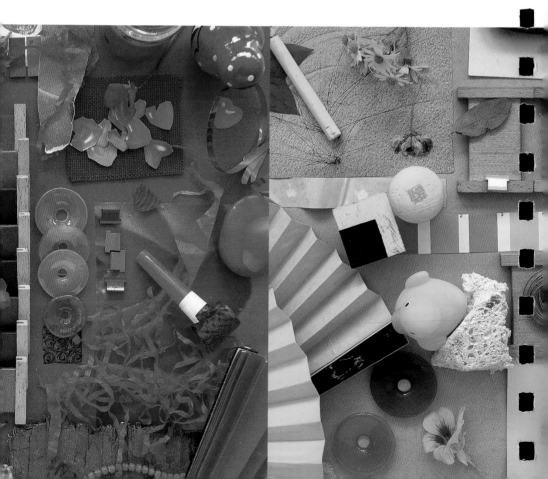

colorwashing, and simple plastering are becoming more widely used. It is hoped that more environmentally friendly products using organic pigments, binders, and solvents will become more readily available.

Mood/color boards

When you are in the process of deciding on a scheme it is a good idea to begin with a reference point. This could be a painting, postcard, photograph, or a favorite object, color, or fabric swatch. Once you have gathered

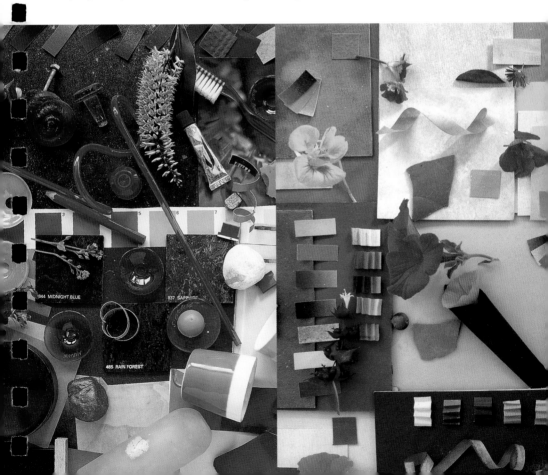

a number of reference materials, the best way to organize them is to create a mood or color board. Combine all the elements you wish to work with on a large piece of thick paper or card. Try to keep the samples in proportion—so if you have a large area of flooring or if the wall effect will be a backdrop to smaller decorative items, aim to display the board with smaller pieces against the larger effect. Try out various sizes of pattern where possible—for example, by photocopying the originals at different scales.

It is important to assess each board against various light sources, to avoid any unnecessary surprises or

disappointments. It is also recommended that you paint up a piece of board or lining paper with the same base color and texture as the actual surface, then experiment with paint in washes, textures, and depths of color. Finally, view these samples in the light source you have decided on.

With such careful preparation and planning undertaken, when it comes to the real thing the work should be spontaneous and relaxed.

Inspiration boards

Each board has been put together to give some idea of the objects, samples, and swatches that could be collected to inspire decorative projects. Many items, such as flowers, can also be color photocopied to keep as reference or to cut out and use for decoupage. Some paint shops can take an item and scan it to obtain an exact paint color for you to work with.

Materials and equipment

Few mediums are more versatile than paint, but to take full advantage of it you need the correct tools and equipment, and some idea of how to use them. Don't splash out needlessly on tools—it is better to work with a few familiar ones than to assemble a large, costly collection that never gets used. Only a small number of specialist items are required to produce the paint effects that follow, and most of the materials are widely available in DIY stores or artist's supply shops.

Paints, glazes, and stainers

Paint is made up of three main ingredients: pigment, binder, and a medium. The pigment provides color and covering power; the binder causes adhesion to the surface; and the medium allows the application.

Today's paint is either water- or oil-based. Water-based products are preferable in many ways as they are non-toxic, odorless, and environmentally safe (although they must be disposed of in accordance with local waste regulations). Oil paints, also known as alkyd paints, dry more slowly—a boon for beginners—and give a more durable finish.

A glaze is the transparent layer of color used over a base coat. The general rule is: use a water-based glaze over a water-based base coat and an oil glaze over an alkyd base coat. The exception to this rule is that you can use an oil glaze over a latex base coat.

Color stainer (or tinter) is a concentrated coloring agent. If you wish to use it for hand-painting, it must be mixed with a medium that has a built-in binder, such as a varnish, glazing liquid, or artist's acrylic paint.

The list that follows describes some of the most commonly encountered types of paint. Remember that properties vary widely between makes. For best results always follow the manufacturer's instructions.

Acrylic primer is water based and used for sealing and covering wood and fiberboard surfaces.

Oil-based undercoat is an undercoat and primer combined, used before applying the base coat, especially on wood.

Latex paint is water based and available in matte (flat) and satin (mid-sheen) finishes.

Stencil paint is a water-based paint that generally flows better than latex paints, and is available in metallic and glitter colors. It can also be used as a stainer.

Wood paint is a matte, opaque paint specially formulated for wood. It is self-priming, has a high chalk and pigment content, and can also be diluted with water to create a wash for bare wood.

Casein (or milk) paint is a water-soluble paint with a soft finish similar to limewash that gives a "dusty" appearance. Excellent for use on furniture and walls, it needs an additional coat if used in an exposed area. *See right* for recipe to make your own.

Oil-based paint comes in gloss, satin (mid-sheen), and eggshell (semi-matte) finishes. Gloss is used as a finishing coat on woodwork. Satin and eggshell are used on woodwork and can be used on walls wherever general wear and tear is likely. They are all wipeable.

Acrylic eggshell paint is a more user-friendly version of oil-based eggshell, with substantially less odor.

Metallic paints are widely available in tubes, pots, and spray cans. New acrylic products are also available offering a range of iridescent, opalescent, and interference colors. These offer unusual shimmering effects that are quite transparent.

Colorwash is a specially formulated, water-based, translucent, colored glaze containing glycol retardants. *See right* for recipe to make your own.

Matte latex glaze is a water-based product used to thin color and to act as a protective top-coat sealant.

Acrylic glaze is non-yellowing, and water- and heat-resistant. It is tinted with acrylic colors for decorative glaze work. Water-based, it gives a short working time, about 15 to 30 minutes.

Transparent oil glaze is used for oil-based paint-effect glazing. It gives more working time but tends to yellow with age. Dilute with mineral spirits.

MAKE YOUR OWN CASEIN PAINT

- Mix 2 lb (1 kg) casein powder with 1¼ pints (725 ml) water in a container.
- Whisk to a thick paste and leave to stand for 30 minutes.
- Add a little liquid pigment and stir well.
- Continue adding pigment until the desired color is achieved.
- Allow a little paint to dry to check its true color.
- Leave the paint to stand until it has the consistency of light cream.
- Whisk again.

An infinite variety of opalescent, metallic, and specialist paints and pigments is available.

MAKE YOUR OWN COLORWASH

- Mix three parts liquid glaze (preferably matte) with one part water to the consistency of light cream.
- Tint as required.

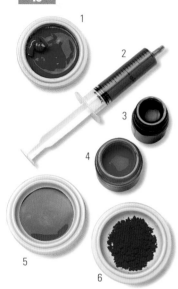

Paint stainers are available in many different forms: 1 artist's oil paint; 2 pigment syringe; 3 water-based dye; 4 water-based stencil paint; 5 artist's acrylic paint; 6 powder pigment.

Artist's oil paints are used for tinting oil glazes for broken-color work and oil-based marbling effects. You could use universal tinters as an environmentally friendly alternative to artist's oil paints.

Universal stainer or **univeral tinter** can be added to any paint or varnish. The strength of color obtained will depend upon the medium being tinted and the amount of white within that medium. As a general rule, add the tinter a drop or two at a time, monitoring the results as you work.

Textured paints and plasters

Exterior house paint comes in smooth or rough finishes and can be used for some plaster or stone effects.

Textured wall finish is available commercially and comes in powder form. It is a mix of quartz, clays, and cellulose. It can be added to matte latex paint by the spoonful. *See left* for recipe to make your own.

Decorator's plaster (gypsum) is similar to plaster of paris, but has a slower drying time. It comes in pink and gray, as well as white which can be tinted with stainers or pigment.

Alternative plasters such as stucco or marmorino plaster are available for those with more specialist knowledge and an understanding of their application. The finish is harder and can be polished to give a smooth, soft gleam.

Natural clay plasters can be mixed with water into a workable consistency and will adhere to most surfaces if prepared properly. They are best used over a breathable surface.

Specialist materials

Metal leaf is available in gold, silver, copper, and a range of metal alloys or Dutch leaf (imitation gold or silver). Most metal leaf is available either loose or in transfer leaf form.

Transfer leaf is used for oil-gilding. Whilst easy to handle and cut owing to a waxed tissue backing paper, it may not retain the luster of loose leaf.

Loose leaf was traditionally used for water-gilding as it can be burnished to a high sheen. It is slightly larger than transfer leaf, but it can be trickier to apply.

MAKE YOUR OWN TEXTURED PAINT

- Add approximately 1 part powder to 2 parts paint, plus a little water if the consistency is thicker than that of double cream.
- Allow a sample of the mix to dry to check its true color.
- Always wear gloves when mixing and working with textured paint.

Bronze and metallic powders are made from metal alloys. Flakes of mica or celluloid can be used to create sparkle or luster colors such as opalescent paint.

Rabbit-skin (Gilding) size is a specialist, water-based glue with a milky consistency. It is used in gilding and is available in powder, granular, or sheet form. *See right* for recipe to prepare.

Gesso is used to create a smooth surface to take thin gold leaf. Traditionally it is made from a mix of rabbit-skin size and whiting. It can also be bought ready mixed. *See right* for recipe to make your own.

Acrylic primer offers a smooth surface as a gesso substitute if it is built up carefully and sanded regularly.

Bole is painted over gesso to add a sealing layer before size is applied to take metal leaf. It enriches the color and makes a pliable cushion to assist the burnishing process. Bole can be bought as a paste suspended in water. A variety of colors are available for use with colored metal leaf. It is mixed with rabbit-skin size before use. *See right* for recipe to prepare, but always check the manufacturer's instructions as some brands may differ.

Crackle medium is one way of creating the effect of cracked, aged paint. Paint the base coat, followed by a coat of crackle medium. When dry, paint on a coat of the top color (the heavier this coat is, the bigger the cracks will be). Cracking will occur due to a chemical reaction between the crackle medium and the top coat of paint. This can be used as an alternative to making your own crackle-effect paint system *(see pages 118–119)*.

Craquelure varnish is a two-part paint pack consisting of a slow-drying base coat and a brittle, quick-drying top coat. It produces an antiqued effect over painted surfaces. Rub artist's oil paint or colored wax into the cracks for extra emphasis.

Whiting is a white chalk powder used in gilding and as a filler for pigment.

TO PREPARE RABBIT-SKIN SIZE

- Soak the size first in a little distilled water to soften.
- Add 10 parts distilled water to 1 part glue in a heatproof bowl over a saucepan of simmering water and stir. Do not let boil.
- Remove any scum that forms while continuing to stir.
- When the mixture is totally liquified it is ready to use.

MAKE YOUR OWN GESSO

- Make up ½ pint (300 ml) rabbit-skin size as above.
- Add 1 lb 6 oz (620 g) sieved whiting and stir gently until the mixture has the consistency of light cream.
- Keep the mixture warm, as it may start to gel as it cools.
- Do not allow to boil as bubbles will transfer to your work.

TO PREPARE BOLE

- Use 1 part bole to ¼ part prepared rabbit-skin size.
- Place the bole in a heatproof bowl over a saucepan of warm water, add a small amount of size, and stir in well to disperse the paste.
- Add the rest of the size and continue to stir gently.

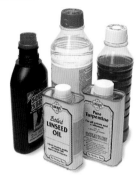

paint stripper, mineral spirit, methylated spirit, linseed oil, and pure turpentine

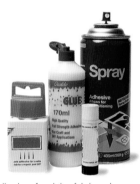

adhesives for gluing fabric and paper, and sealing surfaces

Waxes available include: 1 clear wax; 2 antiquing wax; 3 liming wax; 4 beeswax; 5 gilding wax.

Thinners, solvents, and adhesives

Thinners are used to adjust the consistency and workability of your paint. Solvents are used primarily to clean and remove paint. Some thinners may also be solvents, and vice versa. Adhesives are used both for glueing and, in diluted form, for "sizing" or sealing porous surfaces.

Thinners and solvents

For water-based and acrylic products: use water for thinning and cleaning while wet. Check manufacturer's instructions for cleaning or removing when dry.

For oil-based products: use mineral spirits, linseed oil, or pure turpentine for thinning; use mineral spirits or specialist brush cleaner for cleaning; use paint stripper for removing paint from surfaces.

For shellac, knotting solution, and enamel varnishes: use methylated spirits to thin and clean.

Adhesives

Ready-mixed drywall sealer such as Shieldz by Zinnser is used in many paint effects—both as an adhesive and as a preparatory sealing coat for porous surfaces. It can also be mixed with powders to act as a binder or with paint or plasters to improve adhesion on surfaces. Alternatively, any liquid **white glue (PVA, latex glue)** that turns transparent when dry will serve the same purpose.

Spray adhesive, available from art-supply stores, is an alternative (and less messy) means of sticking paper and other lightweight items to a surface.

Protective finishes

Certain paint finishes need to be protected from exposure to water or steam, to the elements, or simply from general wear and tear.

Waxes

Furniture waxes come in an easily applicable form and in varying colors. If ready-colored waxes are not available, they can be tinted with stainer or tinter. They are applied with a

soft cloth and buffed up with 0000 grade steel wool. Old wax must be removed before starting work on a new surface, as it creates a barrier that will not take paint.

Clear wax protects with a soft sheen.

Antiquing wax is used to create a warm, antique look.

Liming wax imitates bleached wood by leaving a film of white in the grain and so works best on open-grained woods.

Gilding wax is used for highlighting moldings and edges.

Beeswax is a traditional wax used to protect wood from drying out. It is available in liquid form (applied with a brush) and in paste form (applied with a lint-free cloth). The paste is a suitable alternative, although it is more difficult to use.

Varnishes

Oil-based varnish is more robust than its water-based equivalent, but many types go yellow in sunlight or are naturally tinted. Always test a sample piece before use as they can change the coloration of a finish noticeably. Polyurethane is the most popular, but it is quite yellow and can be brittle.

Resin-based water-soluble varnishes do not yellow, are reasonably heat and water resistant, and are more user friendly. Available in matte and satin.

Acrylic water-based varnishes are quick-drying, and available in matte, semi-gloss, or gloss finishes.

Spray varnishes are non-yellowing and need to be treated with great care. They tend to offer only limited protection and work better on water-based effects. They are available in matte and gloss finishes.

Shellac or knotting solution provides a barrier between the wood knots and the painted finish, stopping the resin in the wood from bleeding through and discoloring the paint.

French polish is made from shellac, a natural resin, in liquid suspension. It is the classic finish for fine furniture, but correct application takes some skill to master.

Button polish is made from unbleached shellac buttons, and is darker and more cloudy than French polish. It is a great favorite with restorers to recreate "old" finishes.

Shellac sanding sealer fills the grain in an open-grained wood such as mahogany and allows it to take a better finish.

Protective finishes include: 1 spray varnish; 2 oil-based varnish; 3 shellac; 4 water-based varnish.

gloss-finish varnish

satin-finish varnish

matte-finish varnish

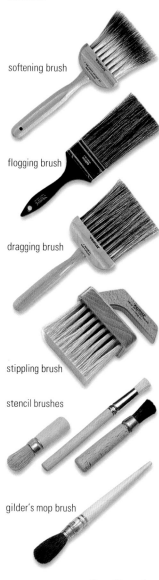

softening brush

flogging brush

dragging brush

stippling brush

stencil brushes

gilder's mop brush

Brushes, sponges, and rollers

One of the secrets of success in decorative painting is to know and use the correct tool for the job. Will it produce a fine enough line? Will it produce the surface texture I want? Always buy the best tools you can afford. They pay for themselves in the end, especially if they are properly cared for.

Remember also that brushes are made of different materials, as are rollers and sponges. Nylon and synthetic brushes work well enough with water-based paints, while oil-based paints generally require better quality hair or bristle brushes. These can be expensive, but are worth the outlay.

Softening brushes such as the high-quality badger-hair softener are very expensive. A hog-hair softener or dusting brush is cheaper and can also be used to remove dust.

Flogging brushes are used for wood graining and some marble effects. They can also be used for dragging.

Dragging brushes are long-bristled brushes that are used for the dragging and graining techniques. An alternative would be an ordinary basecoat brush, but the effect is less subtle.

Stippling brushes come in a variety of shapes and sizes that produce different textural effects. They can be made of bristle or rubber and this dictates price.

Stencil brushes can be domed or flat and are available in different sizes. Made from hard-wearing bristle they produce a fine stipple effect when used over a stencil.

Gilder's mops are soft brushes of camel or squirrel hair used primarily in gilding to remove surplus leaf or to apply metal powders. A soft artist's brush makes a good alternative.

Fitch brushes are usually made of hog hair and come in shapes such as round, oval, flat, or chiselled. They are used

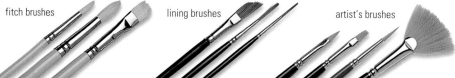

fitch brushes

lining brushes

artist's brushes

for mixing small quantities of paint, cutting in, and painting mouldings and small areas. They are also useful for spattering because of their stiff bristles. Use the tip of the brush to work the paint. Start with a round ¼–½ in (6–13mm), a flat ½ in (13mm), and possibly a chiselled ½ in (13mm).

Lining brushes are essential for line and other decorative applications. They hold the paint in long bristles and allow easy flow. They are also ideal for marbling. Build up a collection starting with sizes 0, 1, and 3.

Artist's brushes come in a variety of shapes and sizes. They range in quality from the best and most expensive sable to the more affordable hog-hair and nylon. They are excellent for cutting in on panels and for working in tight corners. A fine artist's brush can be used instead of a lining brush.

Varnishing brushes come in a wide range of sizes. They are thickly bristled and can be flat or domed. Ideally purchase a 2 in (50mm) flat brush.

Household paintbrushes come in a range of sizes. For priming and undercoating it is best to use a straight-edge brush, and for cutting in edges, a chisel-edge brush. Choose the size that is most suitable for the job and the largest you feel comfortable with. A good range would be ½ in (13mm), 1 in (25mm), 2 in (50mm), 4 in (100mm), and 5 in (125mm).

Tooth brushes or nail brushes can be used to spatter color.

Wire brushes are used for preparing and cleaning surfaces and for liming techniques.

Sponges are used for mottling, stippling, and colorwashing. Use a natural sponge, the surface of which is pitted, or a synthetic sponge that has a smoother surface and is cheaper. A prepared cellulose decorator's sponge is ideal for colorwashing as it will not show marks.

Rollers can be used to apply base colors, plaster coats, and textured effects. Radiator rollers can be used on inaccessible areas and small roller heads can be used for stenciling. Many types of roller heads are available including foam, textured, and sheepskin. Avoid using foam rollers with oil-based paints as they be may affected by the mineral spirits in the paint.

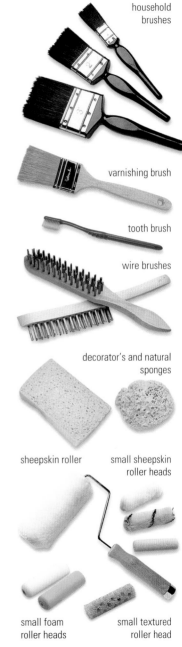

household brushes

varnishing brush

tooth brush

wire brushes

decorator's and natural sponges

sheepskin roller

small sheepskin roller heads

small foam roller heads

small textured roller head

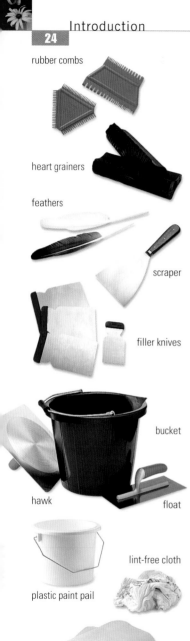

rubber combs

heart grainers

feathers

scraper

filler knives

bucket

hawk

float

plastic paint pail

lint-free cloth

dust cover

Other equipment

Combs are used for combing glazing liquid and textured paints. They are available in rubber, leather, and steel, and come in various grades of teeth. For small jobs you could make your own from thin plastic or stiff card.

Heart grainers are used for wood graining and some marble finishes. They are usually made of rubber and come in different widths and grades.

Feathers are used in marbling for very fine graining instead of fine artist's brushes or sword liners. You can buy goose or swan feathers, but any clean, sturdy feather can be used.

Filler knives are the best flexible metal blades to use for mixing, applying, and smoothing plaster and stucco. The blades can also be useful for scraping out paint containers and cleaning up spillages.

Scrapers are an essential tool for stripping paint and varnish and for cleaning up flaking areas. They are also useful for filling cracks and holes when using ready-made fillers.

A plasterer's hawk and float is used for applying plaster.

Paint containers are necessary for pouring out paint into useable amounts and also for mixing paints and plasters. Paint pails, roller trays, and buckets are available in metal or plastic. An environmentally friendly and cost-effective approach is to recycle durable household waste items—for example, a large jar or plastic container for a paint pail, and a shallow container for a paint tray, as long as they are deep and wide enough to hold and mix your material.

Lint-free cloths will not shed their fibers during use. They are ideal for wiping down and removing dust from surfaces. You will need them for ragging and other techniques, applying waxes, and polishing. They can also be used to dampen in the relevant solvent, remove any mistakes, clean up spills, and wipe your brushes, paint containers, and hands. You can use clean old clothes, but make sure they are made of absorbent natural fibers that will not shed during use.

Dust covers protect furniture and vulnerable surfaces from paint spills. Save old sheets and curtains to use as dust covers. Newspapers can be used as an alternative to sheeting, but newsprint can leave marks.

A carpenter's level helps mark out accurate horizontal lines.

A plumb-bob or plumbline will give perfect vertical lines.

A pencil, eraser, and chalk are used for marking out. Chalk is often preferable as it is easily removed and will not mark the surface. However, a pencil line will give greater accuracy.

A ruler, steel rule, and tape measure will be needed for measuring and marking out. Use a steel rule for cutting against to make your craft knife less likely to slip.

Graph, tracing, and carbon paper are all available in sheet or book form from stationer's or artist's supply shops.

Card can be obtained in varying thickness and can be prepared for use as a sample board, and to texture paint.

Stencil card is also known as manila or oiled card. This is flexible and strong but will eventually become saturated with paint, and stencils will buckle or shrink. It is best to cut several copies of a design if it will be used repeatedly. An alternative is transparent stencil acetate, or Mylar. Make sure you cut your stencil on a self-heal cutting mat.

Sharp scissors, craft knife, or scalpel are essential for decoupage, cutting straight edges, and stencils.

Painter's and masking tape come in a variety of sizes and levels of adhesive. Painter's (low-tack) tape is better for use over new paintwork. Both can be used to mask out areas and position stencils.

Wire or steel wool comes in different grades and can be used for keying (preparing) most surfaces to take paint. Fine wire wool can be used to apply wax, to smooth a surface, and to lightly lift off a top coat and reveal base colors.

Sandpaper comes in a selection of grades. Wet-dry sandpaper is more expensive, but lasts longer and is more controllable.

Sanding blocks are useful for preparing larger sufaces, but are not recommended for some of the more delicate finishing techniques as they are hard and can leave marks.

Everyday household items come in handy for miscellaneous uses. Use a screwdriver for opening paint cans, spoons for measuring paint and powders, a whisk for mixing paint and fine plaster, a sieve for sprinkling whiting, and a heatproof bowl for mixing size, gesso, and bole.

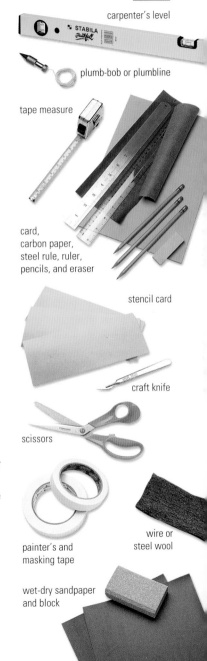

carpenter's level

plumb-bob or plumbline

tape measure

card, carbon paper, steel rule, ruler, pencils, and eraser

stencil card

craft knife

scissors

painter's and masking tape

wire or steel wool

wet-dry sandpaper and block

Basic techniques

Although individual paint effects are covered in detail on pages 40–251, there are a number of general techniques that you should master before you start. These include various ways of preparing a surface; methods of applying paint; finishing techniques that will keep your paint looking good; how to keep your brushes and other equipment in serviceable condition; and how to work safely.

Surface preparation

Careful preparation is essential, as the quality of your base surface will affect the look of your final paintwork. Different surfaces require different treatments.

Cleaning surfaces

The surface must first be thoroughly cleaned: quite apart from the fact that surface grime will dirty any new paint you apply, paint will not adhere to grease and dirt. Wash the surface with household detergent diluted in water and then wipe it down with a clean, damp cloth. For very dirty surfaces, use a solution of sugar soap and rinse off with clean water.

Preparing plaster

Fill any cracks or holes with interior filler and sand smooth when dry. For large cracks, apply filler with a trowel; for small cracks and dents, use a filling knife. After sanding, wipe the surface with a clean, damp, lint-free cloth to remove all dust.

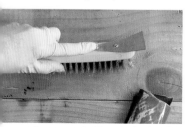

Wash down dirty surfaces with a solution of sugar soap.

Preparing wood

Wood that has previously been painted or varnished must be sanded to remove loose material and leave a smooth working surface to which the paint will adhere. Choose coarse-, medium-, or fine-grade sandpaper, depending on the state of the existing surface and the level of smoothness you require. If you are preparing an uneven or previously treated surface such as wood panelling, you may need to use a wire brush to clean inside grooves or other areas that are difficult to sand. Always sand wood following the direction of the grain. Always wear a face mask to avoid inhaling dust.

For layers of thick, uneven paint and varnish that cannot be

Prepare wood with a wire brush and sandpaper.

rubbed back by sandpaper alone, use a commerical paint stripper. Wear protective gloves and a face mask and follow the manufacturer's instructions carefully. Apply the paint stripper liberally and leave it to soak in for at least 30 minutes before removing the paint with a metal paint scraper.

Water-based paints will not adhere to surfaces that have previously been treated with oil-based stains, or waxed or polished. To remove oil-based stains, dip medium-grade steel wool in mineral spirits and scrub the surface with a circular motion, wearing protective gloves. Waxes, polishes, and shellacs can be removed in the same way using medium-grade steel wool and methylated spirits. Wipe down with diluted detergent. When dry, sand thoroughly.

Fill any sections of missing grain or cracks with commercial wood filler. Allow the filler to dry, then sand. Do not use resin-based fillers if you are using an acrylic primer. With paint finishes that require a very smooth surface, very open grain wood will need to be filled. Use fine commercial filler designed for walls for this purpose. Seal knots on new, bare wood by applying knot sealer with a paintbrush to prevent resin from seeping through to the final paint finish.

Priming your surface

Primers seal the surface, provide initial coverage, and create a bond between the surface and the paint.

Priming plaster

Fresh or previously untreated plaster, or very porous surfaces, should be sealed with a ready-mixed drywall sealer or white latex paint diluted with water before you apply the paint; otherwise you will not have sufficient time to work before the paint dries, as the surface will absorb the moisture in the paint. Brush the sealer or diluted paint on evenly and leave it to dry completely before you apply the paint effect.

Priming wood

For wood, the type of primer depends on both the surface and on the type of paint you are planning to use. In most instances, commercial acrylic primer is suitable, but the instructions in the projects will tell you exactly what to use.

Apply paint stripper with a brush and leave to soak.

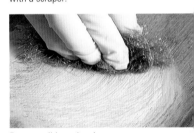
Remove the paint and paint stripper with a scraper.

Remove oil-based stains, wax, or polish with medium-grade steel wool.

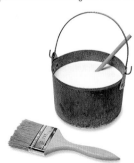
Use diluted drywall sealer or white latex paint to seal plaster.

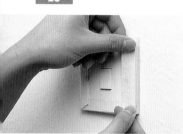

Mask around light switches.

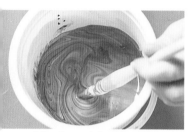

Mix paints and glazes in a paint pail.

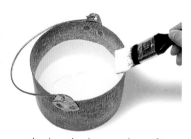

Load your brush to a maximum of two-thirds of the bristle length.

Use painter's tape to mask color edges and remove it once the paint is dry.

Getting ready to paint

Carefully mask all fixtures and fittings, light switches, electrical sockets, and the baseboard with painter's tape, making sure the tape is pressed down firmly.

Arrange all the paints and equipment you need in the center of the room and try to keep them as neat and tidy as possible while you work.

Mixing paints

Always mix paints and glazes in a paint pail. Make up more than you think you will need, because it is virtually impossible to achieve the same consistency and color twice, especially if you're working in a hurry. Try out color combinations on a piece of spare board and position it in different parts of the room at different times of the day to get a good idea of its effect under all circumstances and lights.

Using a brush

Brushes can be used in a variety of ways, but whatever effect you are creating remember these general guidelines. Always use a clean, dry brush. Never load your brush any further than three-quarters of the way up the bristles. Be sure to clean your brushes thoroughly after use to prolong their life.

Painting straight edges

To paint completely straight bands of color (for example, when painting a pattern), mark out the edges of the relevant area with painter's tape. Stick the tape in position, with one edge on the line where the first color will finish, and then paint up to that line and onto the tape. When the paint is dry, just peel off the tape to leave a perfectly straight edge.

To get a second color to line up perfectly with the first, wait until the first color is completely dry and then stick tape along the edge you have just painted.

Always make sure the tape is pressed down firmly, or else the paint may creep under the edge. Remove the tape as soon as possible after painting—the longer it is left on the surface, the more chance there is of a sticky residue being left behind.

Dry-brushing

In dry-brushing, undiluted paint is applied in random directions, leaving a little base color exposed in places. The effect can be used to create or exaggerate the texture on a surface, or to suggest the effect of paint fading over time.

As the name suggests, the brush is used almost dry. Dip the end of the bristles into paint and scrape off the excess on the edge of the paint pail. Hold the brush almost parallel to the surface, and apply the paint using just the tip. Turn the brush over to use the paint on the other side of the bristles and change the angle of the strokes for a random effect.

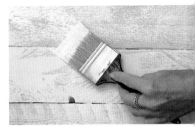
dry-brushing

Stippling

Stippling is a delicate and simple technique to add color and subtle texture to a surface. As the application is so fine, blending of colors can be achieved with ease. Stippling can be used to create a uniform and smooth background for mural or lining work and was traditionally used with dragging and oil glazes on furniture and interiors.

Work in a dust-free environment to minimize the transfer of dust particles that the bristles of the stippling brush might pick up. Dip the stippling brush lightly into the paint and dab off any excess on paper or cloth. Stipple by dabbing the bristle ends onto the surface.

stippling

Dragging

Dragging is a simple method of creating a fine, linear texture with a brush and can be used for a variety of paint effects.

Dip just the tip of the brush into the paint or glaze. Hold the brush in one hand and place your other hand near the tip of the bristles—this will help you control the brush. Pull the brush down through the wet paint, trying to keep the line as straight as possible. For the next section of paint, overlap the previous strip slightly and drag as before.

dragging

Flogging

Flogging is used to create some wood-graining and marble effects. Starting at the bottom of the glazed or painted area, hit the surface in a flogging action with the flat tip of the brush, working upward if you are painting a vertical surface such as a wall or away from you if you are working flat.

flogging

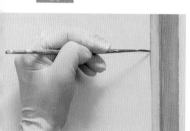

lining

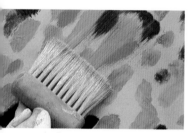

softening

Lining

Some designs require the creation of fine lines – for example, to create the effect of tiles or flagstones. Coachliners are the traditional tools used by signwriters, but they can be difficult to control. A good alternative is a lining brush. The trick is to paint smoothly and confidently: if you hesitate, the line will wobble. Use an even pressure all the way. When working on a dry surface, place the little finger of your painting hand on the work surface to help steady your touch.

Softening

Softening is a technique that is frequently used with paint effects to soften and blur hard brush strokes or to blend one color into another. The brush is generally used dry. Hold the brush handle near the base of the bristles and use long, sweeping crisscrossing movements. To soften hard brush strokes, use the softener in the opposite direction to the original strokes. To blend colors one into another, use the softener in the same direction as the original brush strokes.

CARING FOR BRUSHES

- Before using a new brush for the first time, rinse it in clean water to get rid of any loose bristles that would otherwise stick to the painted surface.
- Clean all brushes immediately after use.
- To clean a brush used for oil-based paint, rinse it out well in a paint pail or bowl using mineral spirits until as much of the color as possible has been removed. Then wash it in warm water with lots of dishwashing liquid until all the paint and mineral spirits have washed away.
- To clean a brush used for water-based paint, wash it in warm water and dishwashing liquid. If the paint has dried on areas of the bristles, use a small nailbrush to remove it.
- After washing brushes, smooth out the bristles and stand the brushes upright in a container to dry. Always store brushes carefully to avoid the bristles being bent.

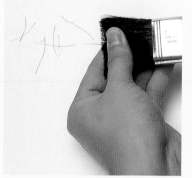

Before using a new brush rinse in clean water and check for loose bristles when dry.

Using a roller

Always use a roller with a tray. Pour some paint into the paint well, taking care not to overfill it: a depth of about ¾ in (2 cm) is usually sufficient.

Loading a roller

Load your roller by rolling it lightly into the paint and then rolling it back and forth on the dimpled surface of the paint tray to cover the roller evenly. Do not overload or you will get drips. Roll your surface, first in one direction and then at right angles to get an even coverage.

A roller will not paint right up to internal angles; stop painting about 1 in (2.5 cm) from the angle and complete the job using a paintbrush. Stipple the edges and corners rather than finishing with a brush stroke or the textural difference will cause the paint effect to appear to have lines and darker edges. Rollers can be used with an extension pole to paint a ceiling or upper section of a wall without the use of ladders.

Cleaning a roller

Remove the sleeve from the roller and clean it in the appropriate solvent for the paint used. Squeeze out as much excess water as you can and leave to dry thoroughly before storing in a box or bag to keep them clean.

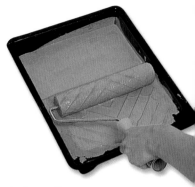

loading a roller

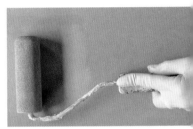

Roll your surface in one direction and then again at right angles.

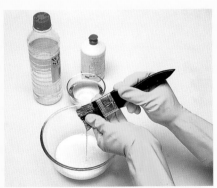

For oil-based paint, rinse the brush out well using mineral spirits until as much of the color as possible has been removed.

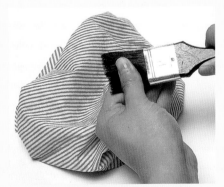

After washing, wipe off excess liquid on a clean cloth and smooth out the bristles before standing the brushes upright in a container to dry.

Rinse the sponge in water and detergent to remove any yellow dye. When it is dry, cut the sponge in half with a sharp knife.

Trim around the heat-sealed edges and tear off the outer sides.

Pick off pieces around the edges and corners. This gives an irregular shape similar to a natural sponge, that is more suitable for decorating.

colorwashing in a figure-of-eight

Using a sponge

Many paint effects require the paint to be applied with a sponge, rather than a brush or a roller. For preference, use a cellulose decorator's sponge, which is close in texture to natural sponge but considerably less expensive. To prepare your sponge for use see *left*.

Colorwashing

Do not dip the sponge in the paint, as it can easily become overloaded. Instead, brush paint onto the surface of the sponge. Apply the paint to the surface in a figure-of-eight movement, as this makes any marks less visible. Try to work in an area approximately 2 ft (60 cm) square, keeping the edges of each application irregular. If you are working with a strong color it is more difficult to control the washes, so try to thin down the application of paint around the edge of each application, where the washes meet, by flipping the sponge over to the clean, paint-free side and lifting off some of the color around the edges. Building up thin layers of dilute paint gives a smoother, more uniform finish and a deeper color. Don't rush by applying thicker paint in fewer layers. Always work with a damp sponge and rinse it out regularly with detergent and water.

Stippling

You can create a textured finish by stippling paint on with a cellulose sponge. To achieve a fine covering when using a fine stencil, use a foam sponge with a dense surface or a foam roller head. Dab the paint on with a "pouncing" motion.

Cleaning your sponge

Clean the sponge in the appropriate solvent for the paint used. Squeeze out as much excess water as you can and leave to dry thoroughly before storing.

Protective finishes

Having put so much time and effort into creating your paint effect, you will want to protect it and make sure it lasts as long as possible. The instructions in the projects will tell you what finish is most appropriate for each effect.

applying liquid varnish

Applying liquid varnishes

Load the brush and work over a limited area at a time. Brush out each stroke with a cross-hatching motion to prevent the brush strokes from being visible. Keep working until the surface has begun to dry slightly, as this will prevent any drips. Always view the surface from different angles to see if you can spot any patches that have been missed. You may need to sand and remove dust between coats for a deeper, smoother finish, or to apply more than one layer for a better overall coverage.

applying wax

Applying beeswax

Beeswax should be applied to the surface with a soft, lint-free cloth. Wait for a few minutes for the wax to penetrate the surface, then remove any excess and buff with a clean cloth.

Applying shellac

Shellac is used to seal gilded and decoupaged effects, and on paint, for a lacquer-style finish before varnishing. The solvent in shellac evaporates very quickly, so careful application is required. Dip a varnish brush into the shellac and glide it onto the surface. After laying on, brush through only twice before evaporation starts, or the smooth look will be spoiled. Wait two hours before applying a top coat of varnish.

buffing with a lint-free cloth

Storing paints and varnishes

Store any half-empty paint tins upside down: any air that has entered the container will go to the bottom of the tin. When you turn it over to use it again, the paint at the top should still be fluid and useable. Keep any mixes or glazes in sealed and labelled containers rather than throwing them away or returning them to the tin.

applying shellac

Health and safety

- Always wear a dust mask and protective gloves when working with oil- and alcohol-based products, plasters, powders and varnishes, and waxes.
- If you have sensitive skin, wear gloves even for water-based products, as lengthy exposure can cause your skin to dry out. Thin surgical gloves are ideal, as they provide protection without impeding your movements.
- When sanding or using toxic products, wear a dust mask and goggles to protect your eyes and lungs.
- Always work in a well ventilated area.
- When working up a ladder be sure that the feet are solidly positioned, will not slip, and the braces are securely locked down. Never try to extend beyond comfortable reach as the ladder could tip over.
- Remember to protect all other surfaces with dust covers to prevent possible damage.
- Do not throw rags soaked with volatile liquid substances such as mineral spirits directly into the dustbin, but lay them out flat to dry before you discard them to prevent the risk of them combusting.
- Label all containers clearly, and keep all chemicals and paints out of the reach of young children – preferably under lock and key.
- Try to avoid using containers which could easily be mistaken for another product by their shape or color. Even if they are properly labeled.
- Whatever product you are using, always read and follow the manufacturer's instructions.

goggles

dust mask

Use extra strong gloves when working with more toxic products such as paint stripper.

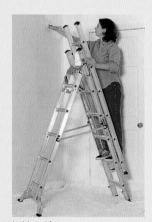

ladder safety

Paint effects
selector

100 paint effects swatches for swift reference

Use this reference guide to choose the paint effect that is best for you and your home. With this comprehensive swatch selector, you can compare different styles and easily gauge which decorative effect is the most appealing. Paint effects have never been easier.

Working with color

44–45 Two-tone colorwashing

46–47 Mixed colorwashing

48–49 Fake clouds

50–51 Colorwashing a textured surface

52–53 Colorwash and stipple mix

54–55 Dry-brushing

56–57 Make your own paint

58–59 Stippling fade

60–61 Linen effect

62–63 Lacquer effect

64–65 Transparent stripes

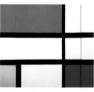

66–67 Mondrian style

68–69 Opaque stripes

70–71 Roller patterning

72–73 Roller spots

74–75 Ragging

76–77 Overlaying colors

78–79 Spray paint and fabric patterning

80–81 Lace stencil

82–83 Muslin frottage

Textured effects

86–87 Sandstone

88–89 Slate

90–91 Terra-cotta

92–93 Stone blockwork

94–95 Limestone paving

96–97 Imitation leather

98–99 Imitation snakeskin

100–101 Denim effect

102–103 Imitation moiré silk

104–105 Imitation suede paneling

106–107 Stucco

108–109 Rustic clay

110–111 Aged plaster effect

112–113 Gesso

114–115 Combing

116–117 Stenciling with filler and mica

118–119 Crackle effect

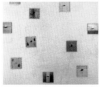

120–121 Craquelure

122–123 Collage

124–125 Collage and decoupage

Traditional effects

128–129 Sienna marble

130–131 Breccia marble

132–133 Carrara marble

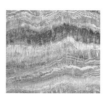
134–135 Rhodocrosite

136–137 Granite

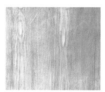
138–139 Oak

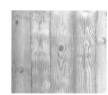
140–141 Pine

142–143 Bird's-eye maple

144–145 Fruitwood

146–147 Mahogany

148–149 Peeling paint

150–151 Antiquing with colored waxes

152–153 Trompe l'oeil

154–155 Drag and stipple with lining

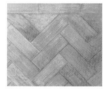
156–157 Fake parquet floor

158–159 Porphyry

160–161 Tortoiseshell

162–163 Lapis lazuli

164–165 Malachite

166–167 Floating marble

Metallic effects

170–171 Metallic paints

172–173 Metallic and matte paints

174–175 Gold-painted squares

176–177 Steel

178–179 Rusted iron

180–181 Verdigris

182–183 Opalescent solid color

184–185 Opalescent and iridescent washes

186–187 Mixing luster paints

188–189 Bronze powders

190–191 Water gilding with real gold

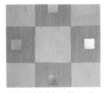

192–193 Oil gilding with real silver

194–195 Imitation gold and silver transfer leaf

196–197 Copper loose leaf

198–199 Gilding on glass

200–201 Metallic paint and metal leaf

202–203 Oil and water on metal leaf

204–205 Metallic paint patination

206–207 Distressing with spirit dyes

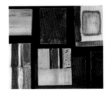

208–209 Chemical patination

Patterns and motifs

212–213 Irregular patterning

214–215 Regular patterning

216–217 Building up colors

218–219 Making a large repeat stencil

220–221 Simple mural

222–223 Printing blocks

224–225 Vegetable stamps

226–227 Found-material printing

228–229 Frottage

230–231 Sprayed leaves and cutouts

232–233 Lining-paper bands

234–235 Circles

236–237 Craquelure stripes

238–239 Outline squares

240–241 Wallpaper

242–243 Wallpaper border

244–245 Acrylic spatter and oil spray

246–247 Simple freehand painting

248–249 Grisaille

250–251 Decoupage grisaille

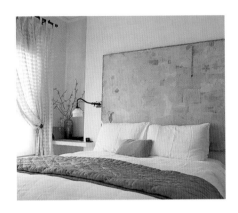

The paint
effects

100 paint effects shown in step-by-step photographs

Use this accessible directory to find the paint effect or faux finish that's right for your space, and give a wall, a floor, or indeed any surface a facelift. With clear instructions, comprehensive lists of readily obtainable materials, and step-by-step techniques sequences, decorating your home has never been this easy!

above: collage bedhead with linen-effect walls and shelving units

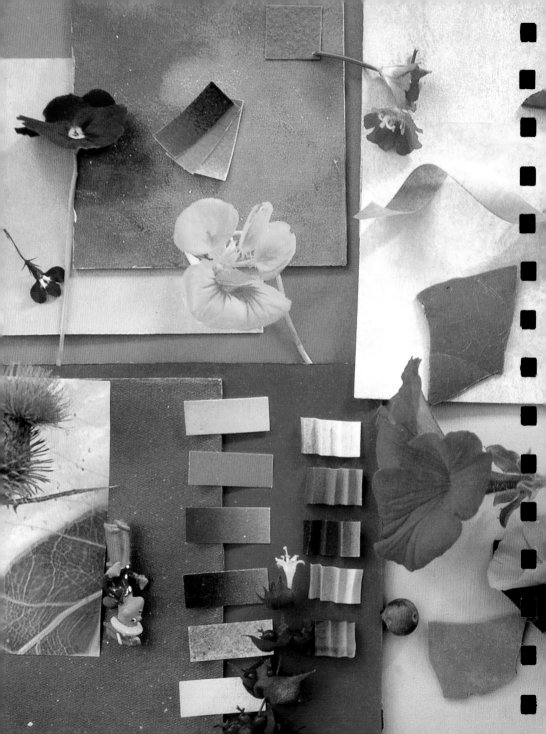

Working
with color

When using paints to decorative effect, the depth and intensity of color that can be achieved is often bewildering to someone used to using flat paint, ready-mixed from a can. Therefore, a look at the possible application methods, using brushes, sponges, rollers, and cloths, can enlighten the novice decorator. This chapter demonstrates the use of much of the equipment available and, more importantly, demonstrates the potential of the color itself when limited tools are used.

To achieve the most interesting layers and washes, a humble sponge will suffice. A household paintbrush can be used with great dexterity to blend translucent glazes and solid paints. It is often a good idea to work within a limited range of colors initially, then expand as you become familiar with the characteristics of certain colors and how they combine. Successful balancing of warm and cold colors is an important step to master, especially if you are trying to suggest space in a small area or create a relaxing atmosphere in a busy room.

The effects demonstrated are suitable for all surfaces, not just walls, so don't be afraid to use paint effects on furniture, floors, floorcloths, or even exterior walls. At this stage the importance of preparation can not be emphasized enough. If you take the time to fully prepare your surface, the resulting paint finish will last that much longer.

Two-tone colorwashing

Materials and Equipment

Lime green matte latex paint
 for the base coat
Bright green acrylic paint
Matte acrylic glaze
Paint pails
Roller and tray
Decorator's sponge
Household paintbrushes

Colorwashing is a simple technique that can be used to great effect. Building up layers of dilute paint produces depth and textural interest, even when using just one or two colors of a similar tone or hue. Clear glaze should be used to protect the effect when you have reached the required depth of color. It is easy to repair a colorwash so remember to keep some of your mixes in airtight containers for future use.

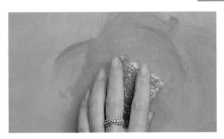

1 Apply the base coat with a roller. Dilute 1 part bright green acrylic paint with 3 parts water. Dampen a decorator's sponge and use a brush to load it with dilute paint. Wash color over the surface using a figure-of-eight movement. Allow to dry.

2 Repeat Step 1 to apply a second colorwash layer in the same color, to enhance the effect. Make sure you work systematically, covering the whole area evenly. Leave to dry.

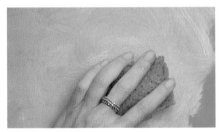

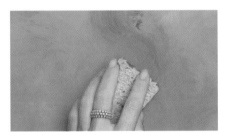

3 Dilute 1 part lime green matte latex paint with 3 parts water and add a small amount of matte acrylic glaze to help fix the paint. Wash this over the deeper color in a smooth, even layer. Leave to dry.

4 Add patches of the first deeper green glaze to increase the depth and texture in some areas. Allow to dry.

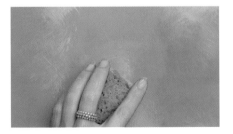

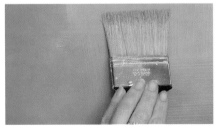

5 Repeat any of the steps as necessary, working with the deeper or the lighter green, to achieve the desired effect. The paint effect becomes more solid as you add more layers. Leave to dry.

6 Use a brush to apply clear glaze with regular brushstrokes. This will protect the finish from staining and damage. Work the glaze in a small area at a time to ensure an even coverage.

Mixed colorwashing

Materials and Equipment

Pale lilac matte latex paint for
the base coat
Acrylic paints: pink, warm blue
White matte latex paint
Roller and tray
Household paintbrushes
Decorator's sponge
Paint pails
Matte acrylic glaze

This colorwash combines warm and cold colors to create a restful shade that will bring a harmonious, relaxing ambience to any room. The layers of pink and warm blue are softened with the pale lilac base color to achieve a chalky finish. This effect demonstrates a different application of a colorwash to that shown on pages 32–33, since here the layers are built up with a strong pattern of cross-hatching.

1 *Apply the base coat with a roller. Dilute 1 part pink acrylic paint with 2 parts water. Dampen a decorator's sponge and use a brush to load it with the dilute paint. Wash the color on in a loose cross-hatching motion. Leave to dry.*

2 *Dilute warm blue acrylic paint as in Step 1, but add a touch of white matte latex paint to soften the color. Use the sponge to apply the paint with the same cross-hatch movement. The color will settle over the pink and suggest a purple. Leave to dry.*

3 *Add additional layers of blue colorwash to deepen the effect. Always keep the sponge moist and make sure it is cleaned well between applications to ensure the colors do not mix and muddy. Leave to dry.*

4 *Add some white to the pink and blue dilute paints and add more colorwashes to achieve the desired effect. Allow to dry.*

5 *Dilute 1 part pale lilac matte latex paint with 3 parts water and lightly and evenly wash this mix over the surface. The paint should be very watery so as not to obscure the previous layers.*

6 *Use a brush to apply matte acrylic glaze. This will make the wash colors shine through the top coat and protect the finish. Work the glaze in a small area at a time to ensure an even coverage.*

Fake clouds

Materials and Equipment

Sky blue matte latex paint for
 the base coat
White matte latex paint
Acrylic paints: aqua blue, gray
Roller and tray
Decorator's sponge
Household paintbrush
Paint pails
Matte acrylic glaze

Here is a simple way to suggest clouds using a sponge technique. The color and shapes are applied lightly with areas of solidity and definition achieved through the build-up of layers. Initially the movement of the sponge is kept light and the edges of the cloud shapes soft, but you can rework the decoration to make it darker or more atmospheric. Additional detail is added using a little gray and more white to give extra depth.

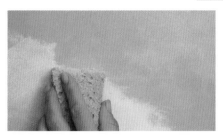

1 *Apply the base coat with a roller. Mix equal amounts of white matte latex paint and water. Dampen a decorator's sponge and use a brush to load it with the dilute paint. Use the sponge to loosely apply cloud shapes to the surface. Leave to dry. Add more white to the edges of the clouds to suggest solidity.*

2 *Use a damp sponge to add a touch of aqua blue acrylic paint here and there to vary the tone. Apply the paint lightly so the white is still visible underneath.*

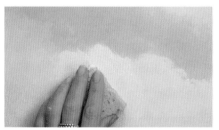

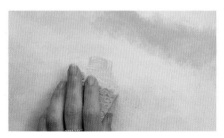

3 *Add more white as necessary, to suggest thicker clouds in places. Building up the cloud shapes with multiple layers adds depth and makes them appear more realistic.*

4 *Use white matte latex paint on the side of a damp sponge to add highlights where the sun shines onto the clouds. Use gray acrylic paint on a clean damp sponge to add lowlights where the clouds are in shadow.*

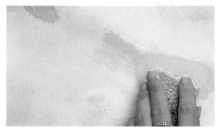

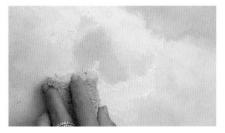

5 *Repeat any of the steps to build up layers and create atmosphere. Keep the washes light so as not to obscure previous work.*

6 *Highlight the edges of the clouds once more, using white matte latex paint on a damp sponge. Protect by applying matte acrylic glaze.*

Colorwashing a textured surface

Materials and Equipment

Ready-mixed drywall sealer,
such as Shieldz by Zinnser
Pale cream matte latex paint
for the base coat
Acrylic paints: burnt sienna,
burnt umber
Roller and tray
Decorator's sponge
Household paintbrushes
Paint pails
Fine-grade wet-dry sandpaper
Matte acrylic glaze

When you strip a wall, you don't always find a perfect plaster surface underneath. Working a paint effect over chipped and damaged plaster may appear a daunting challenge, but colorwashing a textured surface can emphasize the beauty of the imperfections, and add depth to the wall. Here, dilute washes of earth colors are built up to give a soft clay color, similar to that of a worn plaster wall.

1 Seal the wall with drywall sealer and apply the base coat with a roller. Dilute 1 part burnt sienna acrylic paint with 3 parts water. Dampen a decorator's sponge and use a brush to load it with the dilute paint. Wash over the surface in a figure-of-eight motion, pushing the color well into recesses.

2 While the paint is still wet, turn the sponge over and wipe it over the paint. This should lift some color from the surface but leave it still deep in the recesses. Redampen the sponge and follow Steps 1–2 in the same area again, if necessary. Let dry.

3 Dilute burnt umber acrylic paint as in Step 1 and wash it on as before. Lift off the surface color with a damp sponge. You may have to rub quite hard if the color has settled too much. Try to leave the paint in the recesses.

4 The two colors will have given the textured surface an appearance of depth and age. This can be emphasized by lightly sanding the top surface with fine-grade wet-dry sandpaper.

5 If you want to add patches of color again do so now. Due to the sanding the paint will sit on the smoother surface and will require more effort when rubbing into the recesses.

6 Protect the finished effect by applying several coats of matte acrylic glaze with a household paintbrush. Work the glaze in a small area at a time to ensure an even coverage.

Colorwash and stipple mix

Materials and Equipment

Pale cream matte latex paint
for the base coat
Acrylic paints: burnt sienna,
yellow ocher, ultramarine
White matte latex paint
Roller and tray
Decorator's sponge
Household paintbrushes
Paint pails
Matte acrylic glaze

Colorful washes and stippled patches can imitate the transparent glow given by a stained-glass window. To achieve the best result vary the intensity of the washes by carefully building up the colors. A mix of warm colors is balanced by the introduction of areas of blue, like dappled light. If the colors become too dark you can lighten the effect by washing over the surface with the base color and repeating the technique.

1 *Apply the base coat with a roller. Dilute 1 part burnt sienna acrylic paint with 3 parts water. Dampen a decorator's sponge and use a brush to load it with the dilute paint. Wash the color on with a figure-of-eight movement, working the paint until dry.*

2 *Dilute yellow ocher acrylic paint as in Step 1 and apply to a clean sponge. Use the sponge to lightly stipple—dabbing rather than wiping—the color on in patches. Leave to dry. Rinse out the sponge well before applying the next color.*

3 *Dilute ultramarine acrylic paint as before, adding a little white matte latex paint to soften the color. Repeat the stipple technique but do not apply too much blue because it will contrast significantly against the warmer colors. It should appear as no more than a slight bruising. Leave to dry.*

4 *Apply some of the pale cream matte latex paint to a very damp sponge, then wash on a thin layer, going back to the figure-of-eight movement. This will add depth and soften the contrasting colors. Let dry.*

 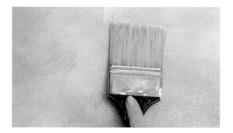

5 *Continue, repeating any of the steps, until you achieve the desired color. Patches of additional layers will give a varying strength of color. Do not overwork the layers or the colors will lose luminosity.*

6 *Glazing the finished effect with matte acrylic glaze protects it and makes the colors show up more. Use a household paintbrush and work in a small area at a time to ensure an even coverage.*

Dry-brushing

Materials and Equipment

Acrylic primer
Pale cream matte latex paint
 for the base coat
Matte latex paints: orange,
 mid-yellow, light yellow
Matte acrylic glaze
Paint pails
Household paintbrushes
Decorator's sponge
Medium- and fine-grade
 wet-dry sandpaper

The dry-brushing technique involves loading just the bristles of the brush with paint before applying it loosely so it does not obscure the previous layer. This effect is often used to suggest texture on a bland surface or to exaggerate the texture of an uneven surface. If worked over wood, as here, the brush should be directed against the grain in short strokes. Here, the effect suggests that the sun has faded the paint.

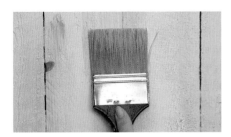

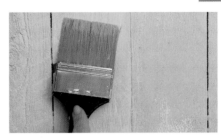

1 *Prime the surface with one coat of acrylic primer and apply the base coat with a paintbrush. Add a little matte acrylic glaze to orange matte latex paint and brush the mix into the recesses between the boards.*

2 *Load a small amount of mid-yellow matte latex paint onto the end of a brush and use loose, random brushstrokes to apply the paint. Do not cover the surface with a solid coat but let previous paint coats remain visible in places. Leave to dry.*

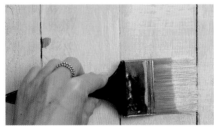

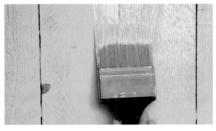

3 *Follow Step 2 to dry-brush a layer of light yellow matte latex paint using repeated short strokes in various directions. This layer will sit on top of the stronger colors, giving the appearance of a lighter, sun-bleached paint.*

4 *To add to the texture, lightly dry-brush on some pale cream matte latex paint. This will enhance the aged effect of the lighter yellow. Try to brush this in a random way and be careful not to obscure the previous color too much. Let dry.*

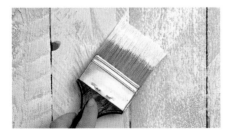

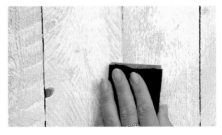

5 *Check the effect when the paint is dry and repeat any of the steps to build up the finish. When you are satisfied, leave the paint overnight to dry.*

6 *Use medium-grade wet-dry sandpaper to lightly rub down the finish, sanding off the top layer in places and bringing out the base colors. Wipe over the surface with a damp sponge. Repeat the sanding with a fine-grade paper to give a smooth finish.*

Make your own paint

Materials and Equipment

Pale blue matte latex paint for the base coat

Casein or milk-based paints (see page 17): light blue, mid-blue, dark blue

Paint pails

Household paintbrushes

Fine-grade wet-dry sandpaper

Matte acrylic glaze

Casein—a form of traditional, milk-based paint—was widely used before the introduction of matte latex paint and gives a smooth matte finish with a chalky consistency. If casein is not available, a prepared or mixable milk paint is suitable. Brushstrokes will remain visible, so use this paint in an area where a textured surface is appropriate.

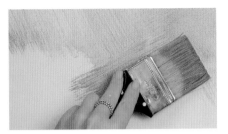

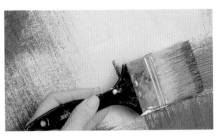

1 *Apply the base coat with a paintbrush. Make sure the surface is free from dust and grease. Use a brush to apply a coat of light blue casein paint in an even layer, cross-hatching to limit the visible brushstrokes. When first applied the color appears transparent. Allow to dry to an opaque finish.*

2 *Use the same cross-hatching technique to apply a layer of the darkest blue casein paint. Let dry.*

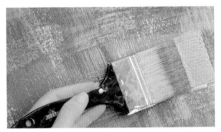

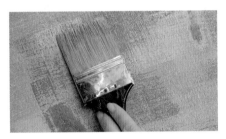

3 *Load the tip of a clean brush with mid-blue casein paint and use a dry-brushing technique (see pages 54–55) to apply the mix. Use short strokes to blend in the light and dark paints. Leave to dry.*

4 *Dry-brush lightly over with the first, palest blue to give a chalky effect. Leave to dry.*

5 *If the texture has built up too much, lightly sand the surface with fine-grade wet-dry sandpaper. Repeat any of the steps to achieve the desired intensity of color and leave to dry.*

6 *Lightly sand the surface once more before sealing with matte acrylic glaze, applied with a brush. Work the glaze in a small area at a time to ensure an even coverage.*

Stippling fade

Materials and Equipment

Pale cream matte latex paint
for the base coat
Matte latex paints: dark green,
light green, white
Matte acrylic glaze
Roller and tray
Paint pails
Stippling brush, hog-hair
softening brush, household
paintbrush

Stippling creates a wonderfully uniform and smooth finish and is an easy way to blend colors. The fine blending made possible by this technique lends itself to obtaining some wonderful fades of dark to light colors. It is important to have a dust-free environment to work in as the bristles of the stippling brush can pick up and transfer particles that are difficult to remove.

1 *Apply the base coat with a roller. Mix 2 parts dark green matte latex paint to 1 part matte acrylic glaze. Dip the bristles of a stippling brush into the glaze and dab off the excess. Stipple the glaze on by dabbing the flat of the bristles against the surface. Cover with a light coat and let dry.*

2 *Mix light green matte latex paint and matte acrylic glaze as in Step 1 and stipple all over as before. An even coverage is important so work over small areas at a time and keep the glaze evenly picked up on the brush.*

3 *Begin to suggest a fading of dark into light green by increasing the stippling density of the darker green color in one area. Here we are working from dark at the top to light below.*

4 *Emphasize the fade by increasing the difference in shading, adding more of the lighter green to its designated area. The lighter green can be stippled almost solid.*

5 *Carefully blend the meeting point of the two greens with a light stippling of both colors. Use a hog-hair softening brush when working on the blending areas for a finer result.*

6 *You can enhance this shading by adding some white paint to the lightest color mix and by increasing the density of the stippling. Protect the finish by applying matte acrylic glaze.*

Linen effect

Materials and Equipment

Pale cream matte latex paint
for the base coat
Matte latex paints: taupe,
burlap
Matte acrylic glaze
Roller and tray
Paint pails
Household paintbrushes

The light texture of this paint effect is built up to suggest an expensive linen fabric covering. If you are experienced with a dragging brush it is possible to achieve a longer, more uniform series of horizontal and vertical lines to suggest a looser weave of linen. When using a different color combination remember to keep the tones similar and start with a sample area to check the strength of color required.

1 *Apply the base coat with a roller. Mix equal amounts of taupe matte latex paint and matte acrylic glaze and add a splash of water. Dip just the tip of a paintbrush into the mix. Apply the glaze by dragging the brush vertically from top to bottom to produce a series of short lines. Try to keep the lines as straight as possible. Leave to dry.*

2 *Mix a burlap-colored glaze as before and repeat the same dragging technique, this time working horizontally, across the vertical lines. Short brushstrokes will ensure the lines are as straight as possible.*

3 *Add occasional darker dragged lines of the first glaze mix. Keep the lines broken to suggest the uneven weave of linen fabric.*

4 *Mix equal amounts of pale cream matte latex paint and matte acrylic glaze and add broken lines to areas that have become too solid. Leave to dry.*

5 *Repeat any of the previous steps to achieve an even texture and regular pattern.*

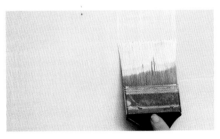

6 *Dilute 1 part matte acrylic glaze with 2 parts water, then mix 1 part pale cream matte latex paint with 3 parts dilute glaze. Apply this with a household paintbrush to protect the finish and add a soft top coat to unify the overall look.*

Lacquer effect

Materials and Equipment

Pale pink acrylic eggshell for the base coat
Red acrylic gloss paint
Household paintbrushes, hog-hair softening brush
Medium- and fine-grade wet-dry sandpaper
Clear (liquid) beeswax or high-gloss varnish
Lint-free cloths

This is a simulation of the high-gloss lacquer finish traditionally used in Japan and China. The paint used is actually a water-based gloss, which means the layers will dry quickly and can be sanded and repainted many times in one day. The build-up of layers gives a longer-lasting finish than a single, solid coat, and achieves a translucency and depth that cannot be matched by flat color.

1 *Apply the base coat with a paintbrush. When the eggshell paint is completely dry, sand the surface with medium- then fine-grade wet-dry sandpaper. Use a circular motion and regularly change the paper.*

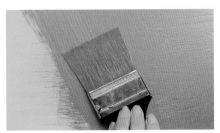

2 *Use a paintbrush to apply the first layer of red acrylic gloss in broad, loose strokes. Repeat the strokes over the surface until a smooth glaze of red covers the pink. Leave to dry.*

3 *Repeat the circular sanding motion with fine-grade wet-dry sandpaper. Clean off any dust.*

4 *Brush on another layer of red gloss as before. Cross the brushstrokes randomly and regularly until smooth. Leave to dry.*

5 *Sand and reglaze the red, following Steps 3–4, as often as necessary to reach the required density. Soften the final coat by brushing over in a variety of directions with a hog-hair softening brush while it is semi-wet. Let dry and finish with a light sanding.*

6 *Apply a coat of beeswax with a lint-free cloth (you will find liquid beeswax easier to apply than the paste form) or a coat of high-gloss varnish with a brush. Use a clean, dry cloth to buff it to a smooth sheen.*

Transparent stripes

Materials and Equipment

Pale cream matte latex paint
 for the base coat
Tape measure, pencil, chalk
 line
Matte latex paints: warm blue,
 pink
Matte acrylic glaze
Paint pails
Rollers and trays
Household paintbrush
Medium-grade
 wet-dry sandpaper
Damp sponge

Stripes make a bold statement, but using transparent glaze allows the introduction of a strong pattern while keeping the colors low key. Sanding the glaze when dry also softens the edges of each stripe. Vary the width of the stripes to fit the dimensions of the room: to give visual impact to a large wall, use plenty of stripes of varying widths; but use fewer, wider bands for an area that is busy with details.

1 Apply the base coat with a roller. Use a tape measure and pencil to mark the wall with a pattern of stripes of varying widths. Use a chalk line to give the first vertical to measure from. Remember that the cream base coat will form some of the stripes.

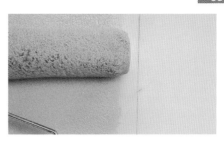

2 Dilute 1 part warm blue matte latex paint with 2 parts matte acrylic glaze. Pour the mix into a roller tray and thinly load the roller. Carefully roll on the glaze, following the first chalk line, to paint a broad blue stripe. Paint in the other blue stripes and leave to dry. Wash off the chalk line with a damp sponge.

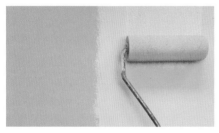

3 Follow Step 2 to roll on pink stripes between the blue stripes, leaving stripes of the cream base coat on either side. The edges can be uneven.

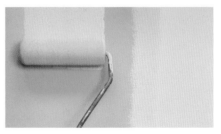

4 Working carefully by eye, roll a stripe of pink down the center of alternate broad blue stripes. Leave to dry.

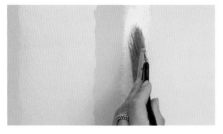

5 Touch up areas of cream paint as necessary, using a brush to stipple between the bands of color. Allow to dry.

6 Sand the stripes with medium-grade wet-dry sandpaper, using a regular movement. This will allow some of the cream to break through the glaze, make the finish more chalky, and soften the uneven rollered edges.

Mondrian style

Materials and Equipment

Acrylic primer
White matte latex paint for the
base coat
Tape measure, pencil, painter's
tape, craft knife
Matte latex paints: red, blue,
yellow, black
Rollers and trays
Household paintbrush
Matte acrylic varnish

This graphic, geometric pattern can be applied to any surface, from a whole wall to a single item of furniture. The colors must be carefully planned, so it is a good idea to draw up a colored paper plan of the design layout before marking up the decoration. Adding the paint in rollered layers means that it will hold firmly and last well.

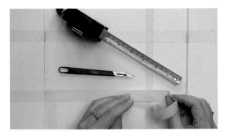

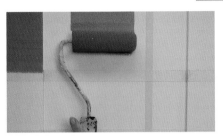

1 Roll on a coat of acrylic primer and apply the base coat with a paintbrush. Use a tape measure, painter's tape, and a craft knife to mark out a series of squares and rectangles. Refer to a Mondrian print for help. The painter's tape should cover what will later become the thin black lines.

2 Roll on red matte latex paint as evenly as possible. Leave to dry and roll on a second layer to achieve a solid color. You may find it useful to lightly mark the squares with pencil to indicate which colors are to be used where.

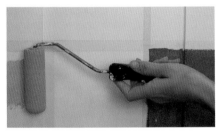

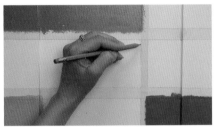

3 Roll on blue matte latex paint in the appropriate places as before. Repeat with yellow matte latex paint. Leave to dry.

4 Make pencil marks along the edges of the painter's tape on both sides and remove the tape.

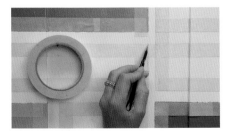

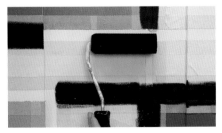

5 Remask, aligning the tape with the pencil lines to mark the black bands. The edges should be as straight as possible.

6 Paint in the black lines with a roller. Leave to dry and apply a second coat if necessary. Once dry, carefully remove the painter's tape and apply matte acrylic varnish with a household paintbrush.

Opaque stripes

Materials and Equipment

Pale cream matte latex paint
 for the base coat
Chalk line, painter's tape,
 cotton fabric, plumbline
Matte latex paints: pink,
 yellow, lilac, bright green
Rollers and trays
Household paintbrush
Fine-grade wet-dry sandpaper
Matte acrylic varnish

This combination of colors is exuberant and vibrant, and because the colors have a similar tonal value—they have all been tinted with white—they mix well without disturbing the eye. In this technique a series of parallel lines is obtained without having to repeatedly measure and mark. By masking the whole surface the butted-up tape can simply be removed for painting and the stripe remasked as necessary.

1 Apply the base coat with a roller. Use a chalk line to mark the first vertical, then mask up your stripes, butting the painter's tape up across the whole surface and using varying widths of tape. To detach the tape slightly, brush the tacky side across a cotton fabric.

2 Remove one or more strips of painter's tape, depending on the width you want the stripe to be.

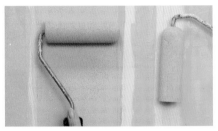

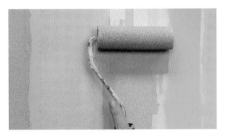

3 Load a roller with pink matte latex paint and apply to the area where the tape has been removed. Remove a strip of tape a little away from the first to roller the second color, yellow, without risk of smudging.

4 To paint a lilac stripe adjacent to the previously painted lines, wait for the paint to dry, then reapply strips of painter's tape over the edges of the dry paint. Roll on the paint. You may want to use a plumbline to ensure you have a true vertical. Let dry.

5 Continue removing and replacing tape to complete the desired number of stripes. Leave to dry.

6 Lightly sand the stripes with fine-grade wet-dry sandpaper to soften the edges. Protect by applying matte acrylic varnish with a paintbrush.

Roller patterning

Materials and Equipment

(Pre-cut) foam radiator roller and tray

Permanent marker pen, craft knife

Off-white matte latex paint for the base coat

Matte latex paints: red, orange, yellow, brown

Matte acrylic glaze

Household paintbrush

Paint pail

Decorator's sponge

Detergent

This simple technique results in a complex effect with a vibrant mix of colors and shapes. The finish can be varied by experimenting with the strength of paint-to-glaze mix—more glaze will give a transparency to the paint that means some colors act as a background texture, although still with a strong, graphic pattern. It is important to use a foam roller so that the cutout shapes retain the paint well and the edges stay clean.

1 Go to an art-supply store and buy a pre-cut, stamp-effect, mini roller. Or make your own: use a permanent marker pen to outline shapes on a mini foam roller. Cut around the shapes with a craft knife so that they stand out to a height of about ⅜ inch (1cm). Use a large roller if painting a wide area.

2 Apply the base coat with a paintbrush. Mix 1 part red matte latex paint to 3 parts matte acrylic glaze. Use a sponge to colorwash the surface (see pages 44–45). Alternatively, you can apply a solid coat of red matte acrylic paint as your background color.

3 Load the adapted roller with orange matte latex paint and use either one clean, straight stroke to apply the paint and pattern, or roll the roller back and forth twice over the area. Continue to cover the whole surface and leave to dry.

4 Wash out the roller and paint tray with detergent and water. Apply a yellow pattern, using the same clean stroke to keep the shapes clear. The first color will appear as a background echoing the pattern. Allow to dry.

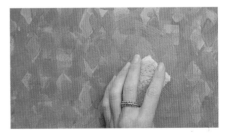

5 Follow Steps 3–4 with brown paint. This final, deeper color can be diluted with 3 parts matte acrylic glaze to make it more transparent. Let dry.

6 Mix equal amounts of red matte latex paint and matte acrylic glaze. Wash this over the surface to soften the colors and give a protective seal.

Roller spots

Materials and Equipment

Cream matte latex paint for the base coat
Matte latex paints: pale cream, lilac, light brown, mid-brown
Matte acrylic glaze
Rollers and trays: mini foam, mini medium-pile, medium household rollers
Fine paintbrush, household paintbrush
Fine-grade wet-dry sandpaper
Detergent

This technique is ideal for decorating a room or furniture quickly, introducing pattern and color without the need for any great skill. As long as the roller end is not overloaded, the result should be a neat and crisp application of colored spots in a random pattern. Consider the density of spots—too many may make a small area appear busy—but keep the colors light and harmonious and the finish will not be overwhelming.

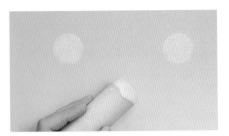

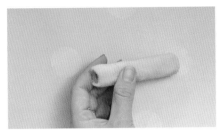

1 *Apply the base coat with a roller. Dab the solid end of a mini foam roller in pale cream matte latex paint. Dab off the excess. Lightly press the paint-loaded end onto the surface and cleanly remove. Continue to create a random pattern of spots. Leave to dry.*

2 *Dab the end of a smaller, medium-pile roller in lilac matte latex paint. Dab off excess paint then press the roller in the center of a cream spot. Add lilac inner spots to some of the cream spots, aiming to evenly balance the distribution. Leave to dry. Clean the roller well with detergent and water.*

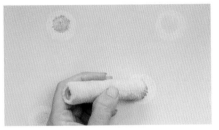

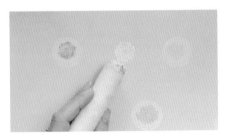

3 *Using a clean medium-pile roller, randomly apply smaller light brown spots to some of the cream spots. If the colors appear too dark, add a small amount of matte acrylic glaze to make the paint more transparent.*

4 *Add mid-brown spots to the remaining circles. Aim for a balanced yet random mix of colors.*

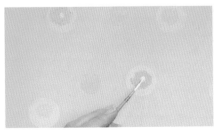

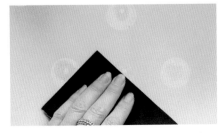

5 *If some colors appear too dominant you can highlight the center with a dot of cream matte latex paint using a fine paintbrush. Leave to dry.*

6 *Sand the pattern lightly with fine-grade wet-dry sandpaper to give a smooth finish and apply matte acrylic glaze with a household paintbrush.*

Ragging

Materials and Equipment

Pale cream matte latex paint
for the base coat
Colorwash mixes: stone, ocher
Roller and tray
Household paintbrushes,
stippling brush
Lint-free cloth
Matte acrylic glaze

This is a relatively easy way to add a little texture to a flat color without changing the overall appearance greatly. It is best to practice using this technique with lighter colors; you can experiment with color mixing on a wider scale when you are more confident. The texture created lends itself to large-scale application, and because the cloth is held in a palm-sized pad, the finish is easily and quickly achieved.

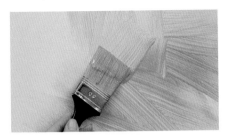

1 *Apply the base coat with a roller. Use a paintbrush to apply stone colorwash mix in broad, even strokes in all directions.*

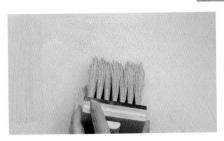

2 *Dab the bristles of a stippling brush into the wet colorwash to remove tiny spots of color. Work quickly and aim for an even coverage.*

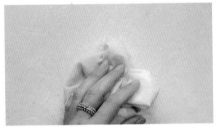

3 *Wad up a pad of slightly damp, lint-free cloth and dab it over the colorwash, lifting off some color. Work quickly before the glaze has time to dry. Prepare a few pieces of cloth beforehand and discard saturated cloth as necessary. Allow to dry.*

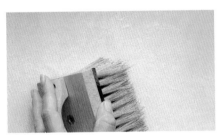

4 *Repeat the whole process with ocher colorwash mix, or redo the stone to achieve a deeper color before applying the ocher. Leave to dry.*

5 *Any areas that appear too subtle can be treated again by dabbing them over with a cloth dampened with colorwash mix, adding extra color and texture where required. Allow to dry.*

6 *Finish by applying matte acrylic glaze with a household paintbrush for protection.*

Overlaying colors

Materials and Equipment

Dark cream matte latex paint
for the base coat
Matte latex paints: dark peach,
light peach
Roller and tray
Mutton cloth
Household paintbrush
Matte acrylic glaze

This is a favorite with decorators because it is easy to execute but results in a complex build-up of colors with a soft, even texture. The mutton-cloth weave is loose but regular and therefore allows color blending to work in a delicate and interesting way. The dark and light peach mix evokes a warm, cosy atmosphere, while the cream adds clean, fresh highlights. This effect can be used with good results on an imperfect surface.

1 Apply the base coat with a roller. Dab a scrunched-up mutton-cloth pad into dark peach matte latex paint and remove the excess. Dab the cloth lightly over the surface. Try to work evenly, picking up any excess and redabbing it until dry.

2 Use a clean piece of cloth to apply light peach paint in the same way. The colors can be blended at this stage but do not cover the first color too much. A large pad of cloth will leave an obvious mark, whereas a small pad will produce a tighter, more controlled texture.

3 When the paint is completely dry, add some of the dark cream base color to increase the texture and soften any areas that appear too dense with color. Leave to dry.

4 Work over the area again with the dark peach to add shape to the finish. You could try a cloud effect or a fade from dark to light. On a wall, try darker corners moving into a lighter center. Let dry.

5 Use a clean piece of cloth to add final touches of light peach to create highlights.

6 Protect by applying matte acrylic glaze, working evenly with regular, short brushstrokes.

Spray paint and fabric patterning

Materials and Equipment

White matte latex paint for the base coat
Open-weave nylon netting fabric
Scissors, spray adhesive
Protective face mask and gloves
Acrylic spray paints: green, blue, silver, light bronze
Roller and tray
Fine-grade wet-dry sandpaper
Beeswax
Lint-free cloth

Nylon fabric can be used as a means of masking a surface from spray paint. Pieces are moved around and the spray paint repeatedly misted over them until the whole surface has received a fine coat of sprayed color. The shapes of the cut fabric will be lightly outlined as each layer is built up. The rough edges of the fabric allow the paint to meet in a broken edge, therefore helping the colors and shapes to blend gently.

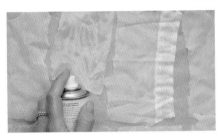

1 Apply the base coat with a roller. Using scissors, cut out random-sized pieces of open-weave nylon netting fabric, leaving the edges uneven. The loose weave will allow some spray paint to pass through and give a light misting of each color.

2 Before placing the fabric on the surface to be decorated, lay it on a work surface and spray one side of each piece with spray adhesive.

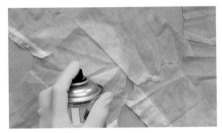

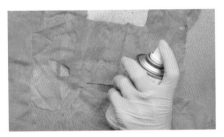

3 Place the fabric pieces, glue-side down, on the surface to be decorated, in a random pattern with some overlapping. Working in a well-ventilated area, wearing a mask and gloves, spray the whole surface lightly with green acrylic spray paint, following the manufacturer's instructions. Leave to dry.

4 Move the fabric and repeat the process with the other spray colors, allowing drying time between each color. The build-up of layers should be subtle and show a dappling effect like light on water. Stronger colors, like bronze, may be used sparingly in areas that are too subtle.

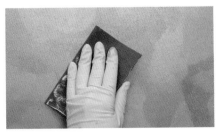

5 Remove the fabric and, when you are happy with the effect, allow to dry before sanding the surface with fine-grade wet-dry sandpaper to soften.

6 Protect the effect with beeswax, applied with a lint-free cloth and buffed to a sheen.

Lace stencil

Materials and Equipment

Taupe matte latex paint for the
 base coat
Selection of lace-edged cotton
Tape measure, pencil, scissors,
 spray adhesive
Protective face mask and
 gloves
Acrylic spray paints: light
 brown, white
Roller and tray

Lace can be used as a positive stencil for small areas
such as tabletops, curtain pelmets, or borders around a
window or floor. You could pick a design that echoes a
fabric decoration in the room. To use the stencil for
repeats or a large area you should stretch the lace on a
metal or wooden frame. Coating the lace with a varnish
or drywall sealer ensures that it remains flat, and
enables you to use it more than once.

1 Apply the base coat with a roller. You could also drag the background (see pages 60–61), as here. Measure and mark with a pencil where you want the fabric to be placed. Using a pair of scissors, cut the lace-edged fabric where necessary.

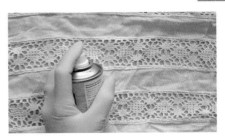

2 Place the lace on a work surface and spray the back with spray adhesive. Leave to dry for a few minutes.

3 Carefully lay the lace in position, glue-side down. When it is as straight as possible, press it lightly into place. Some adhesives allow for repositioning, which is useful if the fabric stretches unevenly.

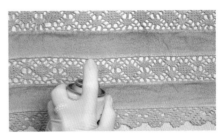

4 Working in a well-ventilated area and wearing a mask and gloves, spray light brown acrylic spray paint directly above the stencil to give a solid, even cover, following the manufacturer's instructions. Leave to dry.

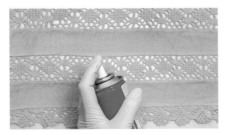

5 To spray a white highlight that will make the pattern look more three-dimensional, angle the spray from one side only, so that the white takes to just one side of the pattern. Leave it to dry.

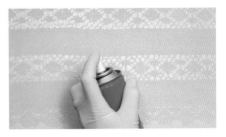

6 Carefully remove the lace and clean off any visible pencil marks. The decoration can be misted over with a very light coat of white spray.

Muslin frottage

Materials and Equipment

White eggshell paint for the
base coat
Pieces of muslin cut to
approximately 2 foot (60cm)
square
Ready-mixed drywall sealer,
such as Shieldz by Zinnser
Colorwash mixes: taupe, blue
Rollers and trays
Matte acrylic glaze
Household paintbrush

The frottage technique involves rubbing a textured
material into wet paint and results in a loose, irregular
texture. In this project it has been combined with
applied color. The muslin fabric used has a wide weave
that allows paint to pass through and an absorbency
that, if used quickly, will pick up color when it is
pressed on a wet surface. This method of texturing
could be used as a background for further decoration.

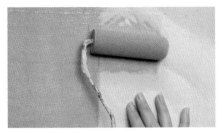

1 *Apply the base coat with a roller. Brush a coat of drywall sealer over both sides of some muslin fabric and let dry. Pour taupe colorwash mix into a roller tray and coat the roller thoroughly. On a separate surface, roll an even layer of colorwash over one side of the muslin.*

2 *Lay the muslin on the white surface, paint-side down. Use a dry roller to press the muslin onto the surface. The roller pressure will cause the colorwash to transfer to the base and remove any excess.*

3 *Prepare a second sheet of muslin and coat with blue colorwash mix. Loosely lay the muslin over the frottaged area so some material overlaps and forms subtle folds.*

4 *Use the dry roller to press the muslin and transfer the color, as before. Clean the roller every now and then to stop it becoming clogged.*

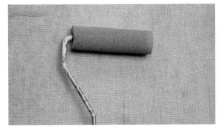

5 *Continue building up layers using fresh pieces of muslin. To intensify the effect, lay down the muslin in various states of folding and overlapping. Make sure the colors do not become muddy.*

6 *Another variation is to apply the colorwash directly to the surface, lay the muslin over it, roller, so that the muslin lifts off some color, and remove. Protect by applying matte acrylic glaze.*

Textured
effects

There are many ways to impart texture to a surface. Substances such as compound fillers, metal, mica, and sand can be added to paint to build up texture in the first application. Real plaster and painted stone effects impart character and a sense of history to a new or blank space, or they can add weight and permanence to a flimsy surface. Traditional techniques, such as using gesso and clay plastering, are demonstrated in this chapter alongside novel faux finishes such as imitation suede and slate. Most faux finishes have been devised for use in areas where the real material is inappropriate or will prove too expensive. It is often also impossible to obtain exactly the right color to suit your needs, therefore a painted imitation may solve many decorative problems. The use of decorative paper to add pattern, texture, and color offers up an endless array of options. The basic materials are cheap and so flexible they can be applied to almost any surface if it is prepared well and sealed with the appropriate varnish. In fact, in the case of craquelure, even varnish can be used to create texture.

When you have experimented with the various techniques, it should be possible for you to use these projects as a guide and begin attempting your own effects. Experimenting with color variations and combinations of different textures can result in a fascinating range of unique effects, while the multitude of protective glazes and varnishes that is now available allows even the most delicate decoration to be sealed and preserved for some time.

Sandstone

Materials and Equipment

Pale cream matte latex paint
 for the base coat
Cream, fine-textured, exterior
 housepaint
Acrylic paints: burnt umber,
 yellow ocher
Ready-mixed compound filler
Paint pails
Decorator's sponges
Fitch brush, dusting brush, nail
 brush, household paintbrush
Strip of straight-edged card
Fine- and medium-grade
 wet-dry sandpaper

This effect can be used to add textural interest to any well-prepared surface—a fireplace, a wall, or even a piece of furniture—suggesting the permanence and weight of real stone at a fraction of the cost. It can be adapted as required, for a strong or subtle coloration, simply by adding more washes and spattered paint and sanding between coats.

1 Apply the base coat with a paintbrush. Dab a
sponge in the exterior housepaint and remove the
excess. Use the sponge to stipple the paint over the
surface. Use a fitch brush for recesses and corners.
Leave to dry.

2 Add a small amount of burnt umber acrylic paint
to the exterior housepaint. Mix 1 part filler with 3
parts paint and stir well. Use the sponge to stipple
this all over, leaving some areas with the thick mix
raised in peaks.

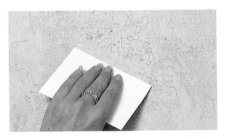

3 When the paint is semi-dry, drag a strip of card
over the surface, flattening some areas by
knocking off the stippled peaks. Leave to dry.

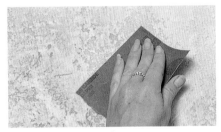

4 Dilute burnt umber and yellow ocher acrylic paints
1 part each to 3 parts water. Use a sponge to
wash on and wipe away the paints, leaving a build-
up of color in the recesses (see pages 50–51). Let dry.
Lightly sand with medium-grade wet-dry sandpaper.

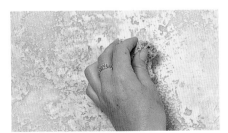

5 Dust the surface with a dusting brush. Dilute 1
part pale cream matte latex paint to 3 parts water
and use a sponge to wash this on all over, enhancing
the stone effect and adding depth to the texture.

6 Dilute the acrylic colors slightly. Dip a nail brush
into the paint, pull back the bristles, and lightly
spatter the color, to suggest the variety of stone.
When dry, sand with fine-grade wet-dry sandpaper.

Slate

Materials and Equipment

Mid-tone gray matte latex paint
 for the base coat
Dark gray matte latex paint
Acrylic paints: dark blue, black
Matte acrylic glaze
Roller and tray
Paint pail
Household paintbrushes
Medium- and fine-grade
 wet-dry sandpaper
Black shoe polish
Lint-free cloths

This effect recreates the dark gray finish of roof slates, and may be applied to any surface where you might consider using actual slate if it weren't for factors such as cost and weight. By protecting the finish with a few thin coats of glaze or varnish the fake slate may actually last longer than real slate, which is very porous and chips easily.

1 Apply the base coat with a roller. Finish by sanding the top coat with medium- and then fine-grade wet-dry sandpaper. The surface should have as smooth a finish as possible so that the dragged color can be pulled across easily.

2 Use a paintbrush to apply a coat of dark gray matte latex paint, using random brushstrokes. Before the paint dries, drag the brush through it in one direction to give a solid graining effect. When using such dark colors you may want to wear gloves. Leave the paint to dry.

3 Mix dark blue and black acrylic paints to make a blue-black. Mix 1 part blue-black paint to 1 part matte acrylic glaze and 2 parts water. Use a paintbrush to drag the dilute glaze on in the same direction as the dark gray paint.

4 Before the glaze has dried, wipe over the surface with a lint-free cloth, pulling the cloth in the same direction as the previous paint and glaze coats.

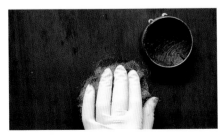

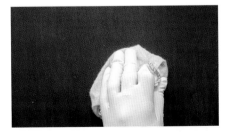

5 Use a cloth to apply a thin layer of black shoe polish, again working in the same direction as the previous layers.

6 Buff the surface with a clean, lint-free cloth. The black polish finish can be regularly buffed with a soft cloth and periodically repolished to protect the surface against water damage or staining.

Terra-cotta

Materials and Equipment

Off-white matte latex paint for
 the base coat
Tape measure, pencil, painter's
 tape
Matte latex paints: terra-cotta,
 gray
Burnt sienna acrylic paint
Textured wall finish (or ready-
 mixed drywall compound)
Matte acrylic glaze
Paint pails
Plasterer's trowel / filling knife
Fine-grade wet-dry sandpaper
Decorator's sponge
Fitch brush, household
 paintbrush

This technique can be used as a solid block, without
the mortar lines, but should be worked in regular-sized
areas so the textured paint can be easily troweled. The
mix cannot be stored for long before it begins to
harden, so when working over a large area it's best to
mix up small batches as you go. Keep a damp cloth
over the mix between uses and retain a color sample
for reference.

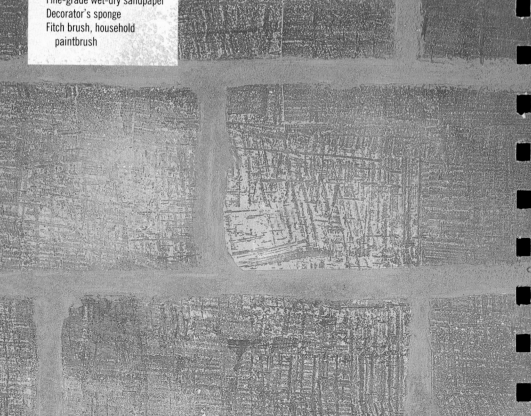

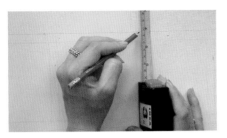

1 *Apply the base coat with a paintbrush. Use a tape measure and pencil to mark a brick pattern on the wall. Allow a narrow mortar line between each brick.*

2 *Mask the mortar lines with painter's tape. Tear the tape's edges a little to give an uneven edge.*

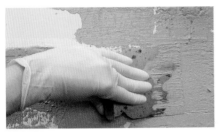

3 *Mix a light terra-cotta textured finish using terra-cotta matte latex paint and textured wall finish (see page 18). Load some of the mix onto a trowel or large filling knife and pull it over the surface. Apply the plaster thinly and do not try to smooth it. Pull quickly in one direction. Leave to dry.*

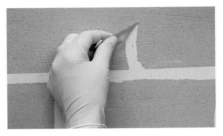

4 *If you wish to build up further layers of textured finish, leave it to dry overnight before recoating. If the surface is too rough, lightly sand with fine-grade wet-dry sandpaper before removing the painter's tape. Slowly pull the tape off to avoid chipping the edges of the bricks.*

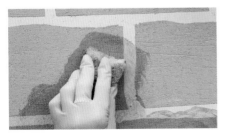

5 *Mix 1 part burnt sienna acrylic paint to 2 parts matte acrylic glaze. Use a sponge to wash this mix all over the surface. Always leave the textured finish for a few hours before adding any colorwashes. Leave to dry.*

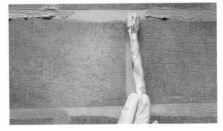

6 *Use gray matte latex paint to mix a textured paint in mortar color and use a fitch brush to paint in the mortar lines. They can be quite uneven. Do not wash excess textured finish down the drain because it will block it. Rinse tools in a bucket and sieve out solid waste for disposal.*

Stone blockwork

Materials and Equipment

Cream matte latex paint for the base coat
Tape measure, pencil, thin painter's tape, craft knife
Burnt umber acrylic paint
Ready-mixed compound filler
Paint pails
Rollers and trays
Household paintbrush
Sponge
Medium- and fine-grade wet-dry sandpaper

The warmth and solidity of mock stone blockwork can be used to great effect in areas that lack character and interest, and it has a soft, smooth texture to the touch. It is also possible to experiment with rollers that have different pile lengths to achieve a tighter or looser texture. The stonework lines should be neat and regular, and it is a good idea to begin marking out in the center of the area to be decorated.

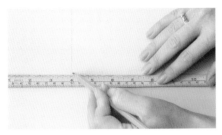

1 *Apply the base coat with a paintbrush. Make sure the surface is free of dust and grease. Use a tape measure and pencil to mark a pattern of blocks to fit inside the chosen space.*

2 *Use thin painter's tape to mask over the pencil lines. Cut the tape neatly with a craft knife where it overlaps into a brick.*

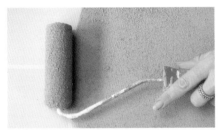

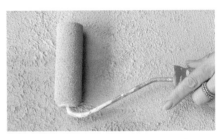

3 *Add burnt umber acrylic paint to cream matte latex paint to mix a mid-brown. Paint a test area and allow to dry to check the true color. Mix 1 part ready-mixed compound filler to 3 parts mid-brown paint and stir well. Use a roller to apply the first coat. Leave to dry.*

4 *Follow Step 3, using less burnt umber acrylic paint, to mix a slightly lighter textured brown. Use a roller to apply a solid, even layer. Leave to dry. Do not wash excess filler down the drain because it will block it.*

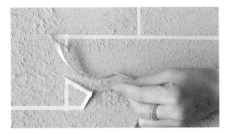

5 *To remove the tape, start at one end and pull the tape back against itself slowly. Aim to keep the lines crisp. This will show the cream base color as the grouting line.*

6 *Use medium- then fine-grade wet-dry sandpaper to rub down the surface. This will cause the darker background brown to speckle the surface. Wipe over with a damp sponge to remove the dust. Repeat as necessary.*

Limestone paving

Materials and Equipment

Cream matte latex paint for the
base coat
Tape measure, pencil
Matte latex paints: pale cream,
white
Acrylic paints: yellow ocher,
burnt umber
Matte acrylic glaze
Ready-mixed compound filler
Textured wall finish (or ready-
mixed drywall compound)
Paint pails
Decorator's sponge
Household and fitch brushes
Medium- and fine-grade
wet-dry sandpaper

This effect can be used over any well-prepared surface, but is particularly successful on a floor as long as it is well protected, although some wear will add to the character of the finish. The colors shown here are for guidance only, and you may prefer to match the effect to an existing scheme. If you want to imitate a real stone, find a sample of the original to work from.

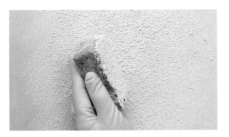

1 Apply the base coat with a paintbrush. Mix 1 part ready-mixed compound filler to 3 parts pale cream matte latex paint. Then mix 1 part textured wall finish to 3 parts colored filler. Use a sponge to stipple the mix over the whole surface. Leave the paint stippled with peaks. Let dry.

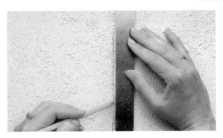

2 Use a tape measure and pencil to mark a pattern of blocks to fit inside the designated space.

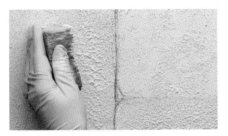

3 Mix yellow ocher acrylic paint and white matte latex paint to produce a warm yellow. Mix 1 part filler to 3 parts paint and stipple it on with a sponge. Let dry. Do not wash excess filler or textured paint down the drain because it will block it.

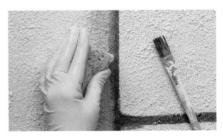

4 Mix 1 part burnt umber acrylic paint to 2 parts matte acrylic glaze and use a fitch brush to paint in the gaps between the blocks. Paint just a few lines at a time and use a sponge to wash the glaze onto the edges of each stone.

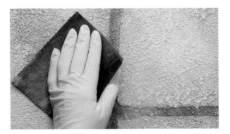

5 Sand well with medium- then fine-grade wet-dry sandpaper. Dust off and wipe over with a damp sponge to check the final color and texture. Repeat any of the steps if necessary.

6 Mix pale cream matte latex paint with a little acrylic glaze and use a sponge to highlight each stone with patches here and there.

Imitation leather

Materials and Equipment

Pale cream matte latex paint
for the base coat
Matte latex paints: mid-brown,
light brown
Burnt umber acrylic paint
Ready-mixed compound filler
Paint pails
Medium-pile rollers and trays
Household paintbrushes
Rag
Fine chisel or gouge
Fine-grade wet-dry sandpaper
Beeswax
Lint-free cloth

The leather effect is created by building up a depth of textured paint, then incising marks through it to suggest the wear and creases of real hide. This finish works wonderfully on walls, furniture, and even on thick paper or card to suggest laminated panels. The all-purpose filler thickens the paint and provides a smooth, soft feel when sanded, while the wax finish adds a luxurious feel as well as protection.

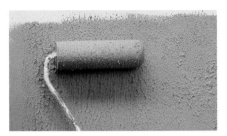

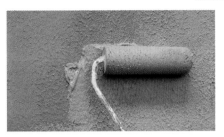

1 *Apply the base coat with a paintbrush. Mix 1 part ready-mixed compound filler with 2 parts mid-brown matte latex paint. This thick paint should be the consistency of double cream. Apply this in a thick layer with a medium-pile roller. Allow to dry.*

2 *Dilute the mix made up in Step 1 with a little water, to the consistency of light cream. Roll on a smooth layer, covering the first coat completely. Leave to dry.*

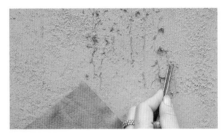

3 *Follow Step 1 to mix light brown matte latex paint and filler. Dab it on with a paintbrush then smooth off with a wet rag, combining smooth and textured areas. Leave to dry. Do not wash excess filler down the drain because it will block it.*

4 *Use a small chisel or gouge to scratch lines to imitate the creases of leather hide. These should be uneven, broken lines, not straight or parallel. Do not dig too deep. Sand lightly all over with fine-grade wet-dry sandpaper until the surface feels smooth.*

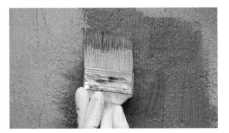

5 *Dilute 1 part burnt umber acrylic paint to 2 parts water. Wash this mix all over with a brush. Leave to dry, then repeat the wash until you have reached the desired depth of color. Allow to dry.*

6 *Use a lint-free cloth to apply a layer of beeswax and buff to a soft sheen.*

Imitation snakeskin

Materials and Equipment

Acrylic primer
Snakeskin source, pencil,
 tracing paper, craft knife,
 cutting mat, painter's tape
Manila stencil card
Matte latex paints: cream,
 dark cream
Burnt umber acrylic paint
Ready-mixed compound filler
Paint pails
Decorator's sponge
Hog-hair softening brush, fitch
 brush, household paintbrush
Fine-grade wet-dry sandpaper
Matte acrylic glaze

This effect demonstrates how easy it is to achieve a complex decoration using just one stencil worked over repeatedly. Hand cutting stencils is a labor of love and very tiring, but well worth the effort for a truly individual result. The decoration can appear very dramatic and theatrical, adding an intriguing pattern to a tabletop or cupboard. On walls it is better to limit the effect to one wall or borders.

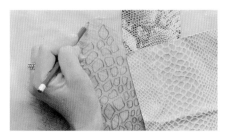

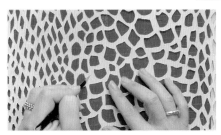

1 Draw a snakeskin design on tracing paper. Turn the paper over and scribble with pencil over the back of the design. Turn the paper over again, lay it on a sheet of stencil card, and redraw the design to imprint it onto the card. Leave a border all around.

2 Use a craft knife over a cutting mat to carefully cut out the stencil. Always use a sharp blade and try to follow all the shapes that can be cut from one side before turning the card to cut the others.

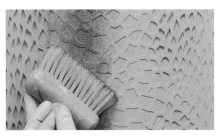

3 Prime and sand the surface using a paintbrush, acrylic primer, and fine-grade wet-dry sandpaper. Mix 1 part ready-mixed compound filler with 3 parts cream matte latex paint. Sponge on the thickened paint and leave to dry. Do not wash excess filler down the drain because it will block it.

4 Fix the stencil in place with painter's tape and draw around the corners with pencil for repositioning later. Stipple dark cream matte latex paint through the cut areas of the stencil with a hog-hair brush. Do not build a solid layer of paint. Remove the stencil to check the effect and lightly sand.

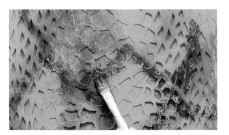

5 Reposition the stencil. Dilute 1 part burnt umber acrylic paint with 2 parts matte acrylic glaze and use a fitch brush to apply darker details over the stencil. Add highlights using cream matte latex paint.

6 Remove the stencil and allow the paint to dry. Apply matte acrylic glaze with a household paintbrush to seal and protect.

Denim effect

Materials and Equipment

Scissors
Burlap
Ready-mixed drywall sealer,
 such as Shieldz by Zinnser
Pale blue matte latex paint
Denim blue colorwash mix
Household paintbrush,
 dragging brush
Rollers and trays
Fine-grade wet-dry sandpaper
Cloth for cleaning
Matte acrylic glaze

The burlap-textured background gives an interesting, worn appearance to this painted denim look. The effect is quite dark so it should be used sparingly, limited to one wall, perhaps, or saved for details. It is a great technique to use for revamping old furniture. The effect can also be adapted in many ways: the dragging could be made much broader, for example, or you could introduce another color.

1 Cut out manageable-sized squares of burlap with a pair of scissors. Coat with a mix of 1 part drywall sealer to 2 parts water and let dry. Make sure the surface is dust and grease free. Roll on a very thick layer of pale blue matte latex paint. Leave for just a few minutes.

2 Press a prepared piece of burlap into the wet paint. Rub over the back of the fabric with a dry roller to make an impression in the paint. Remove the burlap. When dry, lightly sand with fine-grade wet-dry sandpaper to lift any burlap hairs.

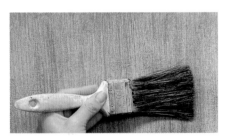

3 Use a paintbrush to apply denim blue colorwash mix in an even layer. Use a dragging brush to drag vertical lines through the wash, removing some of the color. Turn the brush over repeatedly and clean by wiping onto a damp cloth regularly.

4 While the colorwash is still slightly wet, use the dragging brush to pull the color in a horizontal direction to help suggest the weave of the fabric.

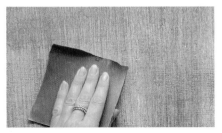

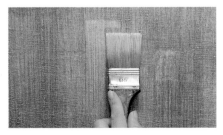

5 Use fine-grade wet-dry sandpaper to lightly sand the surface and reveal the broken texture of the base paint. This will give the effect of worn denim.

6 Protect the effect by applying matte acrylic glaze with a household paintbrush.

Imitation moiré silk

Materials and Equipment

Pale blue matte latex paint for
 the base coat
Mid-blue colorwash mix
Roller and tray
Household paintbrushes,
 hog-hair softening brush,
 flogging brush
Heartgrainer
Rubber comb
Fine-grade wet-dry sandpaper
Cloth for cleaning
Satin acrylic varnish

The painted imitation of moiré silk must have the same fine finish as the original, so just one color is used, keeping the tones of base paint and glaze coat very similar. In this way the pattern is merely hinted at, rather then appearing overbearing. Combining it with other subtle effects, such as stippling and graining, will ensure it retains its luxurious finish. This effect can look stunning if completed in an opalescent finish.

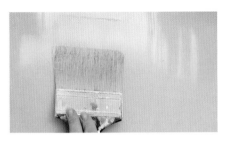

1 *Apply the base coat with a roller. Sand lightly using fine-grade wet-dry sandpaper for a completely smooth finish. Use a paintbrush to apply an even coat of mid-blue colorwash mix. While the wash is still wet, drag the brush through in regular vertical strokes. Turn the brush over regularly and clean with a damp cloth when saturated with paint.*

2 *While the colorwash is still wet, pull a heartgrainer through, starting from one end and working in a regular vertical direction. Pull slowly and gently pivot the tool in a rocking motion so that the effect of woodgrain appears.*

3 *Drag a rubber comb through the wet wash to create vertical stripes in some areas.*

4 *Use a hog-hair softening brush over the whole area to smooth the effect. Follow the direction of the previous strokes.*

5 *When the glaze is almost dry, use a flogging brush to pull it in a vertical direction again. This will add more suggestion of the weave.*

6 *Use the softening brush to pull the lines in a horizontal direction and enhance the suggestion of the weave of the fabric. Leave to dry and apply satin acrylic varnish with a household paintbrush.*

Imitation suede paneling

Materials and Equipment

Pale cream matte latex paint
for the base coat
Tape measure, pencil,
plumbline, painter's tape,
craft knife
Matte latex paints: mid-brown,
light brown
Burnt umber acrylic paint
Matte acrylic glaze
Ready-mixed compound filler
Paint pails
Medium-pile rollers and trays
Decorator's sponge
Household paintbrush
Fine-grade wet-dry sandpaper

This understated effect has a tactile as well as visual appeal: run your hand over the surface and you can feel how similar to stretched suede the sanded paint-and-filler mix is. A thick paint applied with a medium-pile roller creates the illusion of the subtle pile of suede. Washes of color then add depth and interest to the finish. Finally, light sanding takes the peaks off the textured paint until it shows through the washes.

3 *Measure and mark out panels with a pencil, according to the size of area being treated. Use a plumbline to get your first vertical.*

4 *Mask alternate panels. On textured paint the tape may not stick down easily, so check the adhesion before painting.*

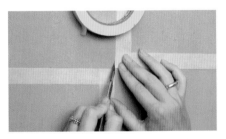

1 *Apply the base coat with a roller. Mix 1 part ready-mixed compound filler with 2 parts mid-brown matte latex paint. Roll at least two coats of the lightly textured paint mix as evenly as possible over the whole area with a medium-pile roller. Leave to dry.*

2 *Mix filler and light brown matte latex paint as in Step 1 and roll on evenly. Leave to dry. Do not wash excess filler down the drain because it will block it.*

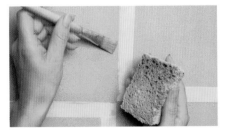

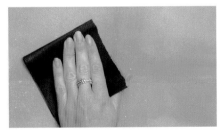

5 *Mix 1 part burnt umber acrylic paint with 2 parts matte acrylic glaze and use a sponge to apply it to each alternate panel. Use a brush to form a darker edge near the tape, feathering the color out into the main panel. Leave to dry.*

6 *Remove the painter's tape and use fine-grade wet-dry sandpaper to lightly sand the panels. Seal with matte acrylic glaze using a household paintbrush. Leave to dry.*

Stucco

Materials and Equipment

Sealed board for mixing
 plaster, knife
Plaster sealant
Rose white matte latex paint
 for the base coat
Ready-made stucco plaster
Burnt sienna liquid pigment
Paint pails
Household paintbrush
Plasterer's hawk and trowel,
 filling knife
Cloth for cleaning
Medium-grade wet-dry
 sandpaper

In this finish the warm terra-cotta shade of fresh plaster is imbued with the sensuous softness and sheen of polished stucco. Stucco has a harder finish than ordinary plaster, yet it is quick and easy to repair as long as samples of color and mixing ratios for the pigment are recorded when it is first used. Keep the plaster mix under a damp cloth and carry a small amount to work with.

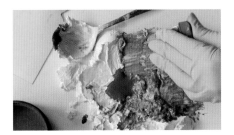

1 Follow the manufacturer's instructions for coloring the stucco. Mix the burnt sienna liquid pigment and ready-made stucco plaster on a sealed board using a knife. Always mix small amounts, checking the color against a sample to retain consistency. Use a cloth to clean up at every stage. Wear protective gloves.

2 Apply the base coat with a paintbrush. Use a brush to apply a thin glaze of plaster sealant. Leave to dry. Apply the first coat of colored stucco, using a plasterer's hawk and trowel for large areas or a filling knife for smaller patches. Pull the plaster thinly and evenly across the surface. Allow to dry.

3 Dampen some medium-grade wet-dry sandpaper and wipe a steel filling knife across the surface in a circular motion. Keep the blade at a shallow angle. This will sharpen the blade and soften the edges.

4 Apply a second layer of the same plaster mix. Apply it in a series of thin layers with the filling knife. Use a continuous motion, pulling and wiping the plaster, changing direction regularly. Clean and rebevel the knife often.

5 Continue adding thin plaster layers. As the surface becomes more solid, lower the angle of the knife and use it to polish the plaster with a circular motion, taking care not to scratch it.

6 As the steel slides over the plaster any raised lines on the surface will disappear and the matte plaster will take on a glossy sheen.

Rustic clay

Materials and Equipment

Cream matte latex paint for the
 base coat
Clay plaster
Craft knife
Muslin
Tape measure
Ready-mixed drywall sealer,
 such as Shieldz by Zinnser
Paint pails
Household paintbrushes
Plasterer's hawk and trowel
Decorator's sponge
Fine-grade wet-dry sandpaper

Clay plasters have been developed to take account of
the needs of the modern user and the natural
environment, and today's products are both ecologically
sound and easy to use. The plaster, in powder form to
be mixed with water, has a soft, matte, chalky finish.
It is breathable and can assist in regulating indoor
humidity. Colors are limited since clay can only be
obtained in natural shades.

1 Apply the base coat with a paintbrush. Adding muslin to the surface will help the adhesion of the clay plaster. Measure up the area to be plastered and cut pieces of muslin into manageable-sized squares to seal the surface.

2 Dilute 1 part drywall sealer with 2 parts water and brush over the surface. Apply the muslin and paint over with more of the dilute drywall sealer until completely adhered. Leave to dry.

3 Follow the manufacturer's guidelines for mixing the clay plaster and water. It is important to try sample areas of varying thicknesses to allow you to make the preferred choice of finish.

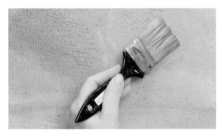

4 Dip a wet paintbrush into the clay mix and apply a thin wash over the muslin. Leave to dry.

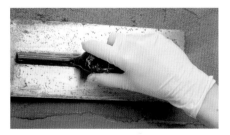

5 Use a plasterer's hawk and trowel to apply a more substantial layer of clay plaster. Do not wash excess plaster down the drain because it will block it.

6 While the mix is drying, smooth the surface by wiping over it with a damp sponge. Leave to dry and sand with fine-grade wet-dry sandpaper. If using more than one color, let the first color dry, then apply the second, blending them at the meeting point.

Aged plaster effect

Materials and Equipment

Pale cream matte latex paint
 for the base coat
Terra-cotta colorwash mix
Off-white matte latex paint
Yellow ocher acrylic paint
Matte acrylic glaze
Finishing plasters: gray, white
Roller and tray
Paint pails
Decorator's sponge
Plasterer's hawk and trowel
Filling knife
Cloth for cleaning
Fine-grade wet-dry sandpaper

Use this technique to introduce a theatrical element to your interior: perfectly finished walls acquire instant character using this dramatic aging effect. Finishing plasters can be bought in light gray or white and are transparent when wet, and opaque when dry. Color can either be added to the plaster mix or applied as a final coat. The plaster is then sealed with a matte acrylic glaze for protection.

1 Apply the base coat with a roller. Use a sponge to wash on terra-cotta colorwash in a figure-of-eight motion. Leave to dry.

2 Mix equal amounts of off-white matte latex paint and matte acrylic glaze and apply as in Step 1. Leave to dry.

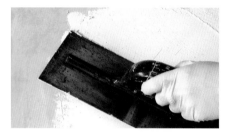

3 Mix up gray finishing plaster following the manufacturer's instructions. Use a plasterer's hawk and trowel to apply a thin, irregular layer, leaving the base colors to show through in some areas. Clean the trowel with a damp cloth often. Leave to dry.

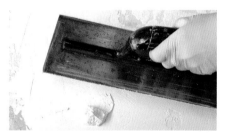

4 Mix up white finishing plaster as before and apply a thin coat as in Step 3, leaving areas of the base colors and the gray plaster still showing. Leave to dry.

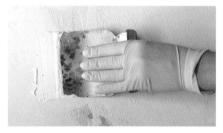

5 Add a little yellow ocher acrylic paint to white finishing plaster to make a cream plaster. Use a filling knife to add patches here and there. The plaster is quite transparent so repeat any of the steps where the finish is too bland and even. Leave to dry.

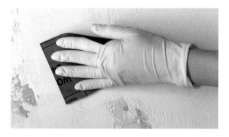

6 Lightly sand the whole surface with fine-grade wet-dry sandpaper until smooth to the touch. Seal by applying matte acrylic glaze with a household paintbrush.

Gesso

Materials and Equipment

Heatproof bowl, mixing bowl
Distilled water
Ready-mixed gesso
Watercolor paints
Household paintbrushes,
 hog-hair brush
Flat metal scraper
Fine-grade wet-dry sandpaper
Lint-free cloths
Beeswax

Gesso leaves a smooth, absorbent surface that is an especially good base for watercolors. The transparency and luminosity of the paints glows through, enlivening the pure white ground. The finish has a cool, smooth feel. It is applied in a series of thin layers that must be taken from the same batch so that the consistency is constant. Gesso is made from rabbit-skin glue and the ready-mixed version only requires warming.

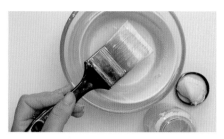

1 *Pour boiling water into a heatproof bowl. Place ready-mixed gesso in a mixing bowl in the water. Keep stirring the gesso until melted to the consistency of light cream.*

2 *Ensure you have as smooth a base as possible, and that it is free of grease and dust. Pour off a little gesso and mix in equal amounts with distilled water. Size the area with the very watery gesso mix. Allow to dry.*

3 *Apply undiluted gesso to the surface using a hog-hair brush. Brush it in well, working in different directions. Apply at least eight coats, adding the next when the previous is matte but not completely dry. Let the final coat dry thoroughly.*

4 *Wet some fine-grade wet-dry sandpaper and sand the surface, keeping a layer of water between it and the gesso. Wipe the surface with a wet cloth to create a "slurry" of gesso to fill hollows. Leave overnight. Hold a flat metal scraper at an angle and pull it diagonally in one direction then the other to recut the surface. Wipe with a wet cloth. Let dry.*

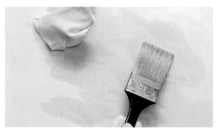

5 *Brush dilute watercolor paints over the surface, blending the colors with the brush. Repeat as necessary, without muddying the colors. Leave to dry.*

6 *Add further watercolors and rag the surface with a damp, lint-free cloth. Protect with beeswax, applied and buffed with a soft cloth.*

Combing

Materials and Equipment

White matte latex paint for the base coat
Tape measure, pencil, painter's tape
Pale blue matte latex paint
Mid-blue colorwash mix
Roller and tray
Household paintbrushes
Grout spreader
Rubber comb
Fine-grade wet-dry sandpaper
Cloth for cleaning
Matte acrylic varnish

The combing technique, when used with a restricted and subtle color palette, can give interesting and sensitive results. Combing can produce many different patterns, and if the paint is combed thickly, the ridges formed create the effect of an embossed surface. As usual, careful planning and application are the keys to success. Preparation is especially important because the comb needs a smooth surface to work consistently.

1 Apply the base coat with a roller. Measure and, with a pencil, mark up the area to be decorated into broad bands.

2 Tape the edges of the bands, making sure the painter's tape is well adhered to the surface.

3 Use a roller to paint alternate bands with pale blue matte latex paint. Leave to dry, then lightly sand with fine-grade wet-dry sandpaper to give a smooth surface.

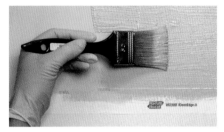

4 Use a paintbrush to apply an even coat of mid-blue colorwash mix over the pale blue base.

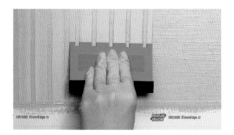

5 While the colorwash is still wet, use a grout spreader to pull thick vertical lines through it. Take care not to lift the painter's tape at the edges of the band. Clean the spreader regularly with a damp cloth. Leave to dry.

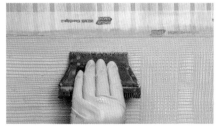

6 Remove the painter's tape. Mask the painted bands. In the next strip, follow Steps 4–5, using a commercial rubber comb to create finer stripes. Work horizontally and vertically to form a checked pattern. Leave to dry, then protect with matte acrylic varnish.

Stenciling with filler and mica

Materials and Equipment

Lavender white matte latex
 paint for the base coat
Ruler, pencil, painter's tape
Simple handmade card stencil
 (see page 99)
Colorwash mixes: lavender, blue
Pink acrylic paint
Ready-mixed compound filler
Mica flakes
Matte acrylic glaze
Roller and tray
Paint pails
Decorator's sponge
Stencil brush, household
 paintbrushes
Fine-grade wet-dry sandpaper

The addition of all-purpose filler to bulk out plain paint causes it to behave more like a plaster, and the mica flakes give a sparkling glitter. This results in a three-dimensional aspect to simple stenciling. The mica flakes can also be added to solid paint and will glisten on the surface, or sprinkled onto wet glaze if working on a flat surface. The flakes are added as required, so let a sample dry to help you decide how much to use.

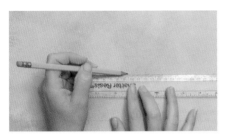

1 Apply the base coat using a roller. Apply a lavender and blue colorwash using a sponge (see pages 44–45). Measure, mark up with a pencil, and mask a border with painter's tape.

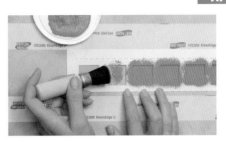

2 Mix 1 part ready-mixed compound filler with 2 parts pink acrylic paint. Position the stencil in the border and hold in place with tape. Use a stencil brush to stipple the thick pink paint through the stencil. Move the stencil on and repeat. Leave to dry.

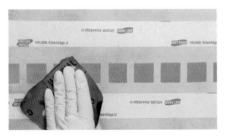

3 Lightly sand the raised decoration with fine-grade wet-dry sandpaper.

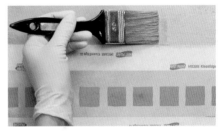

4 Mix 1 part pink acrylic paint with 2 parts matte acrylic glaze and add a teaspoon of mica flakes. Use a soft brush to wash this glitter color over the lavender and blue colorwash. Leave to dry.

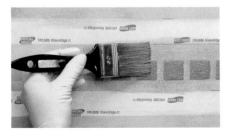

5 Mix a deeper pink glaze by adding more paint to glaze, and include mica flakes as before. Wash this over the stenciled border. Leave to dry.

6 Remove the painter's tape to reveal the original colorwash base as bands on the edge of the stencil border. Lightly sand the border again to bring out the stenciled textured decoration.

Crackle effect

Materials and Equipment

Acrylic primer
Dull green, oil-based
 eggshell paint
Matte latex, water-based
 paints: light blue, white
All-purpose / ready-mixed filler
Mineral spirits
Paint pails
Household paintbrushes, thin
 fitch brush
Hair dryer (or hot air gun)
Medium- and fine-grade
 sandpaper
Lint-free cloth
Matte acrylic glaze or varnish

This finish resembles weathered painted wood and adds tactile as well as visual interest. The crackling effect is due to the different drying speeds of the two paints, while the addition of all-purpose filler to the top coat further speeds up its drying time and helps form a paste that can easily adhere to the eggshell. The latex paint sands down to give a wonderful smooth finish and is still absorbent to colored glaze or varnish.

1 *Prime and sand the surface with fine-grade wet-dry sandpaper. Use a brush to apply a coat of dull green eggshell base color. Leave to dry. Sand lightly and apply a second coat, ending with a downward brushstroke each time to avoid drips.*

2 *Mix 1 part ready-mixed all-purpose filler with 2 parts light blue matte latex paint. Add more filler if necessary to make the mix the consistency of double cream. When the eggshell is touch dry, brush on this mix in quick, even brushstrokes.*

3 *To assist the drying process and to ensure the crackle glaze effect works as evenly as possible, use a hair dryer (or a hot-air gun if one is available) to warm the paint. Move the heat constantly over the surface, working from a distance of at least 2 feet (60cm) to prevent possible blistering.*

4 *Leave to dry thoroughly for at least four hours. The top paint coat will have cracked. Sand with medium-grade sandpaper to remove any roughness from the surface. Wipe off the dust with a dry paintbrush and a damp, lint-free cloth.*

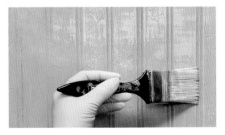

5 *Add a little white matte latex paint to the paint and filler mix and dry brush (see pages 54–55) to add further aging. Leave to dry. Do not wash excess filler down the drain because it will block it.*

6 *Mix equal amounts of the dull green eggshell and mineral spirits and use a thin fitch brush to apply this mix to the grooves in places. Leave to dry. Protect with matte acrylic glaze or varnish.*

Craquelure

Materials and Equipment

Pale cream matte latex paint
 for the base coat
Scissors, decoupage designs
Ready-mixed drywall sealer,
 such as Shieldz by Zinnser
Two-part craquelure varnish
Artist's oil paint: burnt umber
Mineral spirits
Roller and tray
Paint pail
Household paintbrushes,
 flat varnishing brushes
Hair dryer or hot-air gun
Lint-free cloth
Matte or eggshell oil varnish

The fine cracks that appear in the top coat of a craquelure varnish only become obvious when color is rubbed into them, giving an effect reminiscent of the surface of old oil paintings. The two-part varnish—consisting of a slow-drying base coat and a brittle, quick-drying top coat—is an nice way to age colorwork or motifs, especially over a light base. Experiment with thin and thick coats of varnish for the best results.

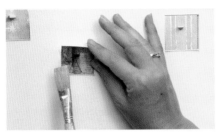

1 Apply the base coat using a roller. Carefully cut out decoupage designs with scissors and use drywall sealer to fix them in place. Leave to dry.

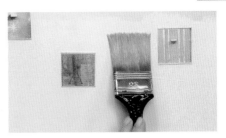

2 Use a flat varnishing brush to apply an even coat of the first part of a two-part craquelure varnish. Leave to dry completely.

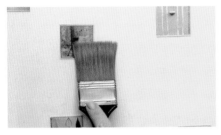

3 Take a clean varnishing brush and dampen it slightly. Apply the top coat of the two-part craquelure varnish in an even layer.

4 To assist the drying process and ensure the craquelure works as evenly as possible, use a hair dryer or hot-air gun to warm the varnish. Move the heat constantly over the surface, working from a distance of at least 2 feet (60cm) (any closer may cause blistering).

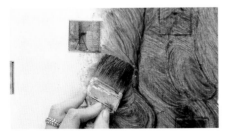

5 Dilute 1 part burnt umber oil paint with 2 parts mineral spirits to make a watery mix. Brush on in a loose scrubbing motion, pushing the color into all the fine cracks that should have appeared in the varnish. Leave to dry for 15 minutes.

6 Make a pad from a soft lint-free cloth and polish off the oil paint glaze, leaving the color in the cracks but wiping the surface back to a dirty cream. Leave to dry overnight and protect by applying matte or eggshell oil varnish with a household paintbrush.

Collage

Materials and Equipment

Unbleached tissue papers,
 handmade Japanese tissue
 papers, dried pressed leaves
 and flowers, colored papers
Ready-mixed drywall sealer,
 such as Shieldz by Zinnser
Ruler
Household paintbrushes
Dead flat oil varnish
Mineral spirits
Paint pail

Blending a range of decorative papers, dried plants, and tissue papers produces an intricate design of images and colors to transform a bland wall. A final varnish coat not only protects but makes the papers more transparent, unifies the colors, and adds depth. The technique is ideal for hiding irregularities, cracks, and holes so can be used to disguise unattractive fitted furniture or shelving that cannot be removed.

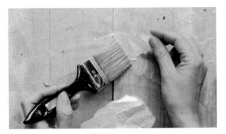

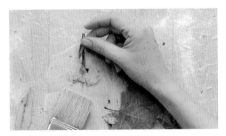

1 *Tear pieces of unbleached and Japanese tissue papers into random sizes. Mix 1 part drywall sealer with 2 parts water. Coat the surface with dilute sealer. Position the torn paper shapes, and paint over them with sealer, working it in well. Overlap the papers to add texture.*

2 *While the paper is still wet, position dried, pressed leaves and flowers and brush over with sealer as before.*

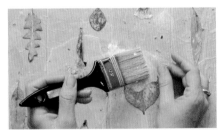

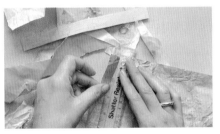

3 *Prepare torn pieces of tissue paper as in Step 1 and use them to cover the leaves, again brushing over them with more sealer solution.*

4 *Tear strips and random shapes from colored papers and prepare with dilute drywall sealer. Apply these and seal. Use a ruler to apply pressure.*

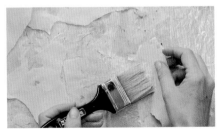

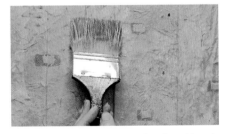

5 *Cover the decoration once more with pieces of tissue paper. Leave to dry overnight.*

6 *Dilute equal amounts of dead flat oil varnish and mineral spirits and paint over the decoration. Leave to dry, then apply a second coat. The papers will become transparent and the decorations will start to show through the layers.*

Collage and decoupage

Materials and Equipment

White matte latex paint for the
 base coat
Tape measure, pencil, ruler,
 scissors
Selection of tissue papers and
 handmade colored papers
Ready-mixed drywall sealer,
 such as Shieldz by Zinnser
Paint pail
Household paintbrush
Satin oil varnish

This project combines collage and decoupage and introduces the concept of multicolored decoration. Collage is the art of making pictures and decoration by layering papers, whereas decoupage is the process of cutting out and gluing paper images. The long fibers of the handmade papers help make this a long-lasting form of decoration, while the use of tissue paper also ensures that the finish does not become too bulky.

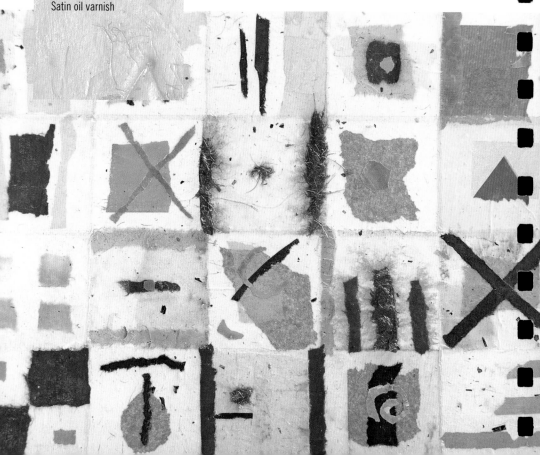

1 Apply the base coat. Measure the area to be decorated and mark up with evenly spaced squares in a grid.

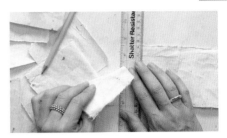

2 Measure and tear against a straight edge squares of tissue papers, slightly larger than the grid squares so that they can be overlaid.

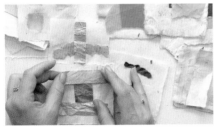

3 Using scissors, cut out abstract motifs from an assortment of colored papers. Arrange these over the tissue-paper squares. Mix equal quantities of drywall sealer and water. Use a brush to apply the sealer to the motifs and fix in place.

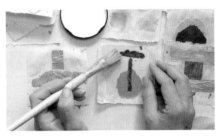

4 Use the drywall sealer solution to fix the decorated paper squares to alternate squares on the grid.

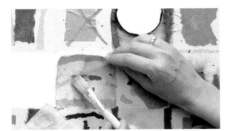

5 Seal the remaining alternate decorated papers, overlapping the edges of the previously sealed squares. Leave to dry overnight.

6 Finish with at least three coats of satin oil varnish, brushing it in well and letting it dry between coats. This will make the papers more transparent as well as protecting the finish.

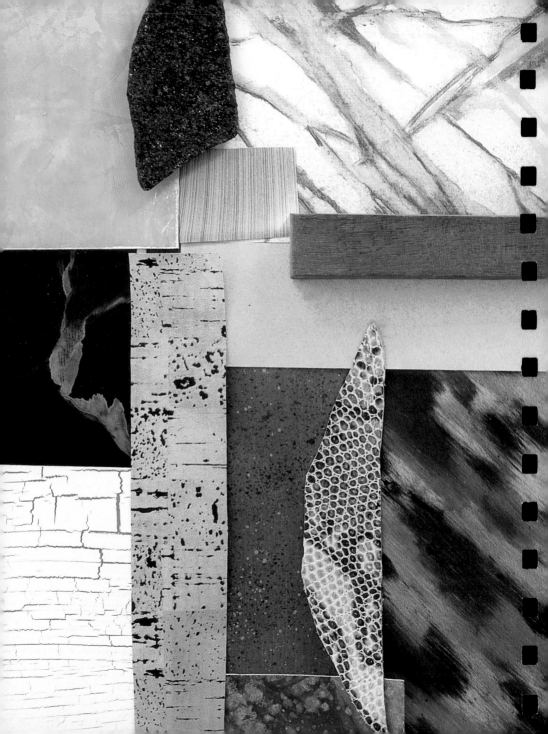

Traditional
effects

The traditional effects are often more advanced and involved than the finishes described in the previous chapters. Many are cost-effective ways of achieving a glamor and richness within a dull interior or on an object of humble origin. Faux or bravura effects aim to deceive the eye, creating an illusion of a real material like marble or wood. These effects range from fantasy finishes to a perfect deception executed well enough to appear to have the weight and substance of the actual material. When marbling, for example, the decorator can either follow the colors and veining of real marble or experiment with a variety of colors and patterns. If the basic principles are followed, you need be limited only by your imagination.

In most cases, it is recommended that you use oil paints to achieve a convincing faux finish. They not only allow you plenty of time to manipulate the wet glaze and achieve the desired effect, but oil glazes also have a luminosity that is not comparable with modern water-based equivalents. Originally these finishes would have been executed on gesso, which offers a wonderful smooth, cool surface. The modern-day equivalent is an eggshell finish oil- or water-based paint, which also works extremely well if sanded carefully.

Some degree of artistry is required from the painter at this stage and these finishes should be used with careful regard to their impact on the overall room scheme. It is advisable to use them where one might conceive of using the real thing.

Sienna marble

Materials and Equipment

White oil-based eggshell paint
 for the base coat
Hog-hair softening brush
Artist's oil paints: raw sienna,
 gold ocher, burnt umber,
 burnt sienna
Mineral spirits
Paint pails
Roller and tray
Household paintbrushes,
 long-bristled artist's brush
Decorator's sponge
Feather
Mutton cloth
Eggshell oil varnish

This effect aims to capture the essence of marble in paint, rather than produce a facsimile surface. The suggestion of solidity, depth, and translucency of real sienna marble is simulated in the glazed layers and soft textures and markings. Oil glazes reproduce the desired translucency and dry slowly, giving you time to manipulate the effect. The base coat of white eggshell paint should imitate the smooth, cool touch of gesso.

1 Apply the base coat with a roller. Mix raw sienna and gold ocher glazes by diluting 1 part oil paint to 3 parts mineral spirits. Paint the glazes on in broad, diagonal shapes, without mixing the colors. Soften by brushing in all directions with a hog-hair softening brush.

2 To add texture, dip a sponge in mineral spirits and lightly dab it over the surface. Dip a feather in mineral spirits and pull it over the surface to add some faint veining. Leave to partially dry, then soften with the softening brush. Allow to dry.

3 Mix 1 part white eggshell paint to 2 parts mineral spirits and brush this loosely on. Smooth over the glaze with a mutton-cloth pad to remove brushmarks. Finish with the softening brush to ensure smoothness and leave to dry.

4 Mix burnt umber and burnt sienna glazes as in Step 1. Apply in broad directional strokes where the veining will be and soften as in Step 3. When dry, dilute burnt umber oil paint in a little mineral spirits and use a long-bristled artist's brush or feather to paint in the veins.

5 The veins should not be too distinct or rigid, so soften them with the softening brush, blending the lines with the more subtle layers beneath. Keep adding to and softening the veins, referring to a photographic source if necessary.

6 While the veining dries, load a brush with mineral spirits and pull back and release the bristles to lightly spatter the surface. Leave to dry. Protect by applying eggshell oil varnish with a household paintbrush.

Breccia marble

Materials and Equipment

White eggshell paint for the base coat
Artist's oil paint: raw umber
Mineral spirits
Paint pails
Household paintbrushes, hog-hair softening brush, long-haired sable brush
Lint-free cloth
Eggshell oil varnish

Breccia marble is formed when shattered fragments of mineral are reformed into solid rock, which is why the pattern resembles two-dimensional pebbles. If you consider the design carefully and make sure there is a flow in the pebble patterns, this finish can look realistic in any color. A contrast in shapes can be achieved by combining sparsely and densely patterned areas.

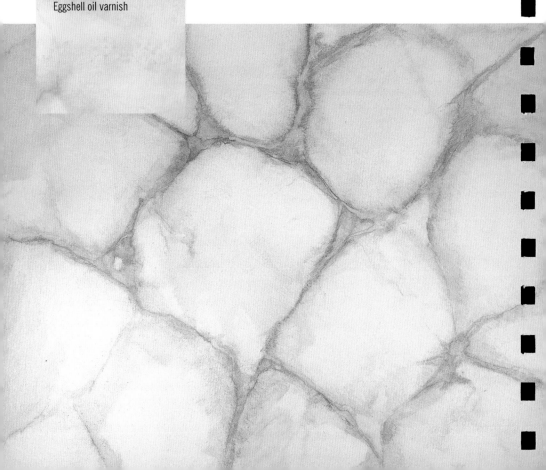

1 *Apply the base coat with a paintbrush. Mix 1 part raw umber oil paint to 2 parts mineral spirits and brush a thin, even layer of glaze onto the surface.*

2 *Use a pad of lint-free cloth to wipe out areas of glaze and mark the marble pattern. Vary the size and look of the shapes, with some small and angular and others large, softly rounded, and pebble-like. Remember to leave glaze edges.*

3 *Soften off the whole surface by brushing over in a variety of directions with a hog-hair softening brush. Leave to dry.*

4 *Dilute more raw umber oil paint in a little mineral spirits. Use a long-haired sable brush to paint in the veining lines around the wiped-out shapes. Soften the lines to blend the color with the background and ensure the veins are not too distinct.*

5 *Continue adding veins to the outlines, mixing softened, subtle, lighter veins with stronger, angular lines and some very graphic, dark areas. If a shape does not have the desired effect you can clean it off with a rag and start again.*

6 *Soften all over, again working into some veins more than others. Gently wipe off areas that are too obvious with a soft cloth and a touch of mineral spirits. Leave to dry. Protect by applying eggshell oil varnish with a household paintbrush.*

Carrara marble

Materials and Equipment

White oil-based eggshell paint
for the base coat
Artist's oil paints:
Payne's gray, Davy's gray,
alizarin crimson
Oil-based glazing liquid
Mineral spirits
Paint pails
Household paintbrushes,
hog-hair softening brush
Feather
Lint-free cloth
Eggshell oil varnish

Carrara marble is generally very understated, with sparse, blurred veins in a clearly forked design. The scale and pattern of veining can be altered to suit the size of the area being decorated: in a small area, for example, the veins can be applied more intensely. The use of three shades of gray, rather than black, gives the marbling a soft appearance, even when veined quite regularly.

1 Apply the base coat with a paintbrush. Mix 1 part oil-based glazing liquid to 2 parts mineral spirits and brush on until the surface is completely wet.

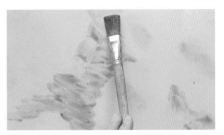

2 Mix 1 part each of Payne's gray, Davy's gray, and a pale pink-gray mixed from Davy's gray and a little alizarin crimson, with 3 parts mineral spirits to make three gray glazes. Use a small brush to apply the separate glazes thinly in patches while the glazing liquid is still wet.

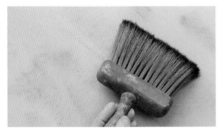

3 Blend in the colors by brushing over in a variety of directions with a hog-hair softening brush. Leave to dry.

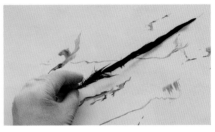

4 Apply another layer of glazing liquid as in Step 1. Add a little mineral spirits to Payne's gray oil paint to make it fluid. Use a feather to add gray veining, pulling the length of the feather across the surface to create vague, broken lines.

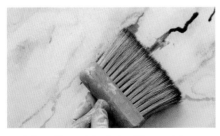

5 Soften off the veining by brushing gently in different directions with the softening brush. The lines will become blurred.

6 Repeat Steps 4–5 as necessary. Wipe out areas that appear too dark with a lint-free cloth. Leave to dry. Protect by applying eggshell oil varnish.

Rhodocrosite

Materials and Equipment

White oil-based eggshell paint
for the base coat
Artist's oil paints: burnt sienna,
alizarin crimson,
yellow ocher
Oil-based glazing liquid
Mineral spirits
Paint pails
Small household paintbrushes,
hog-hair softening brush
Lint-free cloth
Card
Rubber graining comb
Eggshell oil varnish

Rhodocrosite is a highly colored manganese-bearing mineral with large pink to blood-red crystals formed in parallel, undulating curved bands varying in width from 2½ inches (6cm) to tiny pinstripes. The mineral is highly prized and used sparingly, so the painted simulation has traditionally been used for small areas such as borders, tabletops, and detailing.

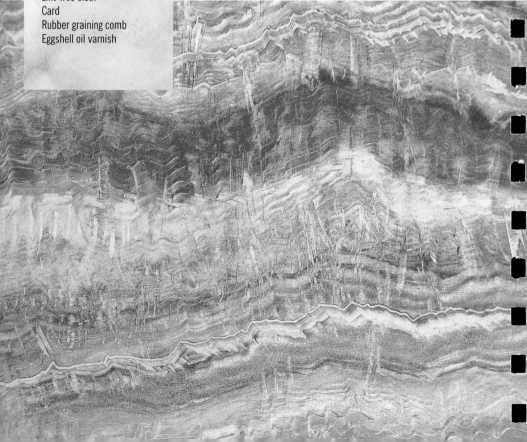

1 Apply the base coat. Lightly draw curving bands of varying widths. Mix 1 part each of burnt sienna, alizarin crimson, and alizarin crimson with a little yellow ocher to 1 part oil-based glazing liquid. Mix 1 part of each red glaze to 2 parts mineral spirits. Brush on the red bands in any order.

2 Making sure you are wearing protective gloves, use a lint-free cloth to wipe out a few curved ribbons between some of the red bands. You can also wipe the cloth lightly over some bands to thin the color for a little variety.

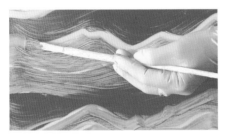

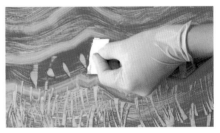

3 Mix a yellow ocher glaze as in Step 1. Apply to the ribbons where the paint has been wiped back. Allow the colors to bleed into each other.

4 Use a torn piece of card to scrape off angled patches of paint from the bands, revealing the white base color. The sharp edges should be at right angles to the bands of strata. Soften by brushing in all directions with a hog-hair softening brush.

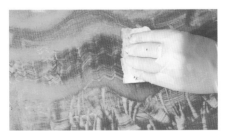

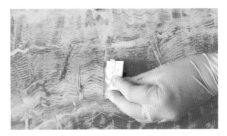

5 Gently pull a rubber graining comb through the bands, following the curves. Pull torn pieces of card of different sizes over the bands as with the comb. Replace the card as it becomes saturated.

6 Lightly repaint the yellow bands to enhance them and etch faults into the glaze with the side of a piece of card. Soften with repeated strokes of the softening brush. Protect with eggshell oil varnish.

Granite

Materials and Equipment

Gray oil-based eggshell paint
 for the base coat
Artist's oil paints: black, white,
 Davy's gray, Payne's gray
Mineral spirits
Paint pails
Roller and tray
Household paintbrushes,
 fitch brushes, hog-hair
 softening brush
Decorator's sponges
Lint-free cloth
Eggshell oil varnish

Granite has a coarse texture that can be reproduced in paint by spattering and sponging. When choosing the area or object to paint with this finish, remember that granite is solid looking, and weight and substance are suggested by decorating with this technique. Often the best faux finishes are actually quite simple to achieve and the real art lies in getting the color mix right, so refer to a sample of the real stone when possible.

1 Apply the base coat with a roller. Mix black and white oil paints to create a black-gray. Combine 1 part black-gray with 2 parts mineral spirits. Use a brush to evenly wash on the glaze.

2 Soften the wet glaze coat by repeatedly pressing a sponge into it, changing the direction and pressure used regularly.

3 Add a dash of mineral spirits to Davy's gray oil paint and a pale black-gray mixed from black and white oil paints. Brush the paints onto clean sponges and dab onto the surface. As the colors bleed into each other the blending will add to the texture.

4 Dip a fitch brush in mineral spirits. Pull back and gently release the bristles to spatter the mineral spirits over the surface. After a few minutes, dab a sponge all over to add to the granite texture. Soften by dabbing with a lint-free cloth.

5 Spatter the surface with a mix of Payne's gray, Davy's gray, pale black-gray, and a dash of mineral spirits. Leave for a few minutes then dab off as in Step 4.

6 Wait until nearly dry, then repeat any of the steps to build up the effect as necessary. When the finish is tacky, soften by brushing over in a variety of directions with a hog-hair softening brush. Let dry. Protect by applying eggshell oil varnish.

Oak

Materials and Equipment

Cream eggshell paint for the
 base coat
Artist's oil paints: raw umber,
 burnt umber, yellow ocher,
 white
Mineral spirits
Paint pails
Household paintbrushes,
 flogging brush
Rubber comb
Heartgrainer
Lint-free cloth
Cloth for cleaning
Eggshell oil varnish

Oak is one of the easier woods to simulate. Dragging, combing, and flogging removes much of the glaze coat which means you can arrive at a subtle copy without the need for softening. The lights added at the end are the most characteristic marks of this particular wood. Real and simulated oak is often used to panel a whole room, and it is therefore a good idea to break up the decoration into panels before you begin painting.

1 *Apply the base coat. Mix raw umber, burnt umber, yellow ocher, and white oil paints to the desired oak shade. Mix 1 part paint with 2 parts mineral spirits. Brush on the glaze then drag the brush back through it, working in a straight line in one direction.*

2 *Make sure you are wearing protective gloves. Pull a flogging brush through the glaze, working in the same direction as before and keeping as even and straight a line as possible. This will thin the glaze coat.*

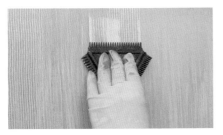

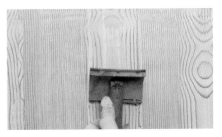

3 *Pull a rubber comb through the glaze in the same direction once again. Comb across the whole surface, using the different sides of the comb to vary the effect. Regularly clean the excess glaze from the comb onto a cloth.*

4 *Pull a heartgrainer through the glaze, pivoting it gently at regular intervals. Continue graining, leaving combed strips of varying widths between each grained one. Alter the angle as you rock and pivot the heartgrainer each time for a natural look.*

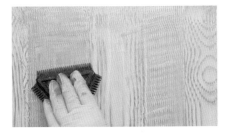

5 *Comb the whole surface once more, including over the heartgraining. Use the flogging brush to flog all the decoration just before it is dry, beating the surface with the bristles as you work down to slightly soften the markings.*

6 *Wrap the comb in a lint-free cloth. Use this tool to wipe out lines of glaze to create the lights. Flog the glaze one more time then leave to dry. Protect by applying eggshell oil varnish with a household paintbrush.*

Pine

Materials and Equipment

Cream oil-based eggshell paint
 for the base coat
Artist's oil paints: raw umber,
 raw sienna, white
Mineral spirits
Paint pails
Roller and tray
Household paintbrushes,
 fitch brush, hog-hair
 softening brush
Heartgrainer
Rubber comb
Eggshell oil varnish

This paint effect introduces a variety of processes and is a good finish to practice to acquire familiarity and confidence with specialist tools and techniques. The real wood is now easily obtainable and affordable, so you might prefer to use this method to produce fantasy versions using unconventional colors. Bear in mind, however, that you need to keep the tones of the base color and the top glaze coat close together.

1 *Apply the base coat with a roller. Mix raw umber, raw sienna, and white oil paints to replicate the color of pine. Mix 1 part paint to 2 parts mineral spirits. Apply the glaze with a brush, then drag a dry brush through the glaze, working in a straight line in one direction.*

2 *To suggest planks of wood, hold the brush on its side at a slight angle so that more pressure is applied on the side closest to you. Pull down, removing glaze in the first instance and causing it to collect on the other side of the brush. Each plank should be about the width of a heartgrainer's head.*

3 *Twist a dry fitch brush into the glaze to create the knots. The more pressure you apply to the brush the wider the imprint will be. Aim for a random, natural look.*

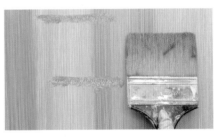

4 *Soften the knots and the effect so far by gently wiping over the surface in different directions with a dry brush.*

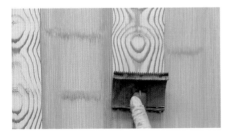

5 *Pull a heartgrainer through the glaze, pivoting the rubber head. Add heartgraining to each plank, altering the angle as you rock and pivot to ensure each plank is different. Pull a rubber comb through the glaze over the heartgraining.*

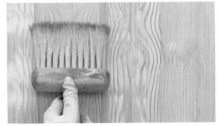

6 *Soften off the decoration with a hog-hair softening brush while it is still tacky. Follow the graining first then gently wipe against the grain to give a slightly blurred effect. Leave to dry. Protect by applying eggshell oil varnish.*

Bird's-eye maple

Materials and Equipment

Pale off-white eggshell paint
for the base coat
Artist's oil paints: raw sienna,
yellow ocher, raw umber
Oil-based glaze
Mineral spirits
Paint pails
Household paintbrushes, fine
artist's brush, hog-hair
softening brush
Decorator's sponge
Eggshell oil varnish

Bird's-eye maple has a unique appearance with small eyes or dots appearing regularly in the grain. These can vary in size and form no particular pattern. This imitation wood effect is best achieved in oil glazes that dry slower than water-based varieties and so give you the time you need to manipulate the effect and achieve the maple look. Although suitable for large areas, this wood finish often looks better if worked in panels.

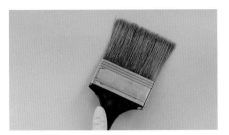

1 *Apply the base coat with a roller. Mix raw sienna, yellow ocher, and raw umber artist's oil paints to produce a golden brown maple shade. Mix equal amounts of paint and oil-based glaze, then equal amounts of maple glaze and mineral spirits. Use a brush to wash on the glaze.*

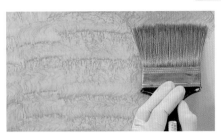

2 *Pull a clean paintbrush down through the glaze in a regular wiggling motion to add the pattern of a loose series of bands.*

3 *Use a sponge to lightly dab off areas where the glaze is too wet.*

4 *To create the eyes, dab the glaze in places using your knuckle and fingertips.*

5 *Use a fine artist's brush to paint in large dots of the maple glaze mixed in Step 1, keeping the spacing random.*

6 *As the glaze dries to a slightly tacky finish, soften the effect by lightly brushing all over in varying directions with a hog-hair softening brush. Leave to dry, then seal with eggshell oil varnish.*

Fruitwood

Materials and Equipment

Cream oil-based eggshell paint
for the base coat
Artist's oil paints: burnt umber,
burnt sienna, white
Mineral spirits
Paint pails
Roller and tray
Household paintbrushes,
pointed fitch brush, hog-hair
softening brush
Heartgrainer
Rubber comb
Lint-free cloth
Eggshell oil varnish

This effect is a fantasy finish based on an imitation of fruitwoods that were often combined when there was not enough of one wood available to complete a whole piece. It uses a variety of techniques to texture the finish and to produce the characteristic knots and graining, similar to those of many hardwoods. You could add more marking to suggest aging in the patina by adding and manipulating another thin glaze layer.

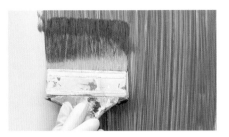

1 *Apply the base coat with a roller. Mix burnt umber, burnt sienna, and white oil paints to give a red-brown wood shade. Mix 1 part paint to 2 parts mineral spirits. Brush on the glaze then drag the brush back through, working in a straight line in one direction.*

2 *Hold a brush at right angles to the surface. Push the bristles into the glaze until they splay out, producing a wood texture of graining and knots. Repeat all over.*

3 *Pull the brush through the glaze with its bristles splayed out to continue the texturing.*

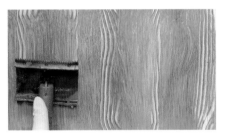

4 *Pull a heartgrainer through the glaze, pivoting the rubber head. Add more heartgraining, leaving small, irregular gaps between each strip and altering the angle as you rock and pivot. Pull a rubber comb through the glaze, over the heartgraining.*

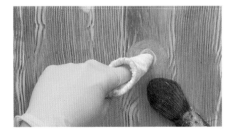

5 *To suggest knots and eyes, use a pointed fitch brush to apply circles of glaze. Wrap a lint-free cloth over a finger and press into the glaze eye to emphasize and highlight the shape.*

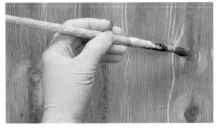

6 *Use a fitch brush to paint in more darks to suggest random eyes and knots. Soften the whole surface by brushing over in a variety of directions with a hog-hair softening brush. Leave to dry. Protect by applying eggshell oil varnish.*

Mahogany

Materials and Equipment

Dark pink oil-based eggshell
 paint for the base coat
Artist's oil paints: alizarin
 crimson, burnt sienna,
 burnt umber
Mineral spirits
Paint pails
Roller and tray
Household paintbrushes,
 hog-hair softening brush
Eggshell oil varnish

Mahogany is well known for its distinctive coloring and pronounced areas of grain. Here we demonstrate how to simulate the flame grain from the topmost part or where the branches come off the main section. It is traditional to use the flame cross-section for the inner panels of doors. The effect can be deepened with an additional burnt umber glaze applied and manipulated over the red decoration.

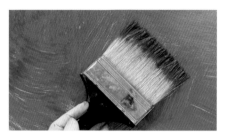

1 *Apply the base coat with a roller. This finish should be worked in panels. Mix alizarin crimson and burnt sienna oil paints to give a mahogany red-brown shade. Mix equal amounts of paint and mineral spirits and brush on the glaze.*

2 *Mix alizarin crimson and burnt umber oil paints to make a darker, brown-red shade and dilute with an equal amount of mineral spirits. Loosely brush on this darker shade in the center and at the outer edges of the panel.*

3 *Scrub a dry brush into the glaze in successive arcs, repeating the curve to begin suggesting the flame effect. Do not stop the movement of the brush but try to complete each arch continuously.*

4 *Soften off the whole surface with gentle strokes of a hog-hair softening brush, working against the grain to slightly blur the lines.*

5 *Pull a dry brush through the glaze at the edges of the panel to suggest the straight grain that would be apparent on either side of the arc grain.*

6 *Use the glaze mixed in Step 2 to paint darks back into the center where the effect may have lightened due to the arc graining motion. Soften off the whole surface and leave to dry. Protect by applying eggshell oil varnish with a household paintbrush.*

Peeling paint

Materials and Equipment

Coarse-, medium-, and fine-
 grade wet-dry sandpapers
Wire brush
Matte latex paints: red, blue,
 pale blue
Water-based crackle medium
Household paintbrushes
Hair dryer or hot-air gun
Dead flat acrylic varnish

Crackle medium used between two layers of paint produces a random distressed effect, as if the paint has peeled back naturally after exposure to the elements. The water-based medium causes the top layer of color to become brittle and crack, leaving a patterned surface. The medium can be reactivated with water, so a third, watery color is easily lifted off. For maximum effect use contrasting colors.

1 *Sand the surface to remove any varnish or paint then wire brush the wood to bring out the grain and provide a key. Brush on a coat of red matte latex paint, making sure the surface is well covered. Leave to thoroughly dry.*

2 *Brush on a layer of water-based crackle medium, working quickly and evenly and following the manufacturer's instructions. Leave to dry.*

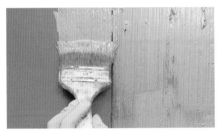

3 *Apply a top coat of blue matte latex paint using quick brushstrokes. Do not work back over the paint but use single strokes to cover in one attempt—the crackle medium is activated immediately and will lift off the top coat if disturbed.*

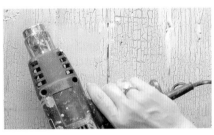

4 *Warm up the top coat with a hair dryer or a hot-air gun. Do not hold the heat source too close or the paint will bubble. As the paint dries it will crack, revealing the base color. Leave to dry completely.*

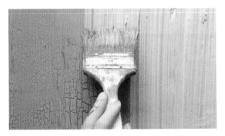

5 *Wash over with a watery mix of pale blue matte latex paint using quick brushstrokes. This watery mix will reactivate the crackle medium, making it possible to move the top coat.*

6 *Gently push the side of the brush into the pale blue top coat. This will lift up some paint without smudging. Continue lifting off areas to suggest peeling. When satisfied, leave to dry. Seal with dead flat acrylic varnish.*

Antiquing with colored waxes

Materials and Equipment

Coarse-, medium-, and fine-grade wet-dry sandpapers
Wire brush
Methylated spirits
Lint-free cloth
Fine wire wool
Waxes: cherry red, antiquing, liming
Mineral spirits
Clear finishing oil

This is a method similar to that traditionally used by French polishers to change the color of wood. Thin layers of wax color the wood without obscuring the grain. Repeated coats seal and protect the porous wood, and each layer is polished to give a fine, clear sheen that is water resistant. The friction caused by polishing heats up and softens the wax, causing it to penetrate further, resulting in a wonderful, deep patina.

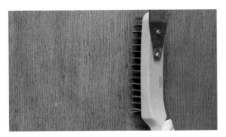

1 Sand the surface to remove any varnish or paint, then wire brush the wood to bring out the grain. Repeatedly clean the surface with methylated spirits and a lint-free cloth. Change the cleaning cloth regularly and continue until the cloth comes away clean when wiped over.

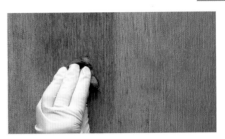

2 Dip fine wire wool in mineral spirits and then into cherry red wax. Rub the wax into the wood, following the grain.

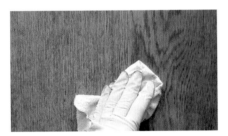

3 Polish the surface with a lint-free cloth to remove excess wax and give a smooth, hard finish.

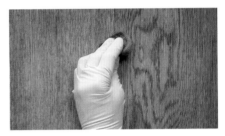

4 Add antiquing wax to a few areas using fine wire wool. This will darken the color here and there and give a deeper, richer coloration. Polish again with a lint-free cloth.

5 Apply a thin layer of liming wax with fine wire wool and polish off as before.

6 Sand lightly with fine-grade wet-dry sandpaper. Use a lint-free cloth to rub on a thin coat of clear finishing oil. Leave to dry and add another layer of oil for complete coverage. Buff to a high sheen.

Trompe l'oeil

Materials and Equipment

Pencil, tracing paper, transfer paper, painter's tape, biro
White undercoat
Artist's oil paints: blue, yellow, purple, white, green, burnt umber
Mineral spirits
Paint palette
Artist's brushes, household paintbrush
Oil varnishes: matte, eggshell

Trompe l'oeil means to deceive the eye. The deception with this simple project is the impression that a flower has been casually dropped on a tabletop. To achieve the effect the light source must be carefully considered, since it is the painted shadow falling to one side of the object that gives the convincing three-dimensional look. Studying the shadows cast by a real object is a great aid to successfully recreating a painted version.

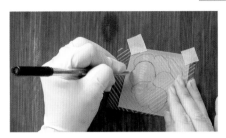

1 *If you are not working on a wooden surface you can apply a faux fruitwood finish (see pages 144–145). Copy the outline shape of a real flower onto a piece of tracing paper.*

2 *Place transfer paper between the sketch and the surface and lightly fix with painter's tape. Redraw the design with a biro to transfer it.*

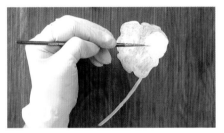

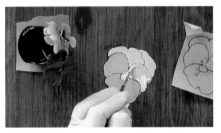

3 *Use an artist's brush to paint the whole shape in white undercoat. Leave to dry and recoat to achieve a solid coverage. Let dry.*

4 *Squeeze a little of each of the artist's oil paints onto a palette. Dilute the blue, main flower color with a little mineral spirits until fluid. Use an artist's brush to wash the color onto the petals. Let dry.*

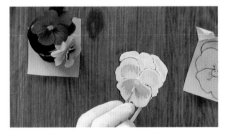

5 *Add a wash of yellow oil paint, diluted as in Step 4, to the center of the flower and purple washes running out from there. Add a green wash to the stem. Mix in a little white oil paint to lighten the colors if necessary. Outline the petals with a purple wash. Leave to dry.*

6 *Use a burnt umber wash to paint in a shadow on one side of the flower and stem to add depth and suggest the three-dimensional shape of the flower lying on the surface. When dry, protect the flower with a matte oil varnish and the surrounding table with an eggshell oil varnish.*

Drag and stipple with lining

Materials and Equipment

White eggshell paint for the
base coat
Ruler, pencil, painter's tape
Artist's oil paints: raw sienna,
burnt umber, raw umber
Mineral spirits
Paint pails
Household paintbrushes,
flogging brush, stippling
brush, fitch brush,
long-haired sable brush
Eggshell oil varnish

Dragging is often combined with stippling when
covering large areas or working on a surface with
awkward moldings and panels. Here it is also
combined with lining to neaten up and enhance the
basic shape of a panel. Lining often follows the shape
of the piece being painted, at the same distance from
the edge all the way round. This method lets you use
the edge of the surface to run your brush along.

1 Apply the base coat. Mix 1 part raw sienna artist's oil paint to 2 parts mineral spirits and paint onto the edges of the panel. Pull a flogging brush through the wet glaze in parallel lines. Let dry.

2 Brush the same glaze mix used in Step 1 onto the central area of the panel.

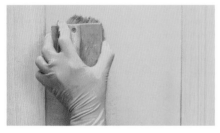

3 Dab the bristles of a stippling brush quickly and evenly into the wet glaze. Leave to dry.

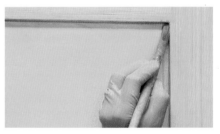

4 Mix burnt umber and raw sienna oil paints and add mineral spirits until fluid. Load onto a fitch brush. Hold one side of the brush against the edge of the panel, then pull the paint in a single movement along the edge. Line each edge and let dry.

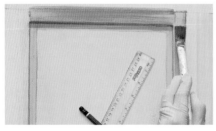

5 Measure the width of the outer line and mask with painter's tape. Using the same dilute paint as in Step 4, fill in the masked band. Paint quickly and evenly so the brush drags the paint on. Leave to dry and remove the tape.

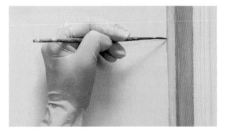

6 Mix raw sienna, raw umber, and burnt umber oil paints, adding mineral spirits to make the paint flow. Paint a thin line with a long-haired sable brush. Paint long runs and look ahead of the brush to avoid wobbling. Rest your little finger on the surface to steady your hand. Finally, apply eggshell oil varnish.

Fake parquet floor

Materials and Equipment

Cream oil-based eggshell paint
 for the base coat
Ruler, pencil, craft knife
Manila stencil card
Artist's oil paints: raw sienna,
 white, burnt umber
Mineral spirits
Paint pails
Roller and tray
Household paintbrushes,
 hog-hair softening brush
 (optional)
Rubber comb
Heartgrainer
Eggshell oil varnish

A painted floor is a flexible solution to a common decorating problem: it offers an individual look with potentially stunning visual impact. This is a quick and easy way to imitate an expensive wood block floor. You can work the painting in clean, crisp lines and strong colors, or alternatively aim for a faded effect with the appearance of years of wear and tear. If protected well the finish will be easy to clean and long lasting.

1 Apply the base coat with a roller. Measure the area to be painted and decide on your pattern. Cut masks of the main shapes from stencil card. These can be used as templates when marking out the pattern as well as masks at a later stage.

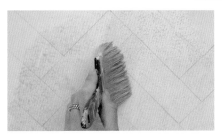

2 Combine raw sienna and white oil paints to make the palest wood shade. Mix 1 part paint to 2 parts mineral spirits. Texture the surface by applying the glaze with a loose stipple technique. Leave to dry.

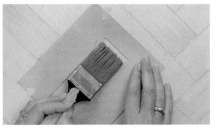

3 Use raw sienna, white, and burnt umber oil paints with mineral spirits to mix three more wood color glazes as in Step 2. Decide which colors will go where. Use a mask made in Step 1 to cover the surrounding planks and wash the first glaze color on.

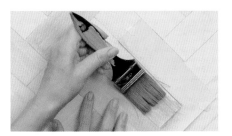

4 Repeat the glazing of the first color on a few of the other planks.

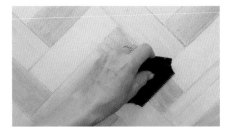

5 Pull a rubber comb through the wet glaze to suggest wood textures. Complete all of the planks in the first color and let dry. Repeat Steps 3–5 with the remaining glaze colors.

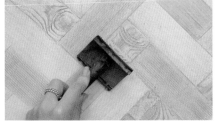

6 Use a heartgrainer on some of the planks and leave some without combing or heartgraining. Use a hog-hair softening brush to blur the graining if it is too bold. Add more layers if desired. Protect by applying several coats of eggshell oil varnish.

Porphyry

Materials and Equipment

Pink eggshell paint for the base coat

Artist's oil paints: alizarin crimson, burnt sienna, burnt umber, white

Mineral spirits

Paint pails

Roller and tray

Household paintbrushes, hog-hair softening brush, fitch brushes

Eggshell oil varnish

Porphyry is a hard igneous rock with a granular appearance and purple-red color. It has few or no veins but, when polished, is similar in appearance to marble. Porphyry is a relatively easy effect to produce, but it's worth experimenting with the background color on some trial pieces before beginning the job proper. The finished effect should be smooth to the touch and can be waxed to imitate the real polished rock.

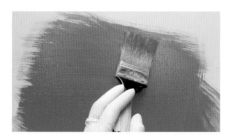

1 Apply the base coat with a roller. Mix equal amounts of alizarin crimson oil paint and mineral spirits. Use a brush to wash the glaze over the surface.

2 Stipple with the bristles of a hog-hair softening brush to create a smooth finish. Leave to dry.

3 Mix two red glazes using alizarin crimson and burnt sienna and alizarin crimson and burnt umber with mineral spirits, as in Step 1. Brush the two colors on in separate patches, stippling with a hog-hair softening brush as you go.

4 Continue adding patches of the glazes. Soften the effect so that the colors blend together to make a solid coat. Leave to dry.

5 Mix a pink glaze using white and alizarin crimson oil paints and mineral spirits as before. Load a fitch brush with the mix then gently knock the brush against another brush to spatter the color. Vary the size of the dots by spattering at different distances from the surface. Leave to dry.

6 Spatter the surface with the alizarin crimson and burnt umber glaze mixed in Step 3. Keep the brushes at a constant distance from the surface for a more even spatter. Leave to dry. Protect by applying eggshell oil varnish with a household paintbrush.

Tortoiseshell

Materials and Equipment

Cream oil-based eggshell paint
 for the base coat
Artist's oil paints: raw sienna,
 burnt sienna, burnt umber
Oil-based glazing liquid
Mineral spirits
Paint pails
Household paintbrushes,
 fitch brushes, hog-hair
 softening brush
Eggshell oil varnish

The pattern commonly known as "tortoiseshell" actually describes the shell of the sea turtle, which was once polished and turned into decorative objects. The pattern is imitated using a series of diagonal strokes in a variety of widths and lengths. It is a complex and intense pattern that usually looks its best in a design made up of small sections joined together, such as a tabletop with simple inlaid shapes.

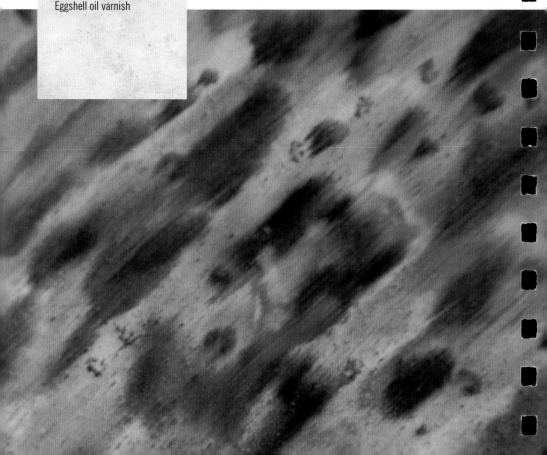

1 *Apply the base coat with a roller. Mix equal amounts of raw sienna oil paint and oil-based glazing liquid. Mix 1 part colored glaze to 2 parts mineral spirits. Brush on the glaze, work until nearly dry to give an even, smooth coverage. Allow to dry.*

2 *Use a fitch brush and raw sienna oil paint to apply a series of directional patches, with space between each shape.*

 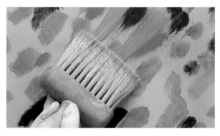

3 *Add small patches of burnt sienna oil paint here and there and larger quantities of burnt umber oil paint, following the direction of the first shapes and butting up to them in some instances.*

4 *Gently pull through with a hog-hair softening brush, following the direction of the previous brushstrokes. Use occasional cross strokes to soften the brushstrokes.*

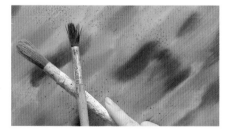 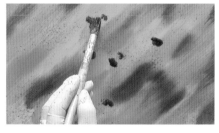

5 *Mix equal amounts of burnt umber oil paint and mineral spirits. Load a fitch brush with the mix then gently knock the brush against another brush to spatter the color. Work close to the surface to achieve a fine spattering and only over some areas. Leave for a few minutes before softening.*

6 *Repeat any of the steps to increase depth if necessary. Add a few small spots of burnt umber oil paint. Leave to dry completely. Protect by applying eggshell oil varnish with a household paintbrush.*

Lapis lazuli

Materials and Equipment

Pale blue oil-based eggshell
 paint for the base coat
Artist's oil paints: ultramarine,
 burnt umber, white, gold
Mineral spirits
Paint pails
Roller and tray
Household paintbrushes,
 hog-hair softening brush,
 stippling brush, fitch brushes
Eggshell oil varnish

Lapis lazuli is a blue mineral flecked with yellow iron pyrites, or fool's gold. It is rare and very valuable, and in earlier times was ground up as a pigment, the modern equivalent of which is ultramarine. To simulate the semi-opaque mineral, the luminosity of an ultramarine glaze is given depth and solidity by the addition of burnt umber and gold speckling in drifts and clusters, before a final waxing for added luster.

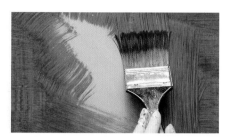

1 Apply the base coat with a roller. Mix equal amounts of ultramarine oil paint and mineral spirits. Wash the glaze over the surface.

2 Use a hog-hair softening brush, or stippling brush if working over a large area, to stipple the blue to give an even finish. Leave to dry.

3 Mix burnt umber and ultramarine oil paints to achieve a darker blue and dilute with mineral spirits as in Step 1. Paint on separate patches of this glaze and the original ultramarine glaze.

4 Stipple with a stippling brush to blend the two colors on the surface. Let dry.

5 Add white to ultramarine oil paint to make a light blue and mix with an equal amount of mineral spirits. Load the glaze onto a fitch brush then gently knock the brush against another brush to spatter the color. Work close to the surface to spatter a fine mist. Repeat to spatter the burnt umber and ultramarine glaze mixed in Step 3.

6 Mix equal amounts of gold oil paint and mineral spirits. Load a clean fitch brush with glaze. Pull back and release the bristles to spatter the surface with large dots here and there. Leave to dry. Protect by applying eggshell oil varnish with a household paintbrush.

Malachite

Materials and Equipment

Turquoise oil-based eggshell
paint for the base coat
Artist's oil paints: viridian
green, raw umber
Oil-based glazing liquid
Mineral spirits
Paint pails
Household paintbrushes,
stippling brush, short-
bristled fitch brushes,
hog-hair softening brush
Card
Eggshell oil varnish

Malachite is a semi-precious, bright green mineral with a unique ornamental quality. The complex pattern of incomplete circles and fractured bands of light and dark green can be imitated by combing torn card through a glaze coat to shape a series of half circles. The uneven edges of the card imitate the random organic pattern of the natural mineral.

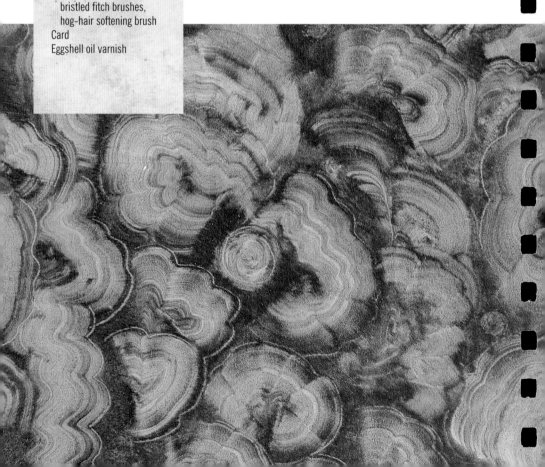

1 Apply the base coat. Combine viridian green and raw umber oil paints to achieve a dark, emerald green. Mix in equal amounts with oil-based glazing liquid, then mix 1 part glaze to 2 parts mineral spirits.

2 Brush this mix on in an even layer. Use a stippling brush to stipple the glaze until it has an even appearance.

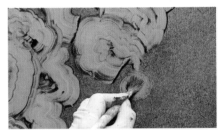

3 Fold a small piece of card and tear along the fold. Use the torn edge to work the glaze, pulling it through in an irregular semicircle, leaving one corner of the card approximately in the center. You may want to practice this action on a trial surface before beginning the decoration proper. Use new pieces of card as old ones get clogged.

4 Using the card, continue forming shapes, allowing them to overlap slightly each time. Use different sizes of card to vary the incomplete circles. In some of the gaps between combed shapes, twist a short-bristled fitch brush in the glaze to imitate the markings of the crystal patterns.

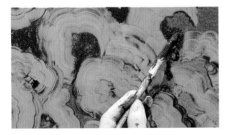

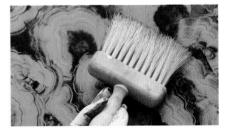

5 Load a fitch brush with more glaze and stipple in dark edges around some of the shapes. Correct any mistakes by adding more glaze and recombing. Use the end of the brush to outline each shape.

6 Soften off the patterns gently with a hog-hair softening brush, repeatedly brushing in various directions until you obtain a regular, smooth finish. Leave to dry. Protect by applying eggshell oil varnish.

Floating marble

Materials and Equipment

White eggshell paint for the
 base coat
Artist's oil paints: sap green,
 Payne's gray, red
Oil-based glaze
Mineral spirits
Paint pails
Small paintbrushes, hog-hair
 softening brush, fitch brush
Lint-free cloth
Ruler, pencil, painter's tape,
 red permanent marker pen
Eggshell oil varnish

Floating marble, also known as fossil marble, can only be achieved successfully on a flat surface due to the spattered mineral spirits. This effect does not imitate a particular marble and so can be created in any mix of colors. It is a random finish: the colors blend when mineral spirits are added and the patterns produced will vary according to how much spirit is used. Marking out squares like floor tiles gives an edge to the finish.

1 *Apply the base coat. Make three glazes by mixing sap green, Payne's gray, and red oil paints each with an equal amount of oil-based glaze. Mix equal amounts of each glaze and mineral spirits. Wash on patches of each glaze.*

2 *Remove some of the color with a pad of soft, lint-free cloth until a thin coat is achieved.*

3 *Soften the brushstrokes and blend the colors by brushing over in a variety of directions with a hog-hair softening brush.*

4 *Load a fitch brush with mineral spirits then gently knock the brush against another brush to spatter the color. Shake a fitch brush loaded with spirits over the surface and dab it into the paints to vary the pattern. Leave to dry.*

5 *Mark the surface into squares and mask with painter's tape. Mix equal amounts of Payne's gray oil paint and mineral spirits and use it to tint eggshell oil varnish. Varnish alternate panels with tinted varnish and the remaining with clear varnish. Let dry.*

6 *Remove the tape and draw over the dividing lines between each square with a red permanent marker pen.*

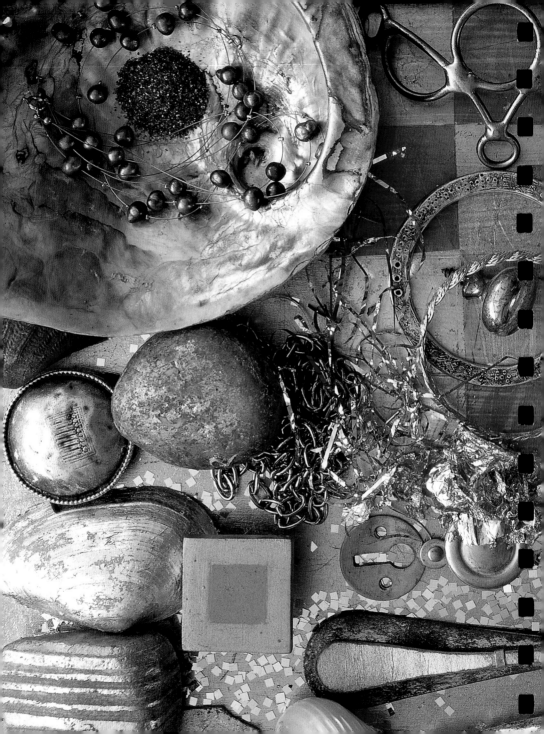

Metallic
effects

Metallic finishes have come into their own since paints, powders, metal leaf, and what was once specialist equipment have become widely available. Traditional gilding is a wonderful craft to master, with a little time and patience, but there are also less costly and time-consuming results to be found using imitation gold and silver leaf and transfer metal leaf. These simpler techniques will introduce beginners to the craft of gilding while also introducing a greater range of possibilities than might have been associated with the tradition. The use of bronze powders offers another gilded effect at a vastly reduced cost, the colors and techniques providing a fascinating array of decorative finishes, while combining metal leaf, metallic paints, and powders allows you to produce rich and varied finishes that are completely unique.

Patination of metals was traditionally shrouded in secrecy, but this section demonstrates some easy methods of patination using readily available chemicals. It also explores methods of contrasting matte and metallic finishes to create interesting and unusual results. The most important issue with metallic work is to experiment and record the results so that you gain a thorough understanding of the accidental mixes possible and can replicate any finish.

Metallic paints

Materials and Equipment

Blue matte latex paint for the
base coat
Metallic water-based paints:
pale silver, copper,
deep silver
Ultramarine acrylic paint
Paint pails
Household paintbrushes
Fine wire wool
Beeswax or high-gloss varnish
Lint-free cloth

The shimmer of the metallic paints as they catch and
reflect the light makes this a dramatic effect that offers
endless possibilities for use both in and outside the
home. The regularity of the mix of colors can be
controlled to give a subtle, easy-on-the-eye finish to
any decorative scheme.

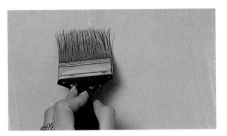

1 Apply the base coat with a paintbrush. Lightly load a household paintbrush with pale silver metallic water-based paint and apply broken brushstrokes in a thread-like vertical layer. Keep the brushstrokes straight and short. Leave to dry.

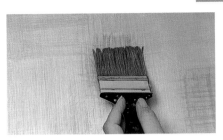

2 Brush on cross-hatching patches of copper and deep silver metallic water-based paints. Alternate the size and color of each patch and brush the patches of color lightly into each other.

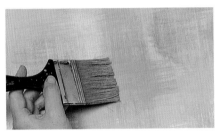

3 Add a little ultramarine acrylic paint to blue matte latex paint to create a deep blue. Using the same subtle approach as before, repeat the cross-hatching using the original blue latex paint and the new, deeper blue mix. Brush these lightly into the patches of metallic paint. Leave to dry.

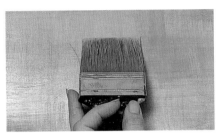

4 Repeat Step 2 using copper and pale silver metallic paints. This softens the colors slightly and adds more depth. Keep adding layers until the desired balance of color and texture is achieved. Allow to dry.

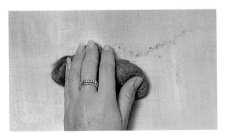

5 Rub over the entire surface with fine wire wool to smooth the patina and add variety to the texture.

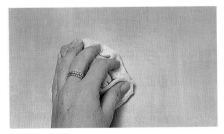

6 The metallic paints may tarnish if the surface is left unprotected. So, apply a coat of liquid beeswax or high-gloss varnish with a paintbrush. Buff to a sheen with a lint-free cloth when dry.

Metallic and matte paints

Materials and Equipment

Pink matte latex paint for the
base coat
Metallic water-based paints:
copper, blue
White matte latex paint
Household paintbrushes
Paint pail
High-gloss varnish or beeswax
Lint-free cloth

Metallic and matte paints can be combined over a surface and the colors blended, like a colorwash, to create a restful atmosphere. It is a good idea to practice dry-brushing because you do not want to overload the brush and obscure previously applied colors. Thinning the paints slightly with water will help the flow. The contrasting matte and metallic areas should be well mixed to give an even appearance.

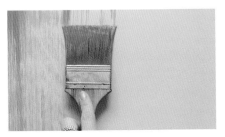

1 Apply the base coat with a paintbrush. Load a brush with copper metallic water-based paint and lightly drag the paint onto the surface in one direction. Use short brushstrokes to help keep the lines straight. Leave to dry.

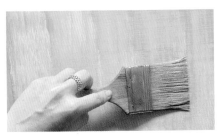

2 Dry-brush (see pages 54–55) blue metallic water-based paint in the opposite direction creating a cross-hatch pattern. Brush lightly, leaving the previous colors showing. Leave to dry.

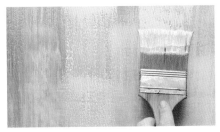

3 Mix white and pink matte latex paints to make a light pink. Dry-brush it on in one direction in patches. Allow to dry.

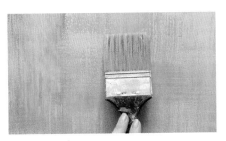

4 Add short brushstrokes here and there of the original pink matte latex paint, particularly in areas where it may have become obscured.

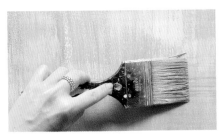

5 Load the brush with a little copper and blue metallic paint and add thin, thread-like lines in the opposite direction to create another cross-hatch pattern. Leave to dry.

6 Apply a coat of liquid beeswax or high-gloss varnish with a paintbrush. Buff to a sheen with a lint-free cloth when dry.

Gold-painted squares

Materials and Equipment

Red matte latex paint for the base coat
Tape measure or ruler, pencil, craft knife, cutting mat, painter's tape
Manila stencil card
Gold metallic water-based paint
Household paintbrushes
Fine-grade wet-dry sandpaper
Button polish or sanding sealer

Painted gold is less reflective than gold leaf, but offers a soft, warm glow. It can appear rich, luxurious, and sophisticated, and ideally should be well lit to enhance its subtle reflective qualities. This grid pattern is similar to the effect you would achieve if using metal leaf. The surface to be decorated must be particularly smooth because any irregularities will be exaggerated by the linear brushstrokes.

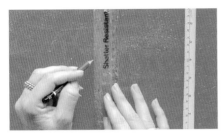

1 *Apply the base coat with a paintbrush. Using a pencil and ruler or tape measure, mark out a grid of 4-in (10-cm) squares.*

2 *Mark a 4-in (10-cm) square on a sheet of manila stencil card and cut out the stencil with a craft knife over a cutting mat, leaving a 1¼-in (3-cm) border all around. Cut out a number of stencils in the same way—you will need to change stencils regularly as paint builds up on them.*

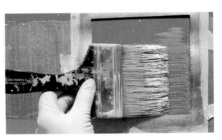

3 *Line a stencil up on the grid on the wall and fix in place with a few pieces of painter's tape. Load a brush with a little gold metallic water-based paint and brush over the stencil in one direction. Repeat in alternate squares over the whole surface. Leave to dry.*

4 *Repeat Step 3 on the remaining squares in the grid, this time brushing the paint on in the opposite direction. Allow to dry.*

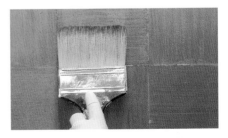

5 *Smooth the finish by rubbing down lightly with fine-grade wet-dry sandpaper, following the direction of the brushstrokes where possible.*

6 *Finish with button polish or sanding sealer to protect the gold from tarnishing and scratching.*

Steel

Materials and Equipment

Gray undercoat for the base coat
Artist's silver metallic oil-based paint
Mineral spirits
Fine wire wool
Black shoe polish
Paint pails
Household paintbrushes
Lint-free cloths

This paint effect has been devised to imitate the two-tone look of brushed steel. Thin layers of black shoe polish add depth to the brushed-on silver paint, dulling it to give a varied surface finish. Artist's oil-based paint is used to make the finish more hard-wearing, and should be allowed to dry thoroughly before waxing with wire wool. This metal finish works very well combined with blues and pale wood, or black and white.

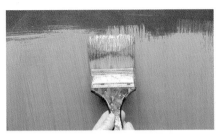

1 Apply the base coat with a paintbrush. Brush on a solid layer of silver metallic oil-based paint as smoothly as possible. Allow to dry and apply a second coat if necessary to achieve a solid coverage. Leave to dry.

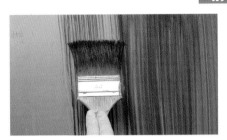

2 Mix equal amounts of gray undercoat and mineral spirits and brush on in one direction, letting the silver show through the thin glaze.

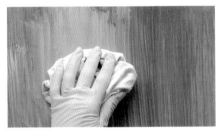

3 Lightly wipe over the gray glaze with a loose pad of lint-free cloth, following the direction of the brushstrokes. Leave to dry.

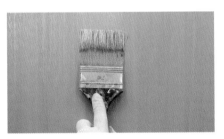

4 Dip a paintbrush in mineral spirits then load it with a small amount of the silver paint. Drag the brush over the surface in one direction to apply a thin layer of silver that does not obscure the darker color underneath. Leave to dry.

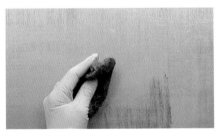

5 Use fine wire wool to apply an even, thin layer of black shoe polish. Follow the direction of the brushstrokes to avoid scratching or marking the paint.

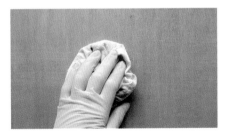

6 Buff up the polish with a soft cloth. Reapply and buff up thin layers of black shoe polish until the surface has a good covering of wax.

Rusted iron

Materials and Equipment

Gray undercoat for the
 base coat
Burnt umber acrylic paint
Metallic water-based paints:
 copper, silver
Matte acrylic glaze
Paint pails
Decorator's sponge
Fitch brushes, household
 paintbrush
Whiting
Sieve and spoon
High-gloss varnish or beeswax
Lint-free cloth

This paint technique suggests the texture and colors that result from the corrosive effects on metal of the elements and the passage of time. Aging iron can appear to rot and has a crumbling, dusty appearance, here imitated with silver paint and whiting. The use of acrylic paints makes this a quick and easy effect to achieve. You could also introduce a wash of black before the copper for a dramatic color difference.

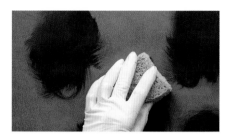

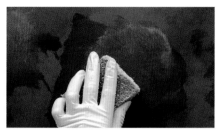

1 Apply the base coat with a paintbrush. Dip a damp sponge in burnt umber acrylic paint and use a circular motion to wash it on in patches. Use a stippling motion to dab on the paint in places for variety. Leave to dry.

2 Use a clean damp sponge to wash on patches of copper metallic water-based paint in patches of various sizes, overlapping the gray and burnt umber areas. Let dry.

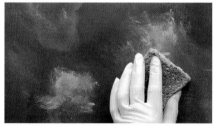

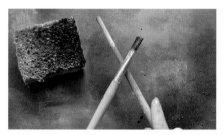

3 Use a clean damp sponge to stipple on patches of silver metallic water-based paint. Wipe the sponge back into the paint to smooth out the effect here and there.

4 Mix burnt umber and copper glazes by combining equal amounts of paint, matte acrylic glaze, and water. Load a fitch brush with the mix and gently knock it against another brush to spatter the color. Spatter both glazes to suggest age spots.

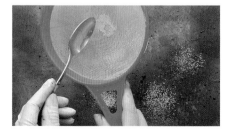

5 Pour some whiting into a sieve and sprinkle it over the surface in patches. The whiting will adhere to the surface where wet. Leave to dry and brush off any excess if necessary.

6 Protect with matte acrylic glaze and high-gloss varnish or liquid beeswax applied with a paintbrush. Buff to a sheen with a lint-free cloth when dry.

Verdigris

Materials and Equipment

Orange matte latex paint for
 the base coat
Copper metallic
 water-based paint
Aqua acrylic paint
White matte latex paint
Paint pails
Household paintbrushes
Decorator's sponges
Whiting
Sieve and spoon
Fine-grade wet-dry sandpaper
Matte acrylic glaze
High-gloss varnish or beeswax
Lint-free cloth

Verdigris is a naturally occurring corrosion that can affect copper, brass, and bronze. Copper verdigris is particularly attractive, the combination of the warm copper and the cool tones of the blue-green patina create an harmoniously balanced, multicolored finish. This painted version is easily achieved and looks authentic, and the addition of a sprinkling of whiting over the drying paint builds up the texture.

1 *Apply the base coat with a paintbrush. Thoroughly sand the dry base coat with fine-grade wet-dry sandpaper to give a smooth surface.*

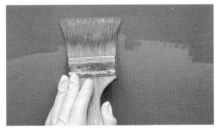

2 *Use a brush to apply a solid coat of copper metallic water-based paint, finishing the brushstrokes neatly in one direction to give an even finish. Leave to dry.*

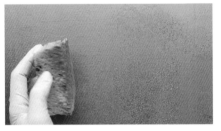

3 *Use a sponge to dab on an uneven layer of aqua acrylic paint. Allow to dry.*

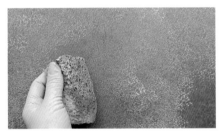

4 *Add a little white matte latex paint to the aqua acrylic paint to lighten it. Use a clean sponge to lightly dab on an uneven layer of paint, allowing the copper to show through in patches. Leave to dry.*

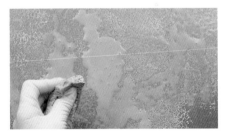

5 *Dilute each of the two shades of aqua paint with an equal amount of water. Puddle the two mixes on in patches by dipping a sponge in the dilute paint and squeezing it out over the surface. Sponge off some of the color in places where it is too watery.*

6 *While the dilute paints are drying, pour some whiting into a sieve and sprinkle it over the surface. The whiting will adhere to the surface where wet. Leave to dry and brush of any excess whiting if necessary. Seal with matte acrylic glaze and a coat of liquid beeswax or high-gloss varnish applied with a paintbrush. Buff to a sheen with a lint-free cloth.*

Opalescent solid color

Materials and Equipment

Two-part blue opalescent
 water-based paint system
Roller and tray
Fine-grade wet-dry sandpaper
Hog-hair softening brush,
 household paintbrush
Decorator's sponge

A solid base coat and opalescent top coat can be bought as a two-part system, with colors coordinated to give the ultimate match. The final finish is a strong color with a hint of luster and a varied shimmer, from bright to soft depending on the build-up of layers. It is a deceptive effect that initially appears as a solid, flat color, but as the light catches the surface you become aware of the glisten of the top coat.

1 Use a roller to apply the first layer of the blue base-coat paint of a two-part opalescent water-based paint system. Allow to dry.

2 Sand well with fine-grade wet-dry sandpaper before applying a second coat of base paint. Continue sanding and applying paint until you have a smooth, even finish with no irregularities and a solid color coverage.

3 Dip a sponge into the second, opalescent top coat of the two-part system and wash on a smooth first coat. Leave to dry.

4 To achieve a deeper, more solid layer, use a brush to add another coat of the second, opalescent part. Working over the thin first coat will make this layer easier to brush on smoothly.

5 Before this layer has dried, brush in all directions with a hog-hair softening brush to even out the brushstrokes, blur the edges, and smooth the effect. Leave to dry.

6 Use a sponge again to build up a few more thin layers of the opalescent paint, to strengthen the finish. This acrylic paint system provides a shiny, easy-to-clean surface that does not require any further protection.

Opalescent and iridescent washes

Materials and Equipment

White acrylic primer for the base coat
Tape measure, ruler, pencil
Opalescent water-based paints: copper, blue
Iridescent water-based paints: red, silver, gold
Small fitch brushes
Decorator's sponge
Fine-grade wet-dry sandpaper

Iridescent paints are lightly colored—often appearing white on the brush—with a hint of luster. Opalescent paints are stronger in color with the same shimmer. Both can be built up as thin washes to produce a subtle gleam. In this instance, applying the effect over a textured wall has allowed the mixed colors to collect in the pits, while the gold wash sits on the surface—this has added depth and strengthened the colors.

1 Apply the base coat with a paintbrush. Use a tape measure, ruler, and pencil to mark out a repeat diamond pattern over the surface.

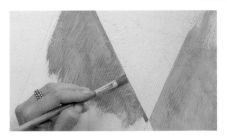

2 Mix equal amounts of copper opalescent water-based paint and water. Use a sponge to wash the glaze over the large areas of a row of diamonds, and a small fitch brush to work into the edges and points. Leave to dry.

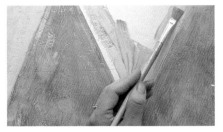

3 Combine equal amounts of blue opalescent paint and water and wash onto the adjacent rows of diamonds as before. Let dry. Add more coats if desired to make a more solid finish. Leave to dry.

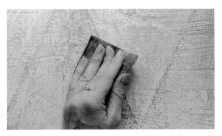

4 Sand all over with fine-grade wet-dry sandpaper to blur the sharp edges of the geometric shape slightly and add interest and texture. Use a damp sponge to wash off the pencil lines if necessary.

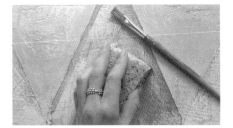

5 Use red iridescent water-based paint over the copper and silver iridescent paint over the blue to add highlights and lowlights. Use a brush to apply the color on the edges and points, and a sponge to pull the color into the shape slightly and soften the brushstrokes. Leave to dry.

6 Dilute equal amounts of gold iridescent paint and water and use a sponge to wash a thin glaze all over. The gold will be quite transparent. This warm layer will soften the design a little so it is less sharply defined. These shiny acrylic paints are easy to clean and the surface does not require protection.

Mixing luster paints

Materials and Equipment

Acrylic primer
Acrylic paints: pale yellow,
 deep yellow, yellow ocher
Luster powder
Paint pails
Household paintbrushes
Decorator's sponge

A simple, curved object can be greatly enhanced by luster paints—the light landing on the object in varying ways will exaggerate the opalescent finish. It is easy to make your own glimmering paints using powders or clear solutions mixed with the water-based color of your choice. Applying the color in washes means it won't be too dominant and allows you to build up a strong, permanent finish.

1 Make sure the surface is grease free and apply six coats of acrylic primer to give a smooth surface. The absorbent, chalky finish of the primer will cover a pitted, rough surface perfectly.

2 Make opalescent paints by separately mixing equal amounts of the three shades of yellow acrylic paints and luster powder, then, for each, combining equal amounts of paint and water. Use a brush to apply the first, pale yellow mix in a loose band at the top of the surface. Soften the brushstrokes with a sponge. Leave to dry.

3 Use a clean brush to apply a wash of the deep yellow in a loose band under the first, softening the brushmarks as before. Leave to dry.

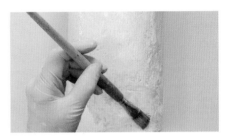

4 Add the final, yellow ocher luster paint wash in a band at the bottom of the surface.

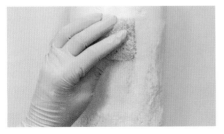

5 Use a sponge to wash the lightest yellow luster glaze all over.

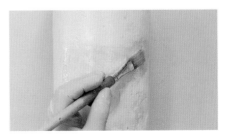

6 Repeat any of the steps as necessary to deepen the colors. The shiny acrylic finish does not need further protection.

Bronze powders

Materials and Equipment

Blue undercoat for the
 base coat
Protective face mask
 and gloves
Pencil, tracing paper, thin card,
 transfer paper, painter's
 tape, biro
Acrylic or oil gold size
Bronze powders: gold, copper
Fine sable brushes, household
 paintbrush
Fine-grade wet-dry sandpaper
High-gloss varnish
 or liquid beeswax
Lint-free cloth

Bronze powders are made from the fine powders of metals and can be found in varying shades of gold, silver, and copper. Their versatility means they can be sprinkled over tacky size or mixed with a binder such as glaze, varnish, shellac, or water-based paints. The powders do not produce the same shine as metal leaf but they are much easier to use and cheaper to buy. The powders are very fine and should not be inhaled.

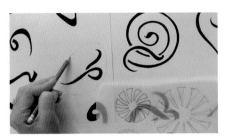

1 *Choose simple motifs with fine points and broad areas to make good use of this method. With a pencil, draw the motifs on tracing paper, then photocopy onto thin card. Keep the images simple.*

2 *Wearing gloves, apply the base coat and sand smooth with fine-grade wet-dry sandpaper. The dusty finish of the blue undercoat will act as a contrast to the sized areas so you can view them.*

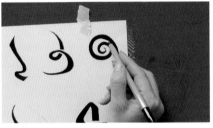

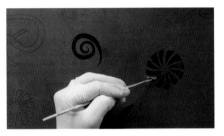

3 *Place transfer paper behind the card and tape both to the surface. Use a biro to draw around the motif and transfer it to the surface. Transfer all the motifs in the same way, keeping the overall design random with space between each image.*

4 *Use a fine sable brush to fill in the shapes with size. Make sure you have a solid layer of size since it is not possible to touch up any missed areas later without ruining the effect. Leave until tacky.*

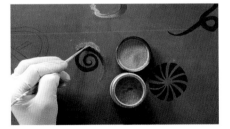

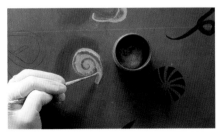

5 *Wear a mask and pick up a little gold bronze powder on a fine sable brush. Paint it along one edge of a sized motif then feather it into the middle of the design, aiming for a shaded look that fades out toward the other edge. You do not want a solid cover. Use a sable brush to dust off excess powder.*

6 *Apply copper bronze powder, working along the opposite edge of the sized shape and feathering the powder in to meet the gold. A less covered inner area will appear darker as the blue background shows through. Seal the surface with high-gloss varnish or beeswax as protection from oxidation.*

Water gilding with real gold

Materials and Equipment

Heatproof bowl, mixing bowls,
 saucepan
Ready-mixed gesso
Red bole
Rabbit-skin size
Distilled water
Whiting
Scissors
Gold transfer leaf
Hog-hair brush, soft brush
Lint-free cloth
Agate burnisher

When gold leaf is applied over multiple layers of gesso and a water-based size, it can be burnished to a shiny, gleaming intensity with an agate burnisher. This also forces the metal leaf to adhere and makes it more resistant to damage. The gesso acts as a cushion for the gold when burnishing and should be smooth enough not to tear the leaf. The red bole provides color enrichment.

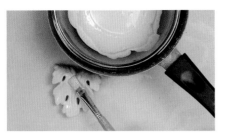

1 Boil water in a saucepan. Place ready-mixed gesso in a heatproof mixing bowl in the hot water. Stir until melted to the consistency of light cream. Ensure the surface is grease and dust free. Paint on eight layers of gesso with a hog-hair brush, applying each layer while the last is matte but still damp.

2 Smooth the surface with a small piece of wet cloth. Prepare red bole and a rabbit-skin size and distilled water mix (see page 19), and combine 1 part bole with ¾ parts size. Use a clean cloth to apply a few even, smooth coats of the mix. Leave to dry.

3 Dust a pair of scissors with whiting and cut up small pieces of gold transfer leaf. Prepare a rabbit-skin size and distilled water mix (as in Step 2 but without the bole dye) and brush over the surface.

4 Work quickly to apply the leaf. Dust your fingers with whiting, then lift a small piece of leaf by the backing paper and position it on the surface. Rub the backing paper with a soft brush. The paper will peel away from the leaf as the metal adheres.

5 Continue adding transfer leaf, overlapping the pieces, to cover the surface. Tamp the gold down with a soft brush, taking care not to tear it, and dust off the excess leaf.

6 Leave the size to dry. Apply another layer of gold, using less size, if necessary, to achieve a solid coverage. Burnish the leaf with an agate burnisher. Burnished leaf does not need extra protection.

Oil gilding with real silver

Materials and Equipment

Heatproof bowl, mixing bowl,
 saucepan
Ready-mixed gesso
Blue bole
Rabbit-skin size
Distilled water
Oil-based gold size
Whiting
Scissors
Silver transfer leaf
Hog-hair brush, soft brushes
Lint-free cloth
Fine wire wool
Gilding medium
 such as Ormoline

Using a quick-drying, oil-based size makes gilding small objects with transfer metal leaf a quick and easy technique. Here, thin, delicate silver leaf has been used, so repeated layers of gesso must be as smooth as possible to prevent tearing. Silver leaf from different sources can vary in color, so make sure you purchase enough leaf for your project. The blue bole under the leaf adds interest when revealed by distressing.

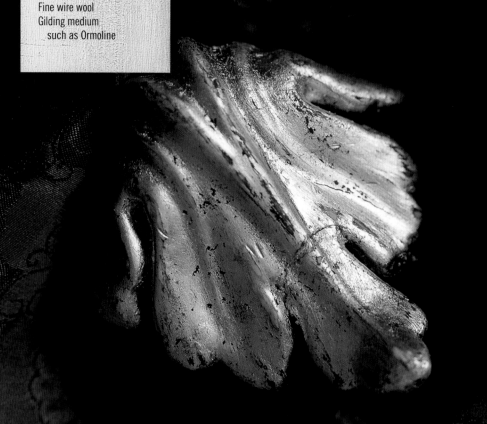

1 *Pour boiling water into a heatproof bowl. Place ready-mixed gesso in a mixing bowl in the water. Stir the gesso until melted to the consistency of light cream. Ensure the surface is grease and dust free. Paint on eight layers of gesso with a hog-hair brush, applying each layer while the last is matte but still damp. Polish with a wet cloth to smooth the surface.*

2 *Prepare blue bole and a rabbit-skin size and distilled water mix (see page 19), and combine 1 part bole with ¾ parts size. Use a soft brush to paint it onto the surface. Keep the bole warm and fluid over a saucepan of hot water. Leave to dry.*

3 *Ensure the surface is completely free of dust, grit, or hairs. Use a soft brush to apply oil-based gold size. Make sure the surface is completely covered. Leave for the appropriate drying time, following the manufacturer's instructions.*

4 *Dust your fingers and scissors with whiting. Cut small pieces of silver transfer leaf. Lift a piece by the backing paper and position it on the surface. Rub the backing paper with a soft brush. The paper will peel away from the leaf as the metal adheres.*

5 *Continue adding transfer leaf, overlapping the pieces, to cover the surface. Use a soft brush to dust off the excess leaf. Leave the size to dry.*

6 *Distress the leaf by gently rubbing the surface with fine wire wool. Protect with gilding medium or let natural patination enhance the look.*

Imitation gold and silver transfer leaf

Materials and Equipment

Heatproof bowl, mixing bowl
Ready-mixed gesso
Acrylic paints: yellow, red, blue
Acrylic gold size
Whiting
Scissors
Imitation gold and silver
 transfer leaf
Household paintbrushes,
 hog-hair brush, gilder's mop
 or soft brush
Fine wire wool, fine-grade
 wet-dry sandpaper
Shellac or sanding sealer

Imitation gold—also known as Dutch metal and brass leaf—and silver leaf—also called aluminum leaf—is widely available and a cheaper alternative to the real thing. The leaf can be applied over any tacky adhesive, even household glue or varnish, but a specialist gilding size is recommended if you wish to have more control and achieve a long-lasting finish. Transfer leaf is easier to use than the loose form, although more expensive.

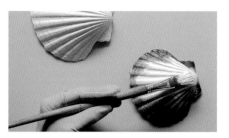

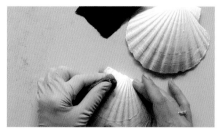

1 Cover the surface with eight coats of gesso (see Step 1, page 191). Leave to dry.

2 Use fine wire wool and fine-grade wet-dry sandpaper to lightly rub down the surface. Touch up with gesso and repeat if necessary.

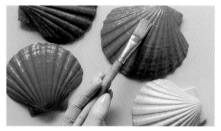

3 Brush on a base coat of the acrylic paints (you may need to apply two coats). Rub down the surface again with wire wool and wet-dry sandpaper. Brush on acrylic gold size to cover the surface.

4 Dust your hands and some sharp scissors with whiting, then cut up sheets of imitation gold and silver transfer leaf into workable pieces.

5 Lift a small piece of transfer leaf by the backing paper and position it on the sized surface. Rub over the backing paper with a gilder's mop or soft brush. The paper will peel away from the leaf as the metal adheres.

6 Continue adding transfer leaf, overlapping the pieces, to cover the surface. Dust off the excess leaf with a hog-hair or soft brush. Gently rub the surface with fine wire wool to distress it and protect with shellac or sanding sealer.

Copper loose leaf

Materials and Equipment

Orange matte latex paint for
 the base coat
Acrylic gold size
Whiting
Copper loose leaf
Firm card cut slightly larger
 than a sheet of loose leaf
Household paintbrushes,
 gilder's mop or soft brush
Button polish or sanding sealer
High-gloss varnish
 or liquid beeswax
Lint-free cloth

Copper adds an unusual, bright, reflective quality to any scheme, and is more subtle than gold or silver. It works particularly well when combined with dark wood and warm colors such as terra-cotta or lilac. The easiest way to use loose metal leaf is on a flat surface, as demonstrated here. Make sure you work away from any gusts of wind because the leaf is extremely light.

1 Apply the base coat. Brush on an even coat of acrylic gold size. Work quickly and in manageable-sized sections because the size dries fast.

2 Cover your fingers and a piece of firm card with whiting to stop the leaf sticking. Waft the card at the edge of the leaf book until the top sheet lifts up. Slip the card under and lift the sheet. Hold the card at an angle to the surface and touch the size with one side of the leaf. Pull the card down and away quickly, lowering the rest of the leaf.

3 Follow Steps 1–2 to apply adjacent sheets of copper leaf, overlapping the edges. Use the card as a straight edge to carefully tear away the excess leaf on the overlapped edges. Remember to dust your fingers and the card with whiting regularly.

4 Remove smaller pieces of loose leaf by gently brushing over the squares with a gilder's mop or a soft brush. This action will also press the leaf down more firmly onto the tacky size. Keep the excess leaf pieces for future use.

5 Seal the surface with button polish or sanding sealer to protect the leaf from tarnishing and give a hard finish to protect against scratches.

6 Apply high-gloss varnish or liquid beeswax with a paintbrush and buff it up to a soft sheen with a lint-free cloth.

Gilding on glass

Materials and Equipment

Pane of glass
Glass cleaner, lint-free cloth
Gelatin capsule
Distilled water
Mixing bowl, heatproof bowl
Whiting
Silver loose leaf
Firm card cut slightly larger
 than a sheet of loose leaf
Household paintbrushes,
 gilder's mop or soft brush
Blackboard paint

This is a simple version of an 18th-century gilding technique that is still in use today. Silver leaf is applied to the reverse of a sheet of glass and sealed with paint, usually black. The gilding is seen through the glass, which becomes a kind of mirror, although the reflections are soft. You may want to practice the technique with imitation silver loose leaf before using the more expensive and lighter, real silver leaf.

1 *Clean both sides of the glass thoroughly. Lay the glass on a dust-free surface with a block under one edge to raise the pane at an angle so that excess size can run down. Prepare to start at the raised edge and place a book of silver loose leaf nearby.*

2 *Take half a gelatin capsule and ½ pint (300ml) of distilled water. Warm a little water and add to the capsule to dissolve it. Top up with the rest of the cold water and stir. Brush the size onto the glass in manageable-sized sections.*

3 *Cover the glass with a layer of silver loose leaf (see Steps 2–4, page 197). When the glass is completely covered, leave to dry.*

4 *Hold the glass panel over steam for a few seconds to allow the size to cure. This will help the leaf to settle and smooth out any wrinkles. Double gild if required, using less size. Steam again.*

5 *Use a soft brush or a gilder's mop to gently brush off the excess loose leaf. Don't worry if the leaf has not adhered in places, these gaps will reveal the background paint and add character to the effect. Brush the excess into a container to save it.*

6 *Ensure the surface is free of particles, then paint on the background color. This is traditionally black. Blackboard paint is quick drying and will protect the silver from tarnishing. Leave to dry.*

Metallic paint and metal leaf

Materials and Equipment

Gray matte latex paint for the base coat
Tape measure, ruler, pencil, craft knife, cutting mat, painter's tape
Manila stencil card
Silver metallic water-based paint
Acrylic gold size
Imitation silver loose leaf
Household paintbrushes, small brush
High-gloss varnish or liquid beeswax
Soft, lint-free cloth

A simple square pattern is made more interesting by combining hard with soft and light with dark, with a hard, bright, imitation silver leaf highlighting the softer, silver metallic paint. When used for wall decoration this effect will be greatly affected by the light sources. Direct light will reflect off the bright metal leaf, softer light will give it all a soft shimmer.

1 *Apply the base coat with a paintbrush. Mark out a grid of squares of your preferred size. Keep the squares equal.*

2 *Use a craft knife to cut out a square stencil to match the size of the squares on the wall, leaving a 1¼-in (3-cm) border all around. Keep the cutout square and find the center point. Cut a smaller square into this stencil. Cut out a number of stencils in the same way—you will need to change them regularly as paint builds up.*

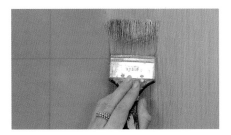

3 *Drag a light layer of silver metallic water-based paint all over the surface, keeping the lines parallel. Leave to dry.*

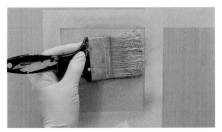

4 *Line the first stencil up on the grid and fix in place with painter's tape. Stipple the silver metallic paint through the stencil and repeat in alternate squares over the whole surface. Let dry.*

5 *Use the second stencil to mark a small square in the center of the alternate, unstenciled squares. Use a small brush to fill in the area with acrylic gold size. Leave until tacky.*

6 *Lay imitation silver loose leaf over the size to cover it (see Steps 4–6, page 197). Brush off excess leaf with a soft brush. Protect with high-gloss varnish or liquid beeswax. Buff with a lint-free cloth.*

Oil and water on metal leaf

Materials and Equipment

Acrylic gold size
Whiting
Imitation silver transfer leaf
Crimson acrylic paint
Payne's gray artist's oil paint
Mineral spirits
Paint pails
Fitch brush, household
 paintbrush, gilder's mop or
 soft brush, hog-hair brush
Decorator's sponge
Eggshell artist's oil varnish
High-gloss varnish
 or liquid beeswax
Lint-free cloth

This subtle finish relies on a variable light source to demonstrate the full effect. The first acrylic paint washed over the metal leaf will not be lifted by the mineral spirits that are used to paint circles into gray artist's oil paint. The hand-drawn quality of the painted circles is in contrast with the smooth, even finish of the leaf. Try to keep the brushstrokes quick and light to achieve a spontaneous effect.

1 Cover the surface with a layer of imitation silver transfer leaf (see Steps 4–6, page 195). Mix equal amounts of crimson acrylic paint and water and wash it over the silver with a sponge. Leave to dry.

2 Combine equal amounts of Payne's gray oil paint and mineral spirits and use a clean sponge to wash the glaze all over. Wipe lightly to avoid disturbing the leaf

3 While the oil paint is still drying, dip a fitch brush in mineral spirits and paint repeated circles a regular distance apart. This will remove some of the oil paint but not the crimson acrylic wash.

4 Dab a sponge over the circles to lift off more of the paint.

5 When the paint is still tacky, lightly soften by brushing in all directions with a hog-hair softening brush. Leave to dry.

6 Seal with eggshell oil varnish followed by high-gloss varnish or liquid beeswax applied with a paintbrush. Finally, buff with a lint-free cloth.

Metallic paint patination

Materials and Equipment

Red matte latex paint for the
 base coat
Acrylic gold size
Whiting, scissors
Imitation gold transfer leaf
Metallic water-based paints:
 pale green, bright green,
 gold, copper
Paint pails
Decorator's sponge
Household paintbrushes,
 gilder's mop or soft brush
Fine wire wool
Lint-free cloth
High-gloss varnish
 or liquid beeswax

The interplay of metallic paint and the brilliant shine of metal leaf produces a wealth of interesting layered textures. The metallic paints look like a matte wash in contrast with the extreme bright shine of the imitation gold leaf, while a wax finish adds a unified, soft glow to the effect. The background of metal leaf gives an overall impression of solidity and permanence that is not possible with just paint.

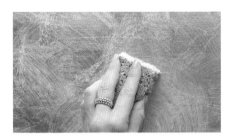

1 Apply the base coat. Cover with a layer of imitation gold transfer leaf (see Steps 4–6, page 195). Mix equal amounts of pale green metallic water-based paint and water. Use a sponge to wash the mix over the whole surface. Leave to dry.

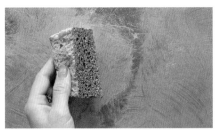

2 Add a light textured effect by stippling on areas of bright green metallic paint, using the sponge, then wiping it back as it starts to dry. Leave to dry.

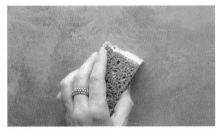

3 Stipple on the bright green metallic paint in areas once again. The build-up of layers will add depth. Leave to dry.

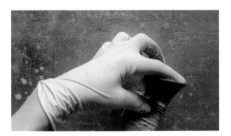

4 Dilute bright green, gold, and copper metallic water-based paints by mixing 1 part paint to 2 parts water. Load a brush with the first color and pull back and release the bristles to spatter the surface. Repeat with the other dilute paints.

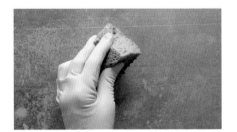

5 Use the sponge to remove excess water and to add texture—the spattered watery paints will lift some of the washes of color. Sponge lightly so you do not remove all the color. Leave to dry.

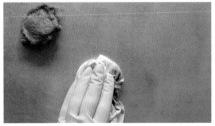

6 Use a lint-free cloth and some fine wire wool to rub off patches of paint here and there. This will remove some of the thin metal and expose the red base color. Protect with high-gloss varnish or liquid beeswax applied with a paintbrush, and then buff.

Distressing with spirit dyes

Materials and Equipment

Yellow matte latex paint for the
 base coat
Acrylic gold size
Whiting
Imitation silver transfer leaf
Spirit dyes: yellow, sepia,
 brown, red, green
Methylated spirits
Paint pails
Household paintbrushes,
 hog-hair softening brush,
 fitch brushes
Lint-free cloth
Fine wire wool
Button polish or sanding sealer

Spirit dyes can be applied to metal leaf to achieve a
controlled distressed finish, imitating the age spots and
tarnishing that occur with time. The dyes will bleed
into each other and have a transparency that allows
the gleam of the metallic base to show through. Using
a selection of spirit dyes, you can patinate the metal to
imitate the effect of chemical or natural corrosion.

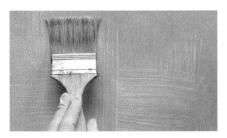

1 Apply the base coat. Brush on acrylic gold size in a manageable-sized section. Leave until tacky.

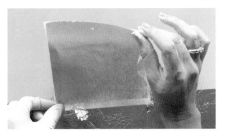

2 Cover your hands with whiting. Lift a sheet of imitation silver transfer leaf by the backing paper. Hold the square as straight as possible and gently place one edge on the size with the rest of the sheet held at a 45-degree angle.

3 Swiftly lay the rest of the leaf down. Gently rub the backing paper with your fingers until the leaf adheres, then remove the paper. Continue laying the leaf, overlapping the edges slightly.

4 Use a softening brush to brush off the excess leaf and keep it in a small container. Reapply a little size to any gaps where the leaf has not adhered and use a small brush to touch up with the excess leaf.

5 Load a spirit dye on a fitch brush and pull back and release the bristles to spatter the surface. Spatter the surface lightly and build up the colors as you gain confidence. If any areas have been spattered too heavily, lift the color off with a soft cloth soaked in methylated spirits.

6 Dip fine wire wool in methylated spirits and gently rub the surface here and there to give a slightly worn appearance. Seal the surface with button polish or sanding sealer to prevent tarnishing.

Chemical patination

Materials and Equipment

Various matte latex paints for the base coats
Protective face mask and gloves
Acrylic and oil-based gold size
Metal leaf: a selection of metals, loose or transfer
Metal powders: such as bronze, brass, and copper
Patinating fluids: such as copper sulphate, ammonia, bleach, and nitric acid
Paint pails
Household paintbrushes, gilder's mop or soft brush
Button polish or sanding sealer

There is a great range of rich color patinas that can be achieved using chemicals on metal coatings. Chemicals used include bleach, copper sulphate, ammonia, and nitric acid. They can be used in combination, diluted with water, and applied in multiple layers. Take great care when using chemicals, remembering to protect yourself and your surroundings.

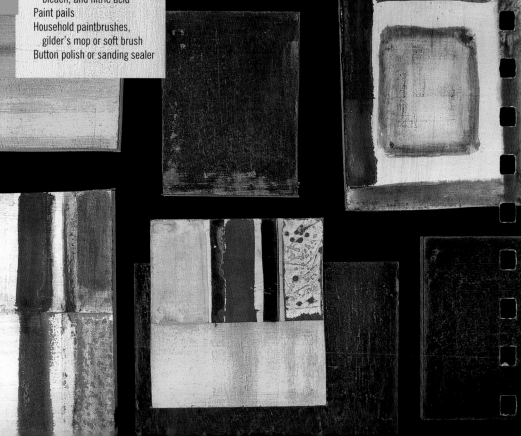

1 Apply the base coats to wooden boards. Warm colors are best combined with real or imitation gold, copper, and bronze. Black, blues, and grays are suited to real and imitation silver, iron, and steel.

2 Brush an even coat of acrylic gold size onto the first board.

3 Cover the board with metal leaf—loose (see Steps 1–4, page 197) or transfer (see Steps 4–6, page 195), real or imitation gold or silver, copper, or bronze. Repeat Steps 2–3 for each board. Make a note on the back of each board to help you record the effects of different chemicals on different metals.

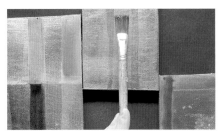

4 Wearing gloves and a face mask and working in a well-ventilated area, experiment by brushing on the chemicals. Follow the manufacturer's instructions to dilute the chemicals for varying effects. Use a damp sponge to wash off the chemicals when the desired level of patination is achieved.

5 To try the full range of patination possibilities it is advisable to experiment with metal powders. Brush on the ready-made variety or sprinkle the powder over tacky oil-based size—this will dry thoroughly, unlike acrylic size.

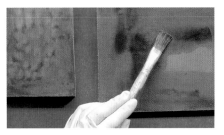

6 Brush on and remove the chemicals as in Step 4. Leave the chemicals for varying lengths of time to assess different rates of coloration. Protect with button polish or sanding sealer.

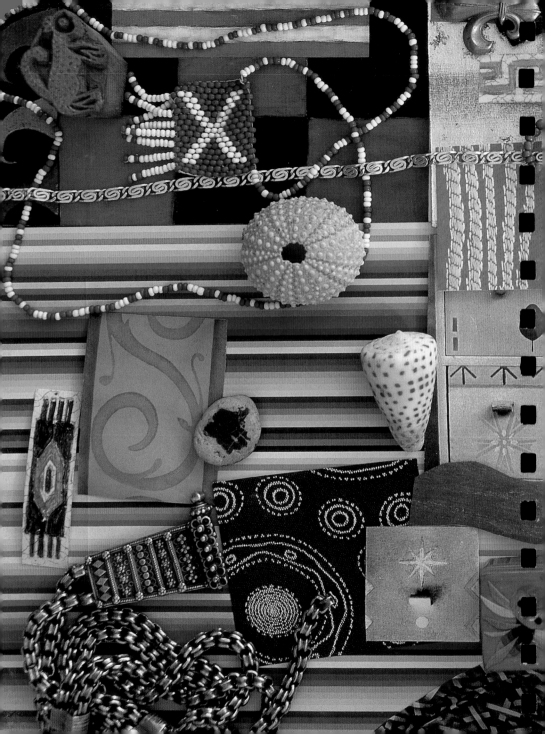

Patterns
and motifs

An endless amount of patterned finishes can be produced using stencils, stamps, and freehand painting. Some of the techniques follow traditional guidelines while others use methods that appear simple but result in sophisticated and glamorous effects. The best results, however, almost always occur when the patterns or motifs are kept simple and clear. The interest comes from the use of transparent layers of color, varying textures, or contrasting surface finishes.

Patterns and motifs used in decoration have a variety of purposes. They are often simply devices used to introduce color, but may also be used to add personal imagery, historical reference, and visually exciting and alternative detail. Figurative elements can be seen as restrictive, but you do not have to be trapped into attempting to emulate a particular era or look. Usually the most successful adventures into this area are the simplest design classics that can be adapted to suit the mood or look of the time, such as spirals, squares, and stripes. Other more personal choices will occur as experience leads you to find your own language and style. Generally, the dictate that it has all been done before should inspire rather than inhibit you as you discover that there is a wealth of successful ideas, combinations, and reference to view and learn from.

Irregular patterning

Materials and Equipment

Stucco equipment (see
 page 106)
Tracing paper, pencil, transfer
 paper, craft knife, cutting
 mat, painter's tape
Medium- and fine-grade
 sandpaper
Manila stencil card
Red oxide acrylic paint
Pale gold bronze powder
Ready-mixed drywall sealer,
 such as Shieldz by Zinnser
Paint pails
Fitch brush, stencil brush
Beeswax
Lint-free cloth

Individual motifs can be stenciled over a surface in a random pattern that can simply be judged by eye. The red oxide is stenciled first to suggest the red bole used in traditional gilding. Misregistering a second stencil of gold paint gives each motif a bold appearance with a deep outline. These letter stencils have been copied from old script and could be made into words or sentences, with a bit of careful measuring and marking.

1 *Apply the stucco (see pages 106–107) and use a filling knife and medium- and fine-grade sandpaper to polish the surface until the plaster has a soft sheen and is smooth to the touch.*

2 *Trace a motif. Place a sheet of transfer paper between the tracing paper and a sheet of manila stencil card and redraw the motif to transfer the design. Repeat with more motifs, spacing them roughly evenly in rows.*

3 *Use a craft knife over a cutting mat to carefully cut out the motifs. Cut out the rows of motifs to make smaller stencils.*

4 *Lightly fix a stencil in position with painter's tape. Dip the pointed tip of a fitch brush into red oxide acrylic paint and dab off the excess paint. Stipple the paint through the stencil of one motif. Repeat to stencil motifs randomly all over. Let dry.*

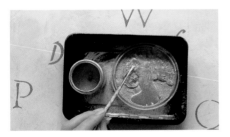

5 *Mix 4 parts gold powder to 1 part drywall sealer and add water a little at a time to make a paint the consistency of light cream. So that you do not end up with too much paint, add the sealer to the powder and then add the water.*

6 *Reposition the stencil over its dry, red print, aligning it slightly off register. Dip a stencil brush in gold paint and dab off the excess. Stipple the gold paint through the stencil. Repeat for each print. Leave to dry and seal using a cloth and beeswax.*

Regular patterning

Materials and Equipment

Acrylic primer for the base coat
Ruler, pencil, graph paper,
 transfer paper, craft knife,
 cutting mat, painter's tape
Manila stencil card
Opalescent and iridescent
 water-based paints (see
 pages 184–185): such as
 gold, blue, red, orange,
 green, copper, silver, yellow
Paint palette
Small paintbrushes
Decorator's sponge
Foam roller head
Fine-grade wet-dry sandpaper

These boards have been individually painted and stenciled using some of the vast array of iridescent and opalescent water-based paints currently available. Here, lighter background colors are contrasted with stronger stenciled shapes that give a bright reflection. The stencils are handmade and can be cut to suit the specific dimensions of any tongue-and-groove boarding.

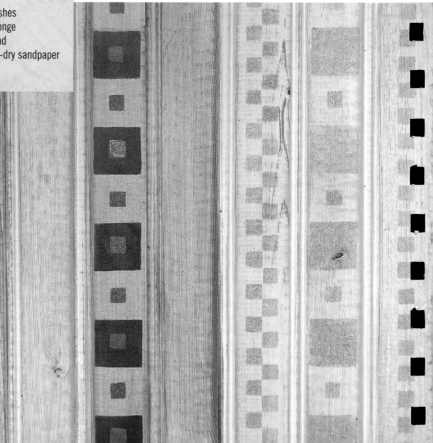

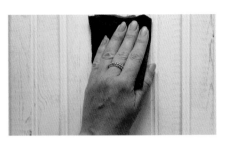

1 *Prime a wooden surface and sand smooth with fine-grade wet-dry sandpaper so that some of the grain shows through. Measure and mark equal-sized vertical strips. (Here we are using tongue-and-groove.)*

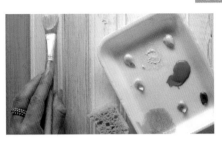

2 *Use a paintbrush to apply strips of opalescent and iridescent water-based paints. Here, each tongue-and-groove panel is painted a different color. Let dry.*

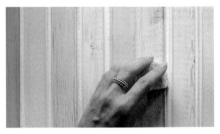

3 *Add a second layer of color to each strip or board to make a more solid covering. Wipe over the damp paint with a sponge to ensure no brushstrokes are visible. Leave to dry.*

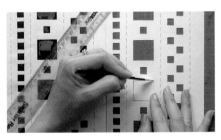

4 *Using the measurements taken in Step 1, mark a series of geometric repeat designs on graph paper. Place transfer paper between the graph paper and manila stencil card and redraw the shapes to transfer the design. Use a craft knife over a cutting mat to cut out three different stencils.*

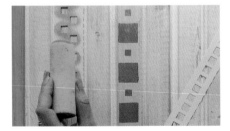

5 *Lightly fix a stencil in position with painter's tape. Dip the end of a foam roller head in one of the opalescent or iridescent paints and dab off the excess. Stipple the color through the stencil. Repeat on alternate or adjacent strips or boards. Let dry.*

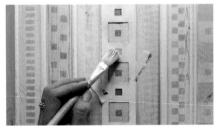

6 *You can apply a second coat of stenciled color for interest by aligning the stencil in a different position and using a brush for variety. These acrylic paints do not need further protection.*

Building up colors

Materials and Equipment

Pale blue matte latex paint for
 the base coat
Sunflower two-part stencil
Ruler, pencil, painter's tape
Matte latex paints: cream,
 mid-blue
Acrylic paints: green, yellow,
 yellow ocher, burnt umber
Paint pails
Household paintbrushes
Foam roller head
Decorator's sponge
Fine-grade wet-dry sandpaper
Matte acrylic glaze

Building up layers of color over a simple flower stencil
can produce a subtle shading effect with a feeling of
depth. The paint is applied lightly and overlaid carefully
so that previous colors remain visible. Different tools
also help to make the shading more varied, such as a
foam roller head for large areas and small pieces of
sponge for the shading, which also adds variety of
texture. Sanding lightly softens the final effect.

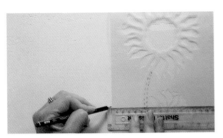

1 Apply the base coat. Decide on the position of the stencil and mark a border line that will contain the stenciled design.

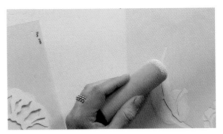

2 Lightly fix the stencil in place with painter's tape. Dip the end of a foam roller head in cream matte latex paint and dab off the excess. Stipple the paint through the stencil to define the image and provide a light base to add further colors to. Leave to dry.

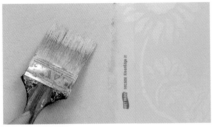

3 Mask the stencil against the line marked in Step 1. Mix 1 part mid-blue matte latex paint to 2 parts water. Brush a blue wash over the area not being stenciled. Let dry and remove the tape.

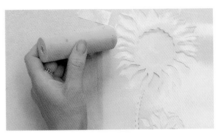

4 Use a clean roller head and yellow acrylic paint to stencil the flowers. Aim for a fairly solid layer of color, but let the texture of the foam allow the cream to show through in places. Leave to dry.

5 Use the same technique to stencil green acrylic paint over the stems.

6 Use small pieces of sponge to stipple the edges to suggest light and shade. Use yellow ocher and a mix of yellow ocher and burnt umber on the flowers and a green and burnt umber mix on the stems. Leave to dry. Lightly sand with fine-grade wet-dry sandpaper and protect with matte acrylic glaze.

Making a large repeat stencil

Materials and Equipment

Tracing paper, pencil, lining paper, transfer paper, craft knife, large cutting mat, painter's tape, ruler
Large sheets of manila stencil card

Large-scale ready-made stencils are expensive to buy, so it can be a good idea to make your own. It is not necessary to create multilayered designs to arrive at an individual and appropriate decoration; repeated simple shapes can give a satisfying result. This simple repeat design could be made more elaborate with the addition of extra stenciled details, such as a shadow line or a small, separate stenciled motif.

1 *Choose a repeat motif and simplify it, reducing it to a basic shape that will be easy to stencil and still look effective. For example, this classic border can be reduced to a single stencil featuring a double swirl. Sketch the simplified motif at a manageable size (or trace it from the original). Measure the area to be decorated and decide on the size of the stencil.*

2 *Draw a simple measured grid over the motif, say 10 squares. Cut lining paper to the size you want the stencil to be and fill with an enlarged 10-square grid. Sketch in the enlarged design with a pencil, referring to the grid on the original sketch. When it appears to be in proportion, pencil a darker line around the design.*

3 *Position transfer paper between the motif and a large sheet of manila stencil card and fix with painter's tape. Redraw the lines to transfer the design. Use several pieces of transfer paper if the size you require is not available. Leave a 2-inch (5-cm) margin top and bottom.*

4 *Cut out the stencil using a sharp craft knife over a large cutting mat. Keep the cutting line smooth and clean by following each curve in a flowing, steady line rather than making many small cuts. Move around the table if necessary.*

5 *Remove the cutout and go back over the lines, trimming away any catches that will cause the paint to bleed.*

6 *Decide how close you want each motif to repeat and mark a straight line on each edge of the stencil. Trim the stencil to give an even border.*

Simple mural

Materials and Equipment

Cream matte latex paint for the base coat
Tracing paper, pencil, transfer paper, craft knife, cutting mat, painter's tape
Manila stencil card
Acrylic paints: such as yellow, green, brown, dark purple
Paint pails
Small paintbrushes, stencil brush
Fine-grade wet-dry sandpaper
Matte acrylic glaze

A simple landscape mural can be painted using tracing paper and a few stenciled details. The main areas are blocked out in flat color, a few of the basic details are freehand painted, and the intricate shapes are stenciled in flat colors to match the overall painting style. Through careful use of closely toned colors it has been possible to suggest the light source and distance without adding extra shading and toning.

1 *Source images and trace them at the same size or photocopy them to enlarge or reduce them. Cut stencils of the fine details, any repeats, and the shapes you do not feel confident of painting freehand (see Steps 2–3, page 213). Apply the base coat.*

2 *Sketch two actual-size murals onto tracing paper, the first featuring the large, solid color areas, the second describing the slightly smaller details. Rub a soft pencil over the lines on the reverse of the paper. Position the paper the right way round on the surface and redraw over the lines to transfer the design.*

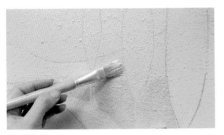

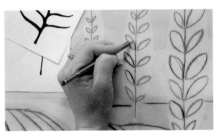

3 *Mix acrylic paints to achieve the desired shades. Use a small brush to paint in the main, solid colors, working neatly up to the lines. Leave to dry.*

4 *Position transfer paper between the second sheet of tracing paper and the painted surface and draw over the lines to transfer the design. Use a small brush to paint in the details and let dry.*

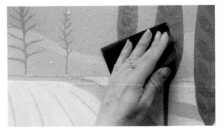

5 *Position the detail stencils and lightly fix with painter's tape. Use a stencil brush to wipe the paint through. Let dry.*

6 *Lightly sand the whole surface with fine-grade wet-dry sandpaper and protect the finish with matte acrylic glaze.*

Printing blocks

Materials and Equipment

Ruler, pencil, craft knife,
 cutting mat, painter's tape
Stencil acetate
Matte latex paints: such as dull
 green, brown, purple, gray-
 blue, pink
Metallic water-based paints:
 such as copper, gold, silver,
 bronze, green
Wooden printing blocks
Decorator's sponges

These printing blocks are made of wood with a carved, raised design. They are usually used on fabric or paper, but applying the color to the block with a sponge allows a greater amount of paint to reach the design and it is therefore possible to print onto a harder surface such as wood or plaster. It is difficult to repeat print in the same position, so if the first print is not complete it is better to clean it off and try again.

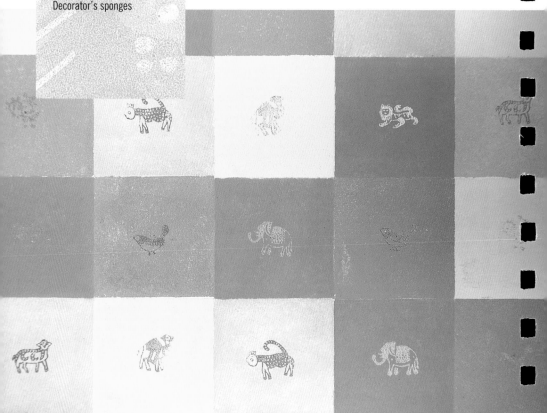

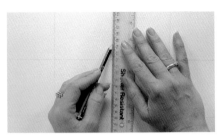

1 *Mark out the surface to be decorated with a grid of equal-sized squares.*

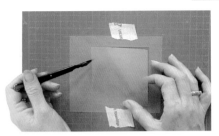

2 *Mark out and cut a stencil with the same dimensions as the squares from stencil acetate, using a sharp craft knife over a cutting mat. Reserve the cutout square for use later.*

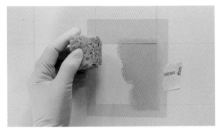

3 *Lightly fix the stencil to the surface with painter's tape, lining it up with a grid square. Dip a sponge in matte latex paint and dab off the excess paint. Stipple the paint through the stencil. Stencil alternate squares in a regular pattern of different colors. Allow to dry.*

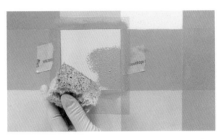

4 *Stencil the remaining squares to create a regular, equal mix of colors. Leave to dry.*

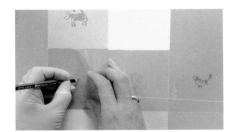

5 *Find the center point of the cutout square reserved in Step 2 and make a hole big enough to make a pencil mark through. Use this device to mark the center point of each square on the surface.*

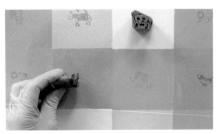

6 *Load a sponge with metallic water-based paint and press a printing block into it to pick up the color. Press the block down firmly and evenly over the central mark. Repeat with different blocks and different colors of metallic paint.*

Vegetable stamps

Materials and Equipment

Gray matte latex paint for the base coat
Painter's tape, permanent marker pen, craft knife
Sharp kitchen knife
Potatoes and rutabagas
Matte latex paints: red, blue, white
Household paintbrushes
Decorator's sponges
Matte acrylic varnish

Vegetable prints can look as sophisticated and professional as any commercially available foam or block prints, if used with a sense of style and ambition. The surface offered by potatoes and rutabagas is very receptive to paint and relatively easy to cut. Any designs must be cut and printed quickly because when the vegetable loses its moisture the stamps will become unworkable.

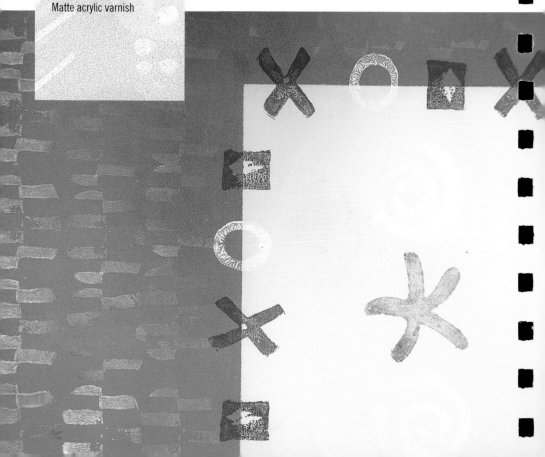

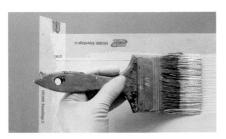

1 *Apply the base coat. Measure and use painter's tape to mark out an inner panel on the area to be printed. Brush a solid coat of white matte latex paint into the panel. Leave to dry.*

2 *Use a sharp kitchen knife to cut potatoes and rutabagas neatly in half. Choose dense, hard vegetables.*

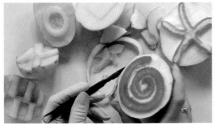

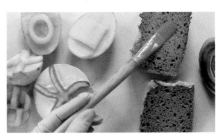

3 *Use a marker pen to draw out simple, graphic designs on the inside of each vegetable half. Use a sharp craft knife to cut away the background, leaving a raised motif for printing.*

4 *Dampen some sponges and use a brush to load the surface of each one with a different shade of matte latex paint. These will be used as pads to apply the paint to the vegetable stamps.*

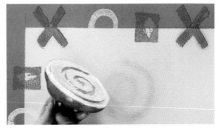

5 *Press a vegetable stamp onto a paint-pad sponge, then press the stamp onto the surface to print the motif. Press down quickly and evenly, not too hard or the paint might squeeze out unevenly.*

6 *Repeat with the different stamps and paint colors to create a simple, bold pattern. When dry, protect by applying matte acrylic varnish with a paintbrush.*

Found-material printing

Materials and Equipment

Cream matte latex paint for the base coat

Found materials such as burlap, bubble wrap, corrugated card, corks, string, carpet

Stiff card, scissors, paper, sponge

Contact adhesive, ready-mixed drywall sealer

Taupe matte latex paint

Metallic water-based paints: copper, gold

Household paintbrushes

Foam roller

Matte acrylic varnish

Making printing blocks is one way of recycling common packaging materials such as corrugated card, bubble wrap, and string. There is an element of surprise and a random nature to this method of printing, so, to eliminate the possibility of disappointment, it is recommended that you experiment with the printing on spare paper first and don't waste your time trying to use objects that do not print well.

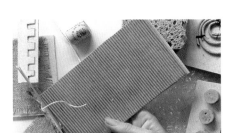

1 *Use sharp scissors to cut out rectangles of burlap and bubble wrap to create background textures. Gather a selection of textured materials, such as corks, string, copper wire, and natural sponge.*

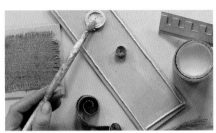

2 *Cut out base plates of firm card and use contact adhesive to fix your chosen articles to the card in the desired pattern. Coat the whole printing block with drywall sealer so that it will last for more than one print. Make more printing blocks as required.*

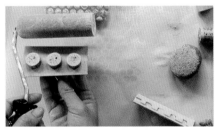

3 *Experiment with each printing block on spare paper to decide which to use where. Apply matte latex paint to the stamp with a foam roller and press the block onto the paper to impart the print. Wipe the stamp clean with a damp sponge after printing.*

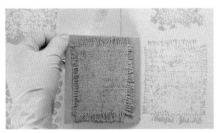

4 *Apply the base coat. Begin to mark out the design by printing the background textures. Roll matte latex paint onto the burlap and bubble wrap and press these onto the surface. Leave to dry.*

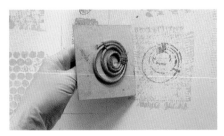

5 *Use bright copper metallic water-based paint to print the details over the background textures. Leave to dry.*

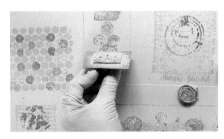

6 *Use gold metallic paint to print the final details. When dry, protect by applying matte acrylic varnish with a household paintbrush.*

Frottage

Materials and Equipment

Maroon gloss water-based
 paint for the base coat
Purple matte latex paint
Matte acrylic glaze
Paint pails
Household paintbrushes
Newsprint
Fine-grade wet-dry sandpaper
Matte acrylic varnish

The frottage technique involves rubbing newsprint over a wet glaze so that it removes some of the paint and causes the remaining color to collect and repeat the folds and lines of the absorbent paper, resulting in irregular, loose marking and texturing that is extremely random. Keep the base and top coats very close in tone for a delicate look.

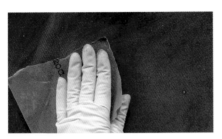

1 *The surface to be decorated must be shiny, so apply a base coat of maroon gloss water-based paint. Sand the final dry coat well with fine-grade wet-dry sandpaper.*

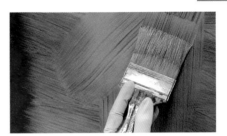

2 *Mix equal amounts of purple matte latex paint and matte acrylic glaze. Combine 1 part purple glaze to 3 parts water to make up a runny mix. Use a brush to wash this mix over the surface.*

3 *While the glaze is still wet, lay sheets of newsprint over the surface and rub the back until the paper is touching all over. Quickly pull the paper off again. This will remove some glaze and leave random marks. Leave to dry.*

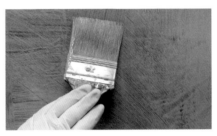

4 *Wash on another coat of purple glaze. If this reactivates the glaze, then it has not been allowed to dry enough and must be cleaned off and left to dry before starting again.*

5 *Repeat Step 3 to press down and remove another layer of newsprint. Allow to dry.*

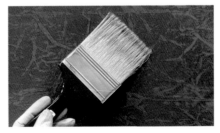

6 *Protect by applying matte acrylic varnish with a household paintbrush. The varnish will also make the top layers more transparent.*

Sprayed leaves and cutouts

Materials and Equipment

Cream matte latex paint for the base coat
Craft knife
Stencil cutouts (see pages 212–213)
Dried leaves
Protective face mask and gloves
Spray adhesive
Acrylic spray paints: copper, bronze
Paper

This decoration has been created by spraying paint over an arrangement of dried leaves of varying sizes and the cutout shapes and letters left over from making your own stencils. The design is informal and random. A unique and delicate shading and layering occurs when the objects are moved and then resprayed, and a variety of effects can be achieved by this method.

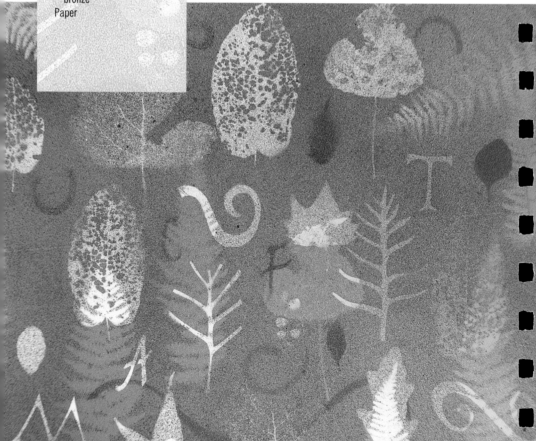

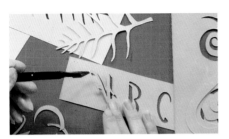

1 Keep the cutouts left over from cutting your own stencils to provide you with some interesting shapes to act as masks for the spray paint .

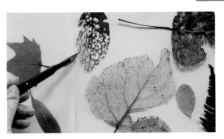

2 Apply the base coat. Dry a selection of leaves by placing them between clean paper then newsprint in a flower press or under heavy books. Arrange the leaves on the surface.

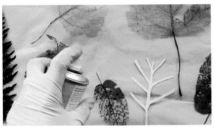

3 When you are happy with the design, transfer each element, reverse side up, to an identical position on a sheet of paper. Wearing a mask and gloves and working in a well-ventilated area, lightly spray over the whole surface with spray adhesive.

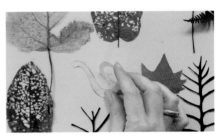

4 Reposition the objects, glue-side down on the surface. Press down well to ensure each element is firmly attached.

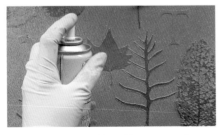

5 Lightly spray the surface with copper acrylic spray paint, following the manufacturer's instructions. After about 10 minutes, lift up a couple of pieces to check whether the spray color is deep enough. Respray to build up depth if necessary. Leave to dry.

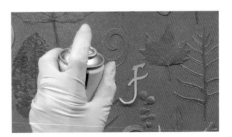

6 Remove some or all of the motifs by picking up each corner with a craft knife. Reposition the elements so that they overlap the first prints in places. Spray with bronze acrylic spray paint. Repeat Steps 5–6 until the desired effect is achieved.

Lining-paper bands

Materials and Equipment

Cream matte latex paint for the base coat
Tape measure, ruler, pencil, scissors
Thick lining paper
Gold metallic water-based paint
Acrylic paints: red, burnt umber
Paint pails
Household paintbrushes
Decorator's sponge
Wallpaper paste
Ready-mixed drywall sealer, such as Shieldz by Zinnser

This project demonstrates the flexibility of everyday lining paper and uses it in an alternative and dramatic way. Strips of lining paper are painted then glued to the surface as wallpaper. Cutting the paper into varyingly measured strips offers you flexibility when decorating, allowing you to rearrange the color and pattern combinations as you wish.

1 Apply the base coat. Mark a horizontal line where you want the lining paper bands to start, then mark a few more lines to act as guides later on.

2 Measure and mark up lengths of lining paper into bands of varying widths. Mark extra on the length to allow for any mistakes. Cut out the strips.

3 Use a brush to paint some of the strips with solid gold metallic water-based paint and red and burnt umber acrylic paints. Leave to dry.

4 Dilute red and burnt umber paints each with equal amounts of water. Use a damp sponge to wash these dilute paints onto the remaining lining paper strips. These colors will be more muted and may need more than one layer applied. Leave to dry.

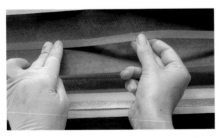

5 On a separate surface, arrange the strips until you find the desired color and pattern combinations. Overlap the bands if desired and aim to leave strips of the base coat showing through occasionally.

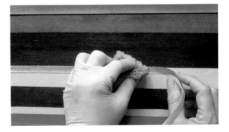

6 Glue down the bands, starting at the first line marked in Step 1. Use wallpaper paste on the wider pieces and drywall sealer for the finer strips. As you position the paper bands, wipe over each one with a damp sponge to help press the paper down and clean off any excess sealer.

Circles

Materials and Equipment

Gray matte latex paint for the base coat
Container lids, pencil
Metallic water-based paints: silver, gold, copper
Household paintbrushes, fitch brush, artist's brush
Damp cloth
Fine-grade wet-dry sandpaper
Satin acrylic varnish

No special drawing or measuring skills are required to paint these bold circles since each shape is simply created by drawing around a circular household object, such as a container lid, and each circle is placed by eye. Use a quality brush to paint in the circles and use fluid brushstrokes, following the shapes carefully to avoid going over the outline.

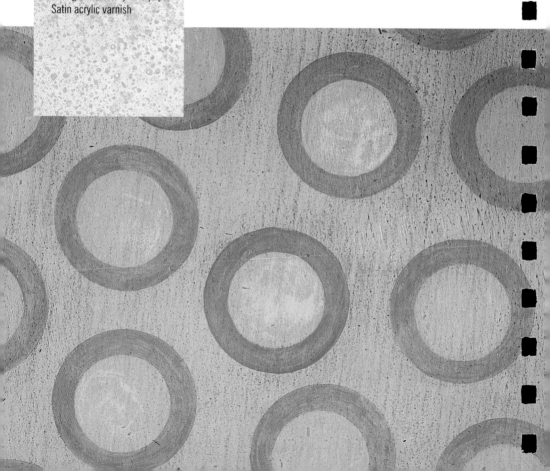

1 Apply the base coat. Sand the final dry coat well with fine-grade wet-dry sandpaper.

2 Brush on a solid coat of silver metallic water-based paint as evenly as possible. Leave to dry.

3 Lightly sand the silver with fine-grade wet-dry sandpaper to add texture.

4 Select two circular household objects, one larger than the other. Use a pencil to draw around the larger circle. Repeat all over the surface, aiming to retain a regular-sized gap between each circle. Position the smaller circular object centrally, by eye, in the larger circle and draw around it as before.

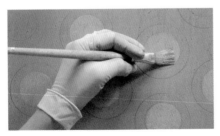

5 Use a fitch brush to paint the inner circles with gold metallic water-based paint. Try to keep the paint within the pencil lines. Wipe off any mistakes with a damp cloth before the paint dries. Let dry.

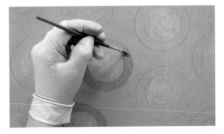

6 Paint the outer bands with copper metallic paint, using an artist's brush and even, fluid strokes. Leave to dry and protect by applying satin acrylic varnish with a household paintbrush.

Craquelure stripes

Materials and Equipment

Pale cream matte latex paint
 for the base coat
Two-part craquelure varnish
Ruler, pencil, painter's tape
Artist's oil paints: green, pink
Mineral spirits
Paint pails
Household paintbrushes
Lint-free cloth
Matte oil varnish

Although craquelure varnish is most often used as an aging medium, it can have a contemporary style. This technique uses the effect as a textured background to hold color. The addition of bright, contrasting colors gives an extra character to the decoration and helps the technique look less commonplace and more unusual.

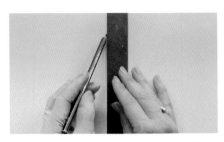

1 Apply the base coat and a craquelure effect (see Steps 1–4, page 121). Measure and mark up the surface into vertical bands.

2 Further detack painter's tape by pressing the tacky side against a cotton or lint-free surface. Mask the lines marked in Step 1.

3 Dilute green artist's oil paint with enough mineral spirits to make a fluid wash. Gently brush the glaze onto the craquelure until it is held in the cracks. Repeat on alternate bands. Leave for one hour only.

4 Slightly dampen a cloth with mineral spirits and gently wipe over the surface to remove the top layer of color, leaving the color mostly in the cracks. Leave to dry completely.

5 Remove the painter's tape and reapply to mask the newly painted strips.

6 Follow Steps 3–4 to apply dilute pink oil paint to the remaining stripes. Leave to dry. Remove the tape and protect by applying matte oil varnish with a household paintbrush.

Outline squares

Materials and Equipment

Red matte latex paint for the base coat

Ruler, pencil, craft knife, cutting mat, painter's tape

Manila stencil card

Metallic water-based paints: a selection of golds from dark to bright

Small paintbrushes

Decorator's sponge

Fine-grade wet-dry sandpaper

Beeswax

Lint-free cloth

Experimenting with a range of different brushstrokes and marks is an extremely simple way of achieving an individual finish that looks complicated. The edges of square masks and stencils are stippled, sponged, and brushed with different shades of gold paint to outline shapes that intersect with each other. Do not overload the brushes and sponges or the light paint application will be difficult to control.

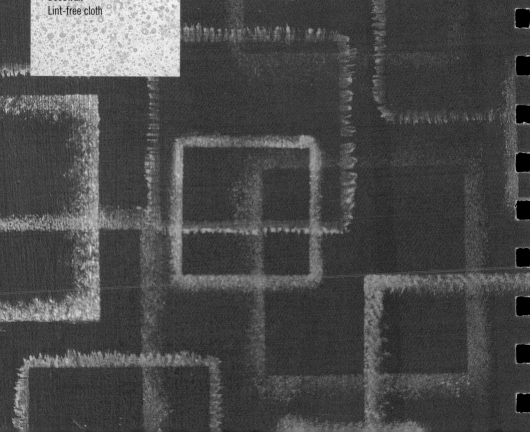

1 *Apply the base coat. Sand the final dry coat well with fine-grade wet-dry sandpaper.*

2 *Mark squares of varying sizes on stencil card and cut them out with a sharp craft knife over a cutting mat. Keep the stencils and the masks.*

3 *Lightly fix the largest square stencil to the surface with painter's tape. Load a small brush with dark gold metallic water-based paint and remove the excess. Stipple the paint around the inside edges of the stencil. Continue adding randomly spaced large squares. Leave to dry.*

4 *Attach a strip of tape rolled back on itself to the back of a square mask. Lightly fix the mask in position, overlapping one of the first gold squares. Dip a sponge in a little mid-gold paint and dab off the excess. Stipple the gold around the edge of the mask. Add more squares as desired and let dry.*

5 *Continue painting squares of decreasing size in different shades of gold. Use a brighter gold and try out another method of application, brushing the paint out from the center.*

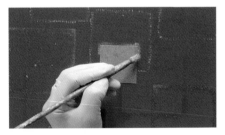

6 *Use the smallest square with the brightest gold, stippling it on with a small brush for another different effect. When you are happy with the arrangement, leave to dry and seal by applying beeswax with a lint-free cloth.*

Wallpaper

Materials and Equipment

Quality lining paper
Matte latex paints: pale cream,
 cream
Rubber or foam stamps
Acrylic paints: such as green,
 orange, yellow, blue
Ruler, pencil
Household paintbrushes, fine
 artist's brush
Decorator's sponge
Matte acrylic glaze
Paint pail

Making your own wallpaper is easier than you might imagine, and extremely cheap. Try to work with simple lines of decoration, even if these are not immediately obvious. Here, the first light leaf stamp is applied in regular vertical lines that are about the same distance apart. This acts as a helpful structural guide. The decoration chosen is best kept simple and limited. Use wallpaper paste as normal to fix it to the wall.

1 *Use a brush to apply a coat of pale cream matte latex paint to quality lining paper. Leave to dry. Dampen a sponge and use this to apply a thin wash of cream matte latex paint all over. Let dry and repeat. Leave to dry.*

2 *Separate a square of the painted lining paper and use it to try out your stamps with various shades of acrylic paint. Aim to use pale colors with some stamps, to act as a background, and contrast these with other stamps in brighter colors.*

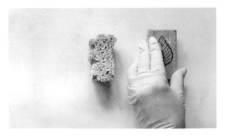

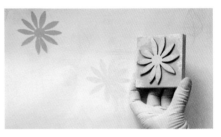

3 *Measure and lightly mark the repeats on the paper, working in vertical and horizontal bands but trying not to make the pattern too grid-like. Dampen a sponge and load the surface with a pale acrylic paint. Press the first stamp into the paint-pad sponge, then press it onto the paper. Repeat to give the first line of the pattern. Leave to dry.*

4 *For a different print, apply color to the next stamp by touching the paint onto the stamp with a small piece of sponge. Use the stamp as before and repeat with another paint color to form the next few lines of the pattern. Let dry.*

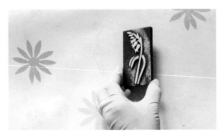

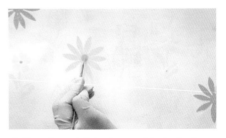

5 *Use the paint application method detailed in Step 4 to apply two colors to the stamp at one time. Repeat the stamping to complete the design.*

6 *Use a fine artist's brush to touch in the details. Let dry. Mix 3 parts matte acrylic glaze to 1 part water and coat the paper to protect it.*

Wallpaper border

Materials and Equipment

Quality lining paper
Steel ruler, pencil, craft knife,
 cutting mat, painter's tape
Matte latex paints: pale gray-
 green, mid-gray-green
Manila stencil card
Household paintbrushes
Decorator's sponge
Matte acrylic glaze

When creating your own wallpaper border you need some quality lining paper and a basic repeat stencil. It is best to use a large, simple repeat design rather than something narrow and detailed that may not be visible in a high position. This border is wider than the stencil because it features a painted line top and bottom to help the motif stand out. Use wallpaper paste as normal to fix it to the wall.

1 Use a craft knife and steel ruler over a cutting mat to cut lining-paper strips wide enough to house the stencil plus a painted line above and below.

2 Working on a flat surface, brush a coat of pale gray-green matte latex paint onto a paper strip. Leave to dry.

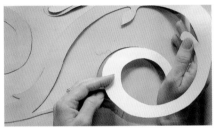

3 Make a large repeat stencil (see pages 218–219).

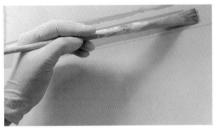

4 Measure and mark the border lines at the top and bottom of the strip. Use a small brush to paint in lines of mid-gray-green matte latex paint. Leave to dry. Use a sponge to stipple the edges of the border with the pale gray-green.

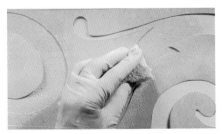

5 Lightly fix the stencil between the painted border lines with painter's tape. Dip a sponge in mid-gray-green matte latex paint and dab off the excess. Stipple the color through the stencil. Leave to dry— the lightly applied paint will dry quickly.

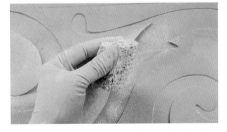

6 Stipple pale gray-green matte latex paint in the center of the design, not going right up to the edges. The edges will be outlined in the darker gray-green for a three-dimensional effect. Realign the stencil and repeat Steps 5–6 to complete the border. Mix 3 parts matte acrylic glaze to 1 part water and coat the paper to protect it.

Acrylic spatter and oil spray

Materials and Equipment

Cream acrylic eggshell paint for the base coat
Acrylic paints: pale blue, brown
Artist's oil paints: raw sienna, raw umber
Mineral spirits
Paint pails
Household paintbrushes, nail brush
Plant sprays
Decorator's sponge
Hair dryer or hot-air gun
Ruler, pencil, painter's tape
Dead flat oil varnish

This project combines oil- and water-based paints and uses pump-handle plant spray guns as a quick and easy way to apply a thin spattering of color. The loose, fluid wash that results is patinated with spattered acrylic paint that acts as a resist to the next spray of oil glaze. Practice spraying the oil glaze onto newsprint until you are confident that the paint is flowing well.

1 *Apply the base coat. Mix pale blue and brown acrylic paints each with a little water. Spatter the surface with dilute paints by dipping a brush in the paint and pulling back and releasing the bristles.*

2 *Mix equal amounts of raw sienna artist's oil paint and mineral spirits. Pour the glaze into a plant spray and, while the spattered paint is still wet, spray randomly all over. Let this layer of oil glaze settle then repeat with a raw umber oil glaze.*

3 *Spatter the acrylic colors again as in Step 1. This will misplace some of the oil glaze and add texture. Continue layering sprayed oil glazes and spattered acrylics until you are happy with the mix.*

4 *Speed up the drying process a little with a hair dryer or hot-air gun. Do not dry the paint completely.*

5 *Brush mineral spirits onto a sponge and lightly sponge the surface to lift off areas of oil paint and add more texturing. Dip a nail brush in the spirits and dab this on for a finer texture. Leave to dry.*

6 *Draw a line down the center of the surface. Mask one side with painter's tape. Brush the raw sienna oil glaze over one half and let dry. Reposition the tape and brush the other half with raw umber oil glaze. When dry, protect with dead flat oil varnish.*

Simple freehand painting

Materials and Equipment

Pale cream matte latex paint
for the base coat
Lining paper, pencil, transfer
paper, craft knife, cutting
mat, painter's tape, biro
Stencil acetate
Deep cream matte latex paint
Acrylic paints: burnt umber,
raw umber, red
Paint pails
Decorator's sponge
Artist's brush, household
paintbrush
Foam roller head
Matte acrylic varnish

To someone with no drawing skills, the idea of using figurative imagery can be very daunting. However, by researching the kind of images you like from books and photographs, and sketching out ideas on lining paper first, the uninitiated artist can paint freehand motifs. Simple stencils cut for the repeat elements of the design could be enhanced with handpainted details.

1 *Apply the base coat. Dampen a sponge and use this to wash deep cream matte latex paint all over. Use a scrubbing motion to suggest an aged wall finish. Leave to dry.*

2 *Sketch out your design on a piece of lining paper until you are happy with the scale and layout.*

3 *Cut stencils of any repeat details (see Steps 2–3, page 213). You can use stencil acetate in the same way as stencil card, and, in this case, because it is easy to see through it is easier to place.*

4 *Place transfer paper between the lining-paper sketch and the surface and lightly fix in place with painter's tape. Redraw the design with a biro to transfer it to the surface.*

5 *Mix a sepia paint from burnt umber, raw umber, and red acrylic paints. Dilute with water until fluid and slightly transparent. With an artist's brush, use long, smooth brushstrokes to paint in the lines. Paint sepia leaves and reapply the paint to those areas of the design in shadow. Let dry.*

6 *Lightly fix the detail stencils in position with tape. Dip a foam roller head in red acrylic paint mixed with a touch of raw umber and remove the excess. Stipple the paint through the stencils and let dry. Protect with matte acrylic varnish.*

Grisaille

Materials and Equipment

Ruler, pencil, tracing paper,
 transfer paper, painter's
 tape
Matte latex paints: gray, white
Black acrylic paint
Paint pails
Artist's brushes, household
 paintbrush
Fine-grade wet-dry sandpaper
Matte acrylic varnish

The grisaille painting style was traditionally used to imitate plaster or painted-wood relief work. The monochrome finish can be achieved using just three tones of a single color. It is usually easiest to begin with the mid-tone across the whole surface and then add the lighter and darker tones to touch in the foreground and distant planes. Decide on the light source and experiment on paper before you commit.

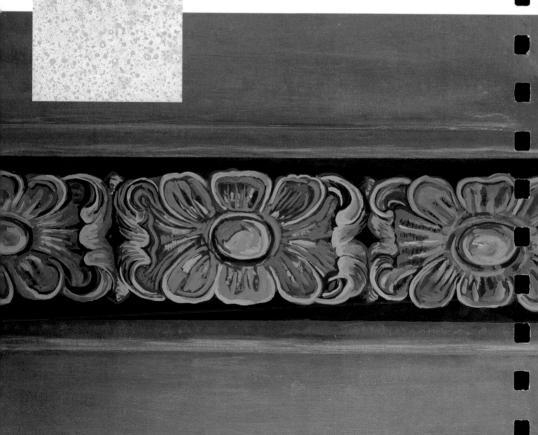

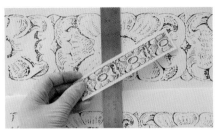

1 Decide on your design and enlarge photocopies to fit the area you wish to decorate. Mix gray matte latex paint with varying degrees of white matte latex paint or black acrylic paint to create three tones, dark gray, mid-gray, and light gray.

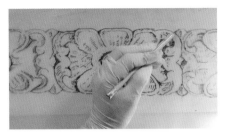

2 Trace the outline and details of the design from the photocopies. Experiment with washes of color on the photocopies to decide on the tonal range you will be using and to ascertain the source of light you will be working with.

3 Apply a base coat of mid-gray and sand with fine-grade wet-dry sandpaper.

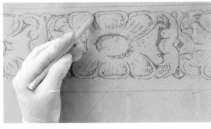

4 Place transfer paper between the tracing-paper sketch and the surface and lightly fix in place with painter's tape. Redraw the design to transfer it.

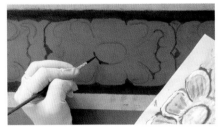

5 Use painter's tape to mask a border around the transferred design. Start with the darkest gray, using an artist's brush to paint it into the background, from the tape to the outline of the mid-gray main shape. Add the dark gray details, referring to the experimental color work done in Step 2. Let dry.

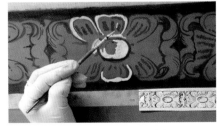

6 Paint the highlight areas with the lightest gray. Let dry, then rework any of the mid-tone and dark areas as necessary. Leave to dry then protect by applying matte acrylic varnish with a household paintbrush.

Decoupage grisaille

Materials and Equipment

Ruler, pencil, sharp scissors
Pale cream matte latex paint
Burnt umber acrylic paint
Paint pails
Household paintbrushes, long-
 bristled artist's brushes
Decorator's sponges
Ready-mixed drywall sealer,
 such as Shieldz by Zinnser
Matte acrylic varnish

An alternative to the painted tradition, this is a quick-and-easy way to imitate a solid, carved decoration. Three tones of a single color—dilute washes of light, mid-, and dark brown—are applied to a paper motif that is stuck in position to suggest a three-dimensional stone relief. Adding a painted shadow line around the stuck-on paper has enhanced the relief effect.

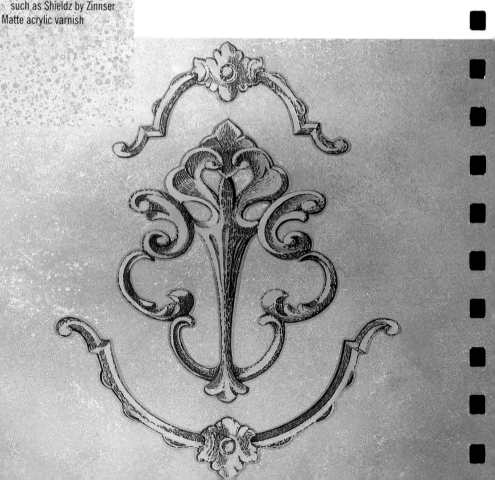

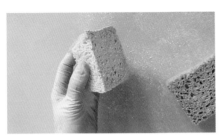

1 Mix burnt umber acrylic paint with varying degrees of pale cream matte latex paint to create three tones, dark brown, mid-brown, and light brown. Use sponges to thickly stipple on patches of each brown, overlapping in places to blend the colors. Leave to dry.

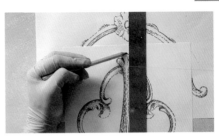

2 Photocopy the chosen design and enlarge to the required size. Make marks on the surface to help you align each separate element later.

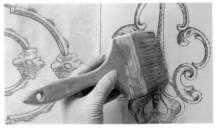

3 Dilute 1 part mid-brown paint with 3 parts water and use a brush to wash the glaze all over the paper copies. Leave to dry.

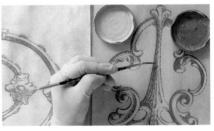

4 Dilute the light and dark browns as in Step 3. Decide on the source of light, then use a long-bristled artist's brush to paint in the highlights and shadows to give a three-dimensional feel. Let dry.

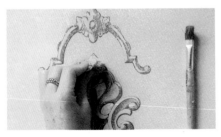

5 Carefully cut out the design using sharp scissors. Use drywall sealer to stick down the paper elements, following the pencil marks made in Step 2. Gently wipe a damp sponge over the paper to remove any air bubbles. When the glue is dry, wash off the pencil marks with a damp sponge.

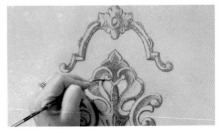

6 Use the mid-brown to paint a thin shadow line around the paper cutout. Using the long-bristled artist's brush will help keep the line constant and even. Protect with matte acrylic varnish.

Glossary

acrylics Fast-drying, water-based paints.

ageing Variety of techniques for simulating the effect of time and wear on new paint, wood, or plasterwork.

base coat First coat of paint for most decorative paint finishes, applied before the glaze or ground coat.

binder Paint ingredient that binds the particles together.

blending brush *see* **softening brush**

bole Colored clay mixed with animal-skin glue, sometimes applied over gesso before gilding.

border Design around the edge of panel, wall, floor, etc. It may be stenciled, printed, or painted freehand.

bravura Spirited brushwork.

buff To polish with a cloth.

burnisher Extremely smooth agate polisher used in water-gilding.

casein Quick-drying, milk-based paint that can be varnished.

clay plaster Versatile, natural "breathing" material.

collage Work put together from assembled fragments of materials such as paper and fabrics.

colorwashing Simple water-based paint technique used to produce a softly textured, patchy finish achieved by applying several layers of thin paint.

combing Technique in which the teeth of a decorator's comb are scraped through a surface glaze to reveal the color below.

complementary colors Any pair of colors that, when placed on a color wheel, occupy opposing positions. The complementary of any primary color (red, yellow, blue) is the secondary color made by mixing the other two.

crackleglaze *see* **craquelure**

craquelure Decorative glaze developed in eighteenth-century France to reproduce the fine network of cracks on Eastern lacquerwork and pottery. Also known as crackleglaze.

cross-hatching Two sets of parallel lines, one on top of the other, with the second set at an angle to the first.

decoupage Method of decorating walls and objects with paper cut-outs protected by a clear glaze or varnish.

distemper Group of paints formed by mixing pigments with water, bound with casein, glue, or egg, which were widely used before the introduction of latex paints.

distressing Process of artificially abrading a new surface to create the appearance of age.

dragging Technique of pulling a long-haired brush through wet transparent glaze or distemper to produce a series of fine lines.

dry-brushing Paint technique that keeps the bristle surface of a brush relatively dry in order to build up a cloudy effect, or to touch up the highlights of a textured surface.

drywall Plaster substitute such as plasterboard.

Dutch metal leaf Imitation gold or silver used in gilding.

eggshell Mid-sheen, oil- or acrylic-based paint used as a base coat for basic and bravura finishes. White eggshell is also used for mixing some pale colors for the glaze coat. Also used to describe a mid-sheen finish of paints and varnishes.

emulsion *see also* **latex** Water-based paint, suitable for most decorative paint finishes if protected by a glaze or varnish.

faux effects Literally: "false" effects. That is, finishes created to imitate another material, such as marble (*faux marbre*) or wood (*faux bois*).

fitch Hog-hair brush suitable for oil work (one type is available for watercolor work). The five types are round, filbert, long, short, and herkomer. Used in many techniques and sometimes as an alternative to a household brush.

flat finish Matte, non-glossy finish.

flogging Colored glaze is laid over a base coat, then flogged with a long-bristled brush. This gives a mottled effect.

flogging brush Coarse horsehair brush used for dragging and flogging; available in a range of sizes.

frottage Literally: "rubbing" (from the French *frotter*—to rub). A technique involving rubbing newsprint over a wet glaze or rubbing a loaded paintbrush on a dry surface.

gesso Fine plaster traditionally prepared with rabbit-skin glue and whiting, and applied to surfaces in many layers to give a completely smooth finish before gilding or painting. Also now available in a ready-mixed, substitute form.

gilding Method of giving surfaces a metallic finish by the application of metal leaf or paint.

glaze Any paint that has been diluted and in which color can be mixed.

gold leaf Sheets of gold beaten to a wafer thinness used in gilding.

grisaille Visual trick that harnesses monochrome shades of paint to represent areas of light and shade and thus create, on a flat surface, the illusion of a three-dimensional ornament or an architectural feature.

heartgrainer Comb that produces faux woodgrain effects.

hog-hair brush Tough, springy hog-hair brush that is suitable for acrylic- and oil-painting.

lacquering Technique for simulating the high-gloss finish of Chinese and Japanese lacquer.

latex Water-based paint, suitable for most decorative paint finishes, if protected by a glaze or varnish.

limewash Substance made of slaked lime and water used to whiten exterior walls. Also known as whitewash.

lining Technique for outlining the shape of a surface with one or more decorative lines.

lining paper Plain, flat wallpaper used to line the walls of a room, often over imperfect plaster. It can be painted if first sealed with diluted undercoat.

luminosity Measure of brightness of a paint.

masking Covering a surface to provide a barrier against a layer of paint.

masking tape Used to mask out areas, hold on stencils etc.

methylated spirits Industrial alcohol used as a solvent.

mica Rock-forming mineral, such as slate, which crystallizes into easily separated layers.

Mondrian, Piet (1872–1944) Dutch abstract painter who limited himself to rectangular forms and very few colors.

muslin Fine, woven cotton fabric used for curtains, hangings, etc

oil gilding Technique in which transfer gold is applied to a surface.

oil glaze *see* **glaze**

oxidation Chemical reaction of a material with oxygen in the air.

painter's tape Low-tack masking tape

patina Color and texture that appear on the surface of a material as a result of age or atmospheric corrosion.

patination Artificially created patina.

pigment Coloring matter used in paints.

plumbline Weighted string used for marking verticals.

primary colors Colors from which all others can be mixed. The primary colors in paint are red, yellow, and blue. They combine to form secondary colors.

primer Sealant for new plaster or woodwork before painting.

ragging Paint technique that employs a crumpled piece of rag to create decorative broken-color finishes.

roller Tool with a revolving cylinder covered in various materials and used for applying paint.

sable brush Good-quality paintbrush.

sandpaper Abrasive paper available in varying degrees of coarseness. *See* **wet-dry sandpaper**.

secondary colors Colors made by mixing two primary colors.

shellac Resin in thin plates.

softening brush Long-haired brush used for softening and blending paint in marbling, woodgraining, and many other bravura finishes. Badger hair softeners are easier to use but more expensive than hog-hair softeners. Available in a range of sizes.

solvent Part of oil-based paints that evaporates during drying.

spirit dyes Used to simulate a distressed surface.

sponging Paint technique that uses a damp sponge to produce a mottled, patchy effect.

spraying Method of directing paint onto a surface in a fine spray.

stainers Sometimes known as universal stainers. Used as an alternative to artist's oil paints for coloring glaze. The range of colors is less extensive and less subtle than artist's oils. *See* **tinter**.

stencil brush Short-haired brushes designed to hold small amounts of paint for stenciling. Available in a wide range of sizes and with long or short handles.

stencil card Stout oiled manila card, from which shapes are cut in order to make stencils.

stenciling Method of decoration in which paint is applied through a cut-out design to create images on a surface.

stippling Painting or texturing a surface with a fine, mottled pattern, using a stippler or stiff-bristled brush.

stippling brush Rectangular brush used for a stippled finish and for removing excess paint in cornices and architraves etc. Available in a variety of sizes.

stucco Fine plaster-type material used both to cover exterior brickwork and to decorate internal walls and ceilings.

sugar soap Alkaline degreasing agent: a type of cleaner that can be applied to a surface before work starts. It needs to be thoroughly rinsed afterward.

tertiary colors Colors made by mixing two secondary colors.

tinter Also known as universal tinter. Highly concentrated coloring agent. *See* **stainer**.

tone Term used to describe how dark or light a color is. Different colors may be the same tone.

tongue-and-groove Joint made between two boards by means of a tongue projecting from the edge of one board that slots into a groove along the edge of the other.

transfer leaf Sheets of gold or silver leaf attached to tissue paper used in oil gilding.

trompe l'oeil Any of a variety of optical illusions, such as *grisaille*, that are designed, literally, to "trick the eye."

undercoat Matte paint applied to a surface before the base coat.

universal stainer *see* **stainer**.

universal tinter *see* **tinter**.

varnish Transparent protective coat applied to completed paint finishes. Varnishes may be matte, eggshell, or gloss, and they may be water-, oil-, or spirit-based.

veining Specialist technique for painting the veins on simulated marble.

water-gilding Technique for applying transfer or loose leaf to a surface.

wet-dry sandpaper Abrasive paper that may be used with water to achieve a really smooth finish.

whitewash *see* **limewash**

whiting Finely ground calcium carbonate used in making gesso.

woodgraining Technique used to imitate the characteristic markings of a variety of natural woodgrains.

Index

Figures in *italics* indicate captions.

Resources

Many of the tools and materials used in this book can be found at hardware and fine-art stores. Check the yellow pages for the location nearest you. Otherwise, you can contact any of the following suppliers:

USA

Dover Publications
11 East Ninth Avenue
New York, NY 10019
www.doverpublications.com

Homestead House Authentic Milk Paint
95 Niagara Street
Toronto, ON M5V 1C3
Tel (416) 504-9984

Lee Valley Tools Ltd.
PO Box 6295, Station J
Ottawa, ON Canada K2A 1TA
Toll-Free 1-800-267-8767
Toll-Free Fax 1-800-668-1807

Paint Effects
2426 Fillmore Street
San Francisco, CA 94115
www.painteffects.com

Pierre Finkelstein Institute of Decorative Painting, Inc.
20 West 20th Street, Suite 1009
New York, NY 10011
www.pfinkelstein.com

Pratt & Lambert Inc.
PO Box 22
Buffalo, NY 14240
www.prattandlambert.com

R&F Handmade Paints, Inc.
110 Prince Street
Kingston, NY 12401
www.rfpaints.com

Sepp Leaf Products, Inc.
381 Park Avenue South
New York, NY 10016
www.seppleaf.com

The Texston Company
www.texston.com

Woodcrafter's Supply Corp.
www.woodcraft.com

The Old Fashioned Milk Paint Co.
www.milkpaint.com

Absolute Coatings Inc.
www.lastnlast.com

Adele Bishop
www.adelebishop.com

UK

Craig & Rose plc
172 Leith Walk
Edinburgh EH6 5EB
www.craigandrose.com

Dulux Decorating Centre
89 Richford Street
London W6 7HJ
www.dulux.co.uk

Leyland SDM
43-45 Farringdon Road
London EC1
www.leyland.co.uk

Daler-Rowney Ltd.
12 Percy Street
London W1A 2BP
www.daler-rowney.com

W.Habberley Meadows
5 Saxon Way
Chelmsley Wood
Birmingham B37 5AY
www.habberleymeadows.co.uk

AUSTRALIA

Porter's Original Paints
Sydney, Australia
Tel (818) 623-9394
Fax (818) 623-9210
www.porters.com.au

Acknowledgements

The book is dedicated to baby Jessie the best companion during much of the work, and Stephen for all his support.

I would like to thank the following people for their hard work and help with the production of this book: John Hilborne, Matt Watson, Louisa Swan, and particularly Sarah Davies who assisted and inspired me. A special mention for Tilly, Amber, Lutia, and Neave for their beautiful boards.

For their generosity and support for this project and for supplying products and advice I would like to thank: Neil from Natural Building Technologies Ltd, Cholsey Grange, Ibstone, High Wycombe, Bucks HP14 3XT, e-mail: www.natural-building.co.uk; Stuart R. Stevenson, 68 Clerkenwell Road, London E3; Tim France for patiently working on to complete a book of many pictures and for great baby entertaining!

I particularly wish to breathe a group sigh of relief with all at Quarto, the project is complete, thank you.